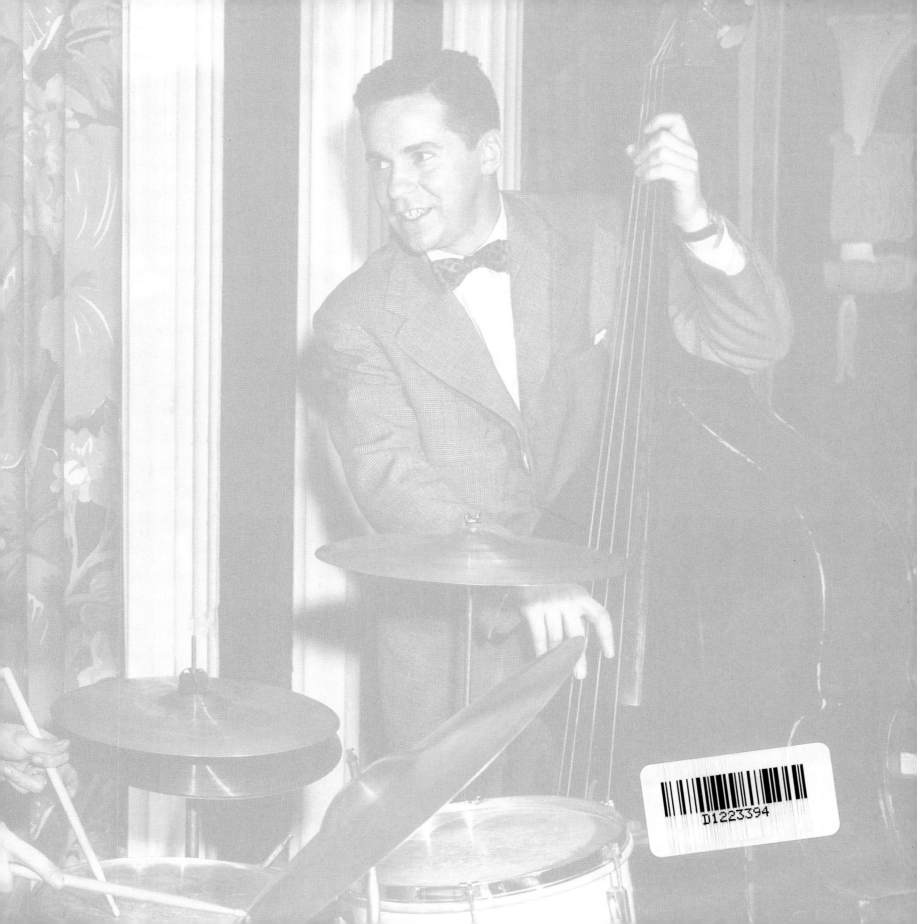

"PoPsie" N.Y.

POPULAR MUSIC

THROUGH THE CAMERA LENS OF WILLIAM "POPSIE" RANDOLPH

BY MICHAEL RANDOLPH
FOREWORD BY QUINCY JONES

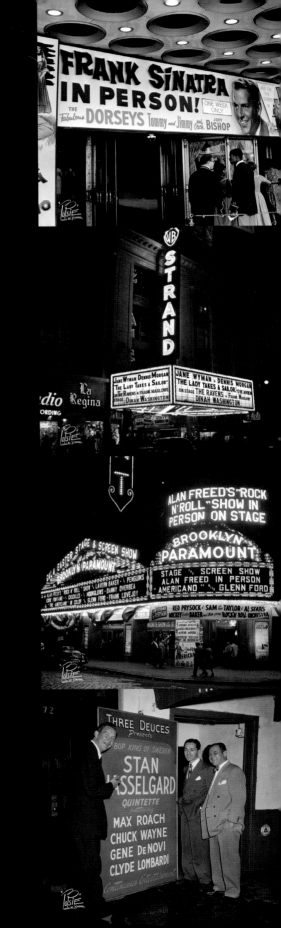

Produced by: Michael Randolph
 Executor to the Estate of: William "PoPsie" Randolph

 Photos by "PoPsie"
 Ocean City, NY
 Key Largo, FL
 PoPsiePhotos.com

Library of Congress Cataloging-in-Publication Data is applied for
with the Library of Congress.
ISBN-13: 978-1-4234-2362-1
ISBN-10: 1-4234-2362-3

Project editors: Michael Randolph, Cliff Malloy
Executive editor: Steve Farhood
Art director: Richard Slater
Designer: Linda Nelson
Text editor: J. Mark Baker

Printed in China through Colorcraft Ltd,Hong Kong

Published by Hal Leonard Corporation
7777 W. Bluemound Road
P.O. Box 13819
Milwaukee, WI 53213

Visit Hal Leonard Online at **www.halleonard.com**

First printing

Cover photos
Left column, top to bottom: **Wilson Pickett** (left) and **Jimi Hendrix**, 1966;
Benny Goodman, 1947; the **Ronettes**, 1962, **Elvis** and the **Jordanaires**, 1956.
Right column, top to bottom: the **Rolling Stones**, 1964; **Billie Holiday** (left) and **Ella Fitzgerald**, 1950;
Peggy Lee, 1952; **Louis Armstrong** (left) and **Duke Ellington**, 1961.

Contents

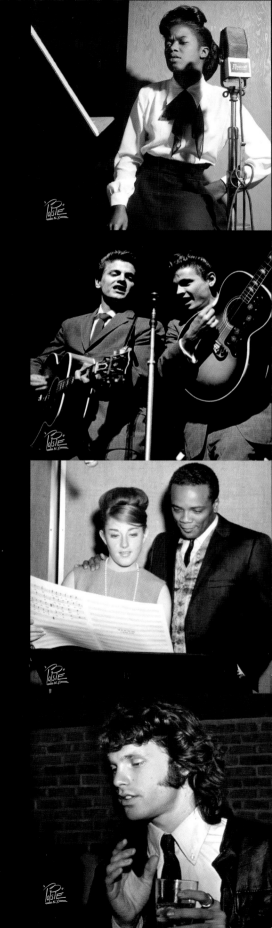

Top to bottom: **Sarah Vaughan** during a November 8, 1949 recording session; the **Everly Brothers**, headliners for Alan Freed's 1957 show at the Paramount Theatre; when **Quincy Jones** began his job as a musical director at Mercury Records in 1964, one of his first tasks was to produce **Leslie Gore**; a surprisingly clean-cut **Jim Morrison** relaxes after a show at The Cellar in New York City, August 1967.

FOREWORD

During the 28 years of his photographic career, William "PoPsie" Randolph established himself as an icon of the American popular music industry. PoPsie was Broadway's most famous jazz and rock photographer. His artistry is a part of the landscape of American popular music. Through his lens, PoPsie's images captured a candid way of life that was central to the experiences of many musicians, vocalists, and their producers. Nearly 30 years after his untimely death in 1978, PoPsie is still recognized and is often referred to by the music industry as "the legend of Broadway."

While managing Benny Goodman and Woody Herman's orchestra in the early Forties, PoPsie's foundation for his career in freelance photography was built on his personal experiences and contacts with the artists and producers of the music industry.

When John Hammond—legendary talent scout and freelance producer for Columbia Records—discovered great talents in jazz, folk, blues, and rock, who was on location to help launch their careers with publicity and record date photos? PoPsie! John and PoPsie shared the same itinerary in life: they brought mainstream recognition and respect to black musicians and their music. PoPsie, along with jazz luminary Benny Goodman, coined the phrase, "It takes black keys and white keys to make good music."

As a band-boy and manager, PoPsie witnessed the mass appeal for jazz through much of the Thirties. To cater to the tastes of urban African-Americans, jazz itself was growing in several different directions. It was indebted both to Southwestern blues and jazz musicians that featured vocal blues artists and to bands like Count Basie.

Lionel Hampton, a vibraharpist who had worked with Goodman, produced a more down-home, riff-based jazz style with a heavy beat. At age 18, I received an offer to tour as a trumpeter with the legendary Hampton; he requested to use my talents to arrange many tunes.

Relocating to New York City, I received a number of freelance commissions arranging songs for artists like Sarah Vaughan, Count Basie, Duke Ellington, Gene Krupa, and my old friend Ray Charles. The recording studios, concert halls, and nightclubs of New York City witnessed decades of these historic sessions along with PoPsie's camera.

Quintessential New York photographer "PoPsie" Randolph chronicled the transition of modern music from swing to jazz. His camera captured segues from rhythmically flavored modern blues to a developed style of chordal numbers, pumping shuffles of the electric guitar, and archetypal rock 'n' roll.

I feel fortunate to have had a part of my life chronicled by a great photographer like PoPsie.

The soul of American popular music is forever embraced by the photographs of... William "PoPsie" Randolph.

–Quincy Jones

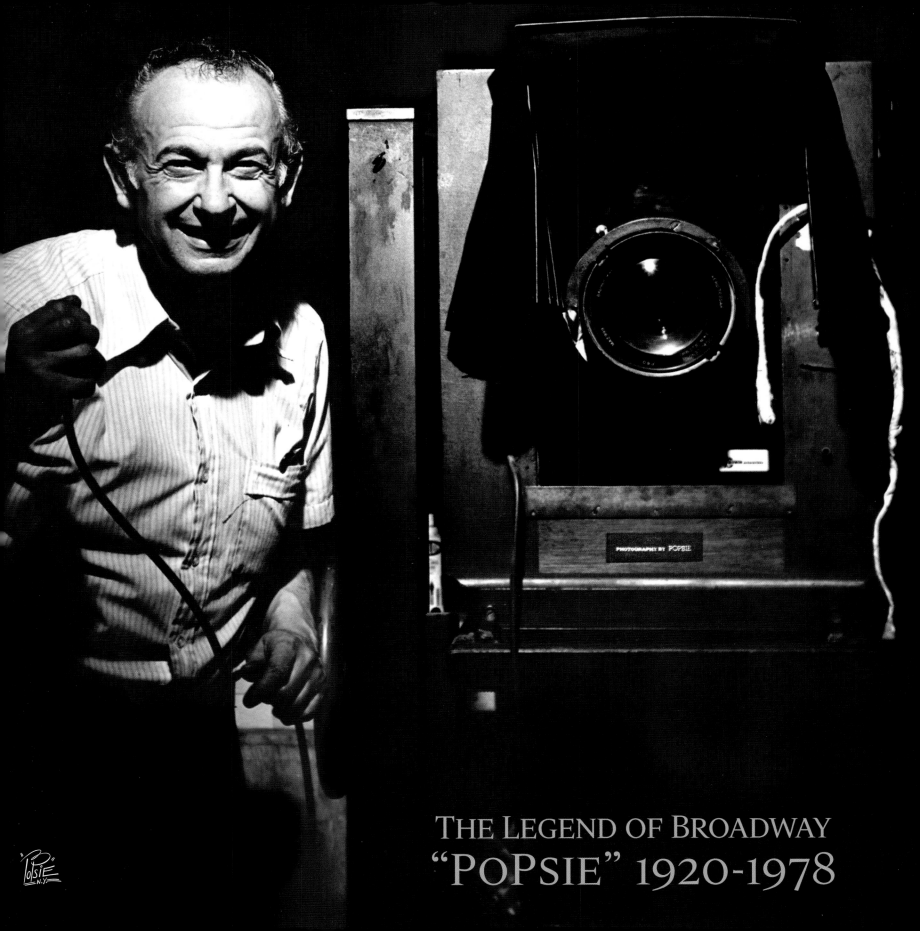

THE LEGEND OF BROADWAY
"POPSIE" 1920-1978

INTRODUCTION

In a long and prolific career spent haunting the recording studios, jam sessions, concert halls, and nightclubs of New York City, PoPsie chronicled the postwar transformation of American music from swing and jazz to rhythm and blues and rock 'n' roll more vividly and more avidly than any photographer of his era. The 100,000 negatives left behind after his death in 1978 span the giddy, glitzy heyday of swing in the Forties, the hot and cool jazz spawned in the clubs of 52nd Street, the rumbling emergence of black R&B and doo-wop and the sudden explosion of rock 'n' roll in the late Fifties, the rise of Brill Building pop and the British Invasion of the Sixties, and the growth of rock into a multibillion-dollar industry by the Seventies.

PoPsie, as he was known even to his children, had the advantage of being a musical insider. Born William Sezenias to Greek immigrant parents in Manhattan in 1920, he dropped out of school in the eighth grade. Scuffling for money during the Depression, he first worked as a towel boy at a midtown bordello frequented by musicians, and after as a shoeshine boy. By then he was attracted to musicians as much by his love of their art and high-stepping lifestyle as by the big tips they always gave him. Caught up in the excitement of the music scene, he became a manager, working first with Ina Ray Hutton and her All-Girl Band, then Woody Herman's herd, and finally his idol, Benny Goodman.

Touring the country on one-night stands with these groups, PoPsie got to know the music business and most of the major musicians. He had long been fascinated by photography; Goodman gave him his first camera, and in 1945, PoPsie settled in New York with his new bride—a chorus girl from George White's *Scandals*—and started shooting. He was fast and reliable. Record companies and magazines kept him busy with publicity photo sessions, parties, concerts, and club dates. The nightlife never ended, and to keep up he sometimes lived in his studio for weeks at a time, often going days with no time to change his clothes and subsisting largely on cheap hamburgers and pure adrenaline. He was a quintessential New York hustler, hard-nosed and endlessly aggressive. He loved real talent, but also the tinsel and hype endemic to the music business. More than anything, he loved the fast lane, and in the end it killed him.

PoPsie's photographs capture the buzz and roar of modern urban music in furious flux, as well as the dawn of the new age we now inhabit. His showbiz obsessions somehow yielded a recognizable style.

And what's a more appropriate tag for that style than "PoPsie"?

Opposite page: **PoPsie** on Broadway, January 28, 1958.

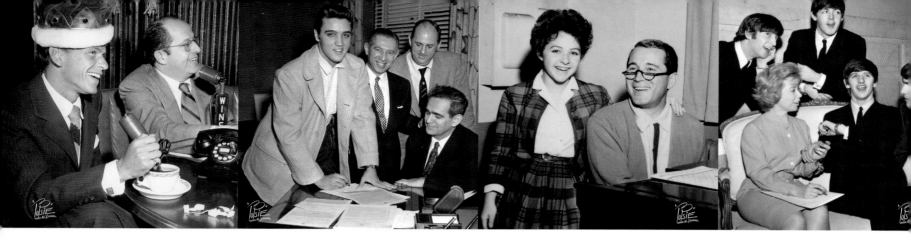

THE COLLECTION

William "PoPsie" Randolph was *the* preeminent paparazzo photographer of the New York scene from 1945 to 1975. He literally lived in his studio and on the streets, shooting on assignment for various record companies, publicity firms, newspapers, and trade magazines. He chronicled the convergence in the Fifties of Tin Pan Alley, uptown rhythm and blues, and rockabilly, and their transmutation in the early Sixties into what we know today as the multibillion-dollar rock 'n' roll industry. The 100,000 negatives left behind after PoPsie's death in 1978 constitute a truly astounding collection.

The range of material is astounding. When Frank Sinatra was named "King of the Singers" at Sardi's one woozy night, PoPsie was there to snap the King with his crown. When Elvis Presley came to New York to cut his first records with RCA Victor, Randolph was in the studio with him. When Bobby Darin signed with Atlantic Records, PoPsie got the shot. When Harry Belafonte entered a New York studio to launch the mid-Fifties calypso craze, PoPsie documented the occasion. He photographed all of the major teen idols through the years, from Eddie Fisher and Frankie Avalon to Jimmy Clanton and Fabian. He caught Kenny Rogers in a frock coat and lace when Rogers was a member of the First Edition. He captured the Righteous Brothers in a recording session, the Miracles onstage, and the controversial folk group, the Weavers, in tuxedos after a Town Hall concert in 1950.

PoPsie photographed Frankie Lymon and the Teenagers boarding a plane for their first and only British tour. He caught the Beatles, the Rolling Stones, the Animals and other legendary British Invasion bands of the early Sixties arriving at Idewild (now JFK) Airport for their first U.S. visits. When disc jockey Alan Freed invented rock 'n' roll at his renowned all-day concerts at the Paramount Theatre and the Brooklyn Fox in the Fifties, PoPsie was there, clicking off priceless performance and backstage shots of such immortals as Bill Haley and His Comets, Chuck Berry, and the Platters. And in dozens of exuberant crowd shots, PoPsie captured the true heart of the original rock 'n' roll explosion.

A trademark of the PoPsie style was his affinity for odd couples: Chuck Berry jamming with Trini Lopez; Brenda Lee at the piano with Perry Como; Johnny Mathis in a mad embrace with Laverne Baker; Gene Pitney trading verses with French superstar Charles Aznavour; Alan Freed swapping one-liners with Salvador Dali; Dr. Joyce Brothers interviewing the Beatles; Count Basie backing up Pat Boone, of all people, on a TV special; beefcake singer Tom Jones hanging out with the Rolling Stones at the New York Playboy Club; Nat Cole meeting composer W.C. Handy; Lesley Gore at a party with Ed Sullivan; Peter and Gordon rehearsing for TV with a young Michael Landon; Ella Fitzgerald nightclubbing with the great Billie Holiday.

PoPsie was always after the one-of-a-kind shot, and he succeeded with a startling consistency. Just for him, the Ronettes did a lighthearted dance; Atlantic Records president Ahmet Ertegun and producer Jerry Wexler went into a pressing plant with singer Joe Turner to pose with pressing of copies of Turner's classic song, "Shake, Rattle and Roll;" the Rolling Stones strutted down Broadway; the Beatles posed with gossip columnist Dorothy Kilgallen; Dick Clark jived and grinned with the wonderful Coasters backstage during *American Bandstand.*

PoPsie caught Bill Haley rehearsing a new number in the recording studio with Haley's glasses on—a first. He captured a haunting portrait of R&B star Jackie Wilson staring at a film of himself in action onstage. And PoPsie, a lifelong jazz fan, created definitive images of legendary performers such as Benny Goodman, Count Basie, Dexter Gordon, Peggy Lee, and in one particularly winning shot, bandleader Dizzy Gillespie and a very young John Coltrane. His shots of Miles Davis in the early Fifties bring back the brooding cool of the bebop era with an accuracy unmatched by any other contemporary lensman.

Much of Randolph's work was in portraits, usually for record company publicity departments eager to present memorable images of their artists. In this traditionally restrictive format, PoPsie created an aura of innocent enthusiasm about his subjects that today is recognizable as a full-fledged style, much in the way George Hurrell forged a style out of movie star portraits. Had it not been for PoPsie, many of these pioneering artists would be nothing but blanks in our cultural consciousness. Who else, after all, photographed the greatest of the one-hit wonder doo-wop groups, the Penguins? Who else got shots of the Tokens, Bryan Hyland, the Earls, Little Esther Phillips, Billy Ward and the Dominoes, Question Mark and the Mysterians, the Crew Cuts, Darlene Love, Barry Mann, the suavely melodic Duprees, the superb Maxine Brown, the Crystals and the inimitable Lloyd Price?

Among the other artists PoPsie shot were Aretha Franklin, Ben E. King and the Drifters, Carole King, Dave "Baby" Cortez, Brook Benton, Bobby Bland, drummer Gene Krupa, electric guitar pioneer Les Paul and his wife, Mary Ford, Motown superstar Marvin Gaye, percussionist Mongo Santamaria, Lou Christie, producers Phil Spector, Quincy Jones, Lou Adler and Don Kirshner, disc jockey Murray "The K" Kaufman and Sam "The Sham" Samudio.

These unique shots offer a fascinating glimpse of an era that PoPsie so lovingly detailed.

Opposite page: **Frank Sinatra** and **Phil Silvers**, February 1955; **Elvis** signing with the William Morris Agency, January 1956; **Brenda Lee** sings alongside legendary crooner **Perry Como** during rehearsals for his yearly Christmas program, December 1960; **Dr. Joyce Brothers** and the **Beatles** at the Plaza Hotel press conference, February 1964.

Below: A young **Miles Davis** trying to convey his ideas into "The Birth of the Cool," January 1949; **Carole King** asked PoPsie to photograph her during her stint as a songwriter at the Brill Building, December 11, 1961; **Brian Hyland** takes five during a recording session to review the lyrics of a new song, June 1961; **Gene Krupa**, an old pal of PoPsie's from their time together in the Goodman Orchestra, asked him to get some shots for a 1949 RCA recording session.

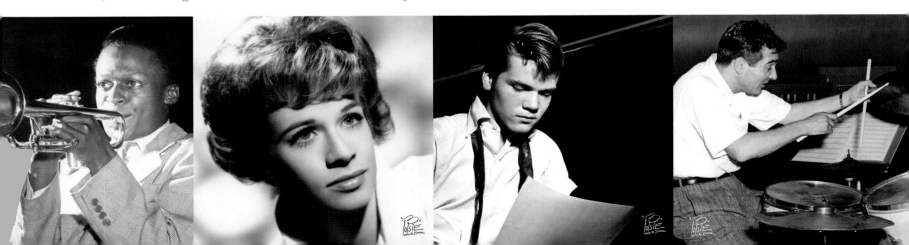

BANDBOY TO PHOTOGRAPHER

PoPsie became Benny Goodman's band manager. They were very close. While on or off location, PoPsie and BG behaved like brothers—and even argued like brothers. A movie was made about the two of them called *Sweet and Lowdown*. Benny Goodman starred as himself; Jack Oakie was PoPsie.

In 1944, PoPsie married a showgirl and decided it was time to leave the road and settle down. During his music tour days, he had become interested in photography. Goodman asked PoPsie what he'd like as a gift of appreciation, and PoPsie chose a camera.

Photography had been PoPsie's hobby for a long time. As a boy, he'd get discarded negative clips from Fox Studios, make sun photos from them, "fix" them with urine because he couldn't afford to buy chemicals, and wash them in the public fountain. He told Goodman he'd like to try photography for real.

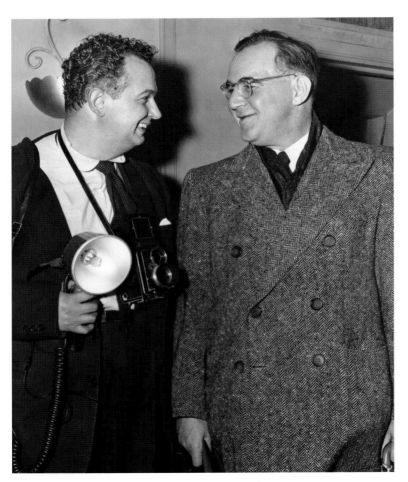

In addition to the camera, Goodman gave PoPsie, who was getting started in business, fifty dollars a week for the next two years. PoPsie already had a built-in clientele. Aligned with Goodman for many years, he helped discover a good list of musical and vocal talent. These artists and personalities, many of whom had put their feet on his shoeshine box, now posed for his camera.

Photos by PoPsie appeared for years in *Billboard*, *Record World*, *Music Business*, *Rolling Stone* and *Cashbox* magazines. A night shot of New York's Paramount Theatre and photos of Big Band personalities appeared in Time-Life's "This Fabulous Century" series.

Rock stars, New York personalities, jazz greats, Bing Crosby, Frank Sinatra, Peggy Lee, Billie Holiday, Count Basie, Rudy Vallee, and Helen O'Connell all smiled for PoPsie.

PoPsie became one of the top theatrical lensmen in New York.

Glad to Know It

New York – The secret is out! Now it can be told! The name of "PoPsie," popular band boy with Woody Herman, really means "Shut up!"

PoPsie, a lad of Greek extraction, was working at the Arrowhead Inn several years ago and making more noise than suited the Greek waiters, so they began hollering "Popsie vreh!" at him. Roughly translated, that means "Shut up!" or "Pipe down!" or "Cease the noise!" So bandsmen began calling him "PoPsie" and the name stuck. His real tag is William.

Sezenias to Randolph

Chicago, 1945 – PoPsie was working a show at the Chicago Theatre with Benny Goodman's band as Benny's manager.

During the show, PoPsie walked outside of the theatre, headed for a nearby telephone booth to book the hotel rooms (in his name) for the BG band performing at the next venue. He was tired of pronouncing and spelling his Greek last name (Sezenias) to the surly and half-witted hotel phone operators; he looked up from the telephone booth and glanced at a street sign... it was Randolph Street!

Chicago Times

PoPsie, Benny's Bandboy Belongs to Unsung Craft

By FRANK STACY

Everybody's always talking about the trumpet player's style or the killer sax man or the new chick with the band, but you never heard a word about one of the guys out back... and he's an important guy, too, because the band literally wouldn't get anywhere without him.

"PoPsie" Randolph, band boy with Benny Goodman, thinks that it is about time a little credit was given to the fellow whose most important job is taking care of the band's baggage, but who also makes the phone calls, watches the instruments, stalls off the unwanted visitors, goes out to the corner for Cokes and shaving cream, etc., etc. The list is so long that when PoPsie finished reciting it, he began to wonder how he'd been getting by without three assistants.

PoPsie, who's just about the top bandboy in the business, is a native New Yorker, 22 years old and 3-A in the draft because he supports his family.

Started with Trumpet

Back in the Thirties, he got the "swing" bug like everybody else, and when he saw Louis Armstrong in *Pennies from Heaven*, that was the clincher. From that minute on, he knew that he had to get with a band somehow. His mother bought him a trumpet and he worked on it like mad but without ever getting that something which makes the difference between professional playing and playing for fun.

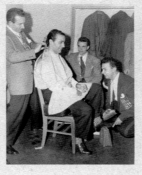

So instead of filling a trumpet seat, he had to take a job in a drug store to keep going. But..."PoPsie" made sure that it was a drug store planked right in the middle of the music district, where he could keep his eye on what was going on.

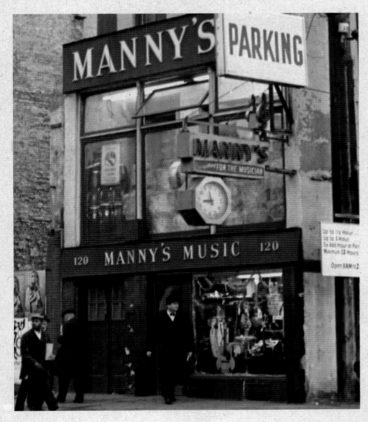

Worked at Manny's

He started hanging around the music shops on his time off and finally got himself hired as a spare hand at Manny's music shop on 48th Street, where all the musicians in the world land at one time or another. People in the business got to know him, and one night, in an emergency, he was hired to go with Teddy Powell's band. Supposed to join the band the next morning, he was so excited that he couldn't sleep at all that night and was down to greet his new boss two hours ahead of time!

Powell took a liking to him and PoPsie stayed with the band for seven months. While they where doing the Shribman circuit, he left Teddy and joined Ina Ray Hutton at the Totem Pole in Auburndale, Mass. His job with Ina gave him his first look at the country because they barnstormed all over the Southwest. He made a hit with the blond leader, too; once when he had an argument with somebody in the band, and stayed behind to tell her that he was quitting, she persuaded him to stay on and flew him to their next location with her.

Helps Entire Profession

Back in Brooklyn with Ina, PoPsie was thinking over an offer to go with Vaughn Monroe's boys, when he went up to the Astor Roof to dig BG. Through what turned out to be a lucky mistake, the headwaiter mistook PoPsie for someone else and gave him a table right in front of the band. Freddy Goodman spotted him, came over for a talk, and offered him the job he's got now.

PoPsie is the by-word in the business. He's got a habit of righting messages on the walls of the theaters and bandstands wherever he goes, and through these he's known to managers and musicians all over the country. Sometimes it's just "Hello, Joe, how are you" or "Dig the mouse in row two on the left," but often he jots down pertinent facts about the spot which will be helpful to the next band coming in. He also acts as a free clearing house for musicians, keeping everybody posted on who has left what band and who's free to take his place. Known to everyone, and with a terrific memory for names, he has probably found as many jobs for unemployed musicians as any booking agency.

Likes Sitting In

PoPsie, even though he's no Harry James, has sat in with a lot of name bands including Woody Herman, Alvino Rey and Benny Goodman and still can't make up his mind whether he wants to be a trumpet player or a band-manager. Sitting in is probably his biggest kick in life, except for keeping his mother posted on what he's doing. And this is strictly on the level, because, even though he doesn't see home often, he's an honest-to-goodness home boy at heart.

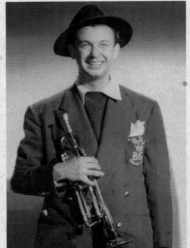

"Boy," he says, "wait'll my mother sees me in Benny's new movie, I'll bet she even starts cryin', huh?"

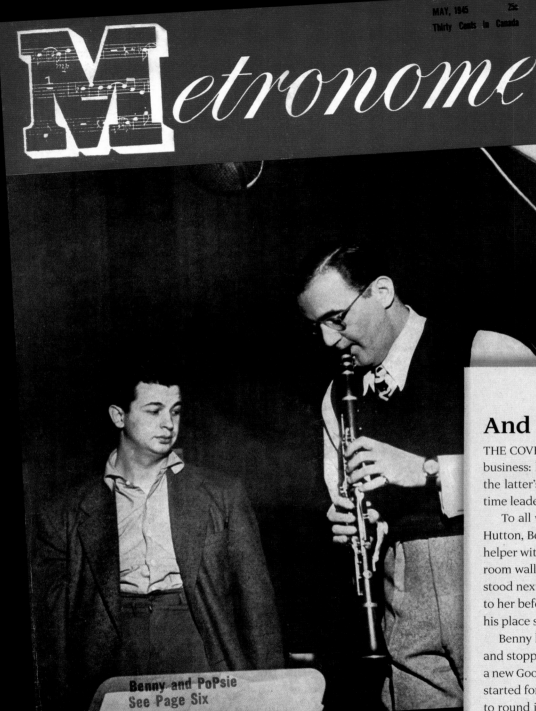

MAY, 1945 25c
Thirty Cents In Canada

Metronome

Benny and PoPsie
See Page Six

And Kings Return

THE COVER this month is devoted to two well-know characters in this business: left, PoPsie Randolph; right, Benny Goodman. The former is the latter's manager; the latter is the former's boss, friend, and some-time leader of jazz bands.

To all who know PoPsie, the curly-headed ex-band boy for Ina Ray Hutton, Benny and Woody Herman is a character's character, a genial helper with a remarkable penchant for scrawling his name on dressing-room walls and windows. When he was married, some months ago, he stood next to his wife's bridesmaid and was within words of being wed to her before someone discovered the mistake. PoPsie laughed and got his place straightened out.

Benny has had so many different personnels under him, has started and stopped so many times, that people inevitably scoff at the start of a new Goodman band. But Benny has usually stopped for a purpose and started for another, both good. This latest edition of his band is bound to round into something greatly distinguished. His sextet is already, in the unanimous opinion of the writers and editors of METRONOME, any-how, one of the greatest small units yet. This month, he really gets underway with his organization at the 400 Club. There's much to look forward to in Benny's direction.

We think the two characters deserve a cover and a salute. Five page forward, the first; herewith, the second.

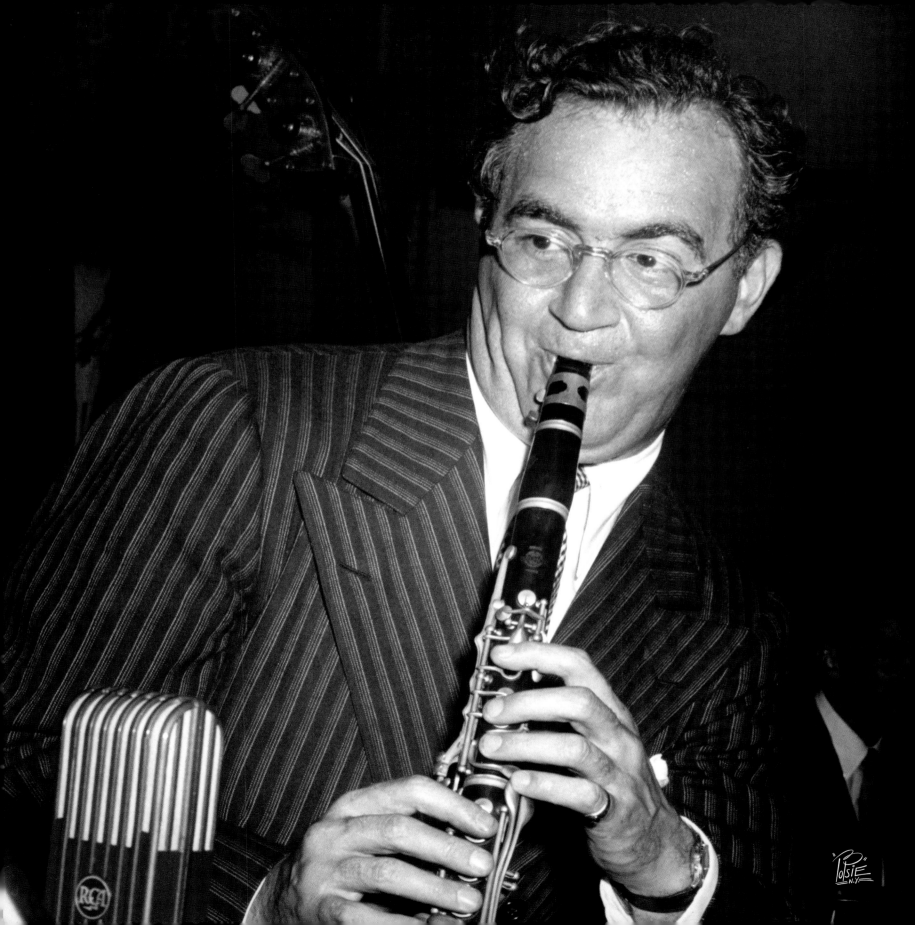

CHESTERFIELD PRESENTS GLENN MILLER'S MOONLIGHT SERENADE

THE FORTIES

Armed with ingenuity and a camera purchased by Benny Goodman as a wedding present, in 1945 former band boy William "PoPsie" Randolph was ready to turn a lifelong passion into a way of life. Immediately, PoPsie's photography was preferred by record labels and publishers hungry for images for a burgeoning post-war music community ready to celebrate the good times.

Lady Day

Billie "Lady Day" Holiday was just
entering her prime in this photo, taken
at the Strand Theatre in 1940.

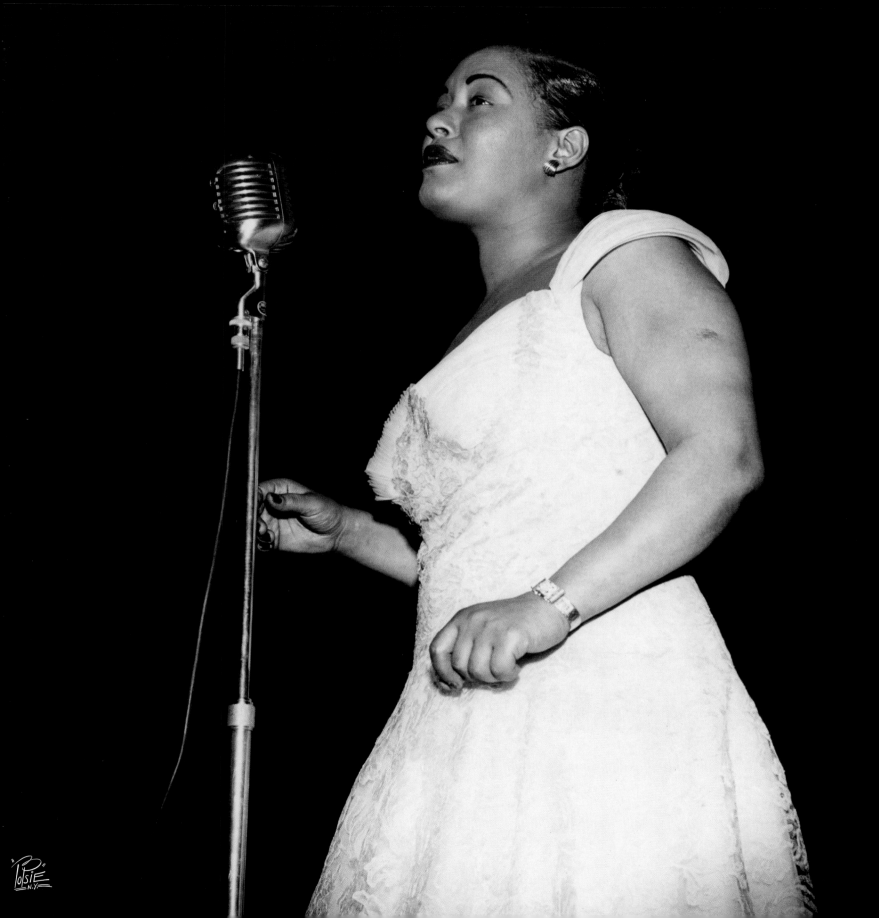

Glenn Miller was photographed in New York during his 1942 USO tour. In October of that year, he reported for induction into the U.S. Army and helped many GIs get through a long and difficult war, appearing in hundreds of shows all over Europe.

Miller's dedication to his country and fellow military men eventually cut short his own life; his plane was shot down over Paris on December 15, 1944.

This 1943 photo was one of the first of a recurring theme from PoPsie… Take two people from different backgrounds and put them together for a unique photo opportunity. **Bob Hope** was in New York to promote one of his movies. He decided to moonlight as a sideman in **Les Brown's Band of Renown**. Lucky for Bob, Les didn't need him as a trumpeter.

In September 1943, **Louis Prima** was in town to lay
down some tracks for the armed forces. These were later
released as "V-Discs" to military bases around the world.
PoPsie caught up with Prima at the Commodore Hotel and
snapped this shot during one of his vocal numbers.

At the time of this 1946 photo, **Les Paul** and **Mary Ford** had just become an attraction in New York and had started to record many of the jazz standards that made them household names. Paul later lent his name to one of the most popular guitars in music history.

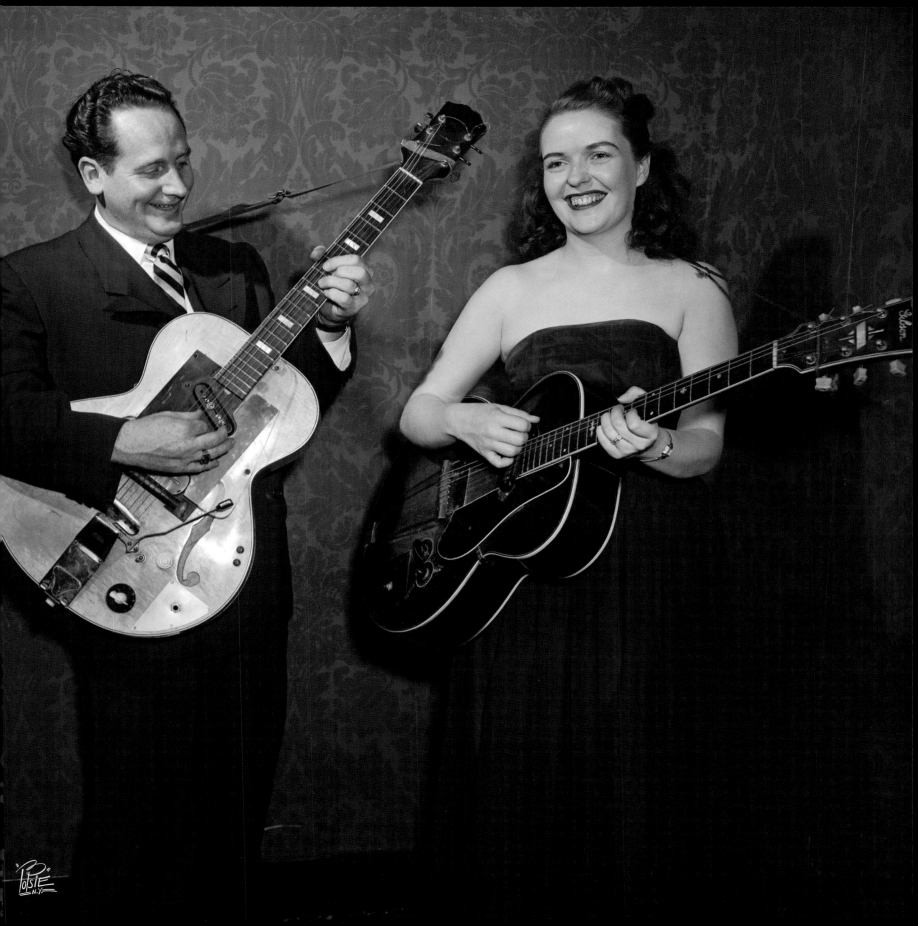

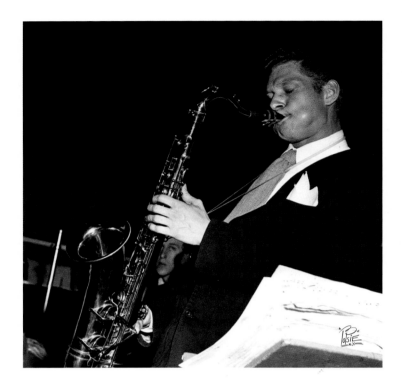

Above left: PoPsie provided portraits over the years for the musicians who needed to promote themselves to nightclubs, bandleaders, and—if they were lucky—the many record labels that sprang up in New York in the Forties. This is one of PoPsie's earliest portraits for **Stan Getz**, who recorded his first sessions as a bandleader in 1946, fresh off his success as one of the Four Brothers in Woody Herman's Thundering Herd.

Above right: **Zoot Sims** is hard at work during a session with the Woody Herman Orchestra in 1948. PoPsie had access to most of the musicians and clubs around NYC, and they didn't mind him getting shots like this.

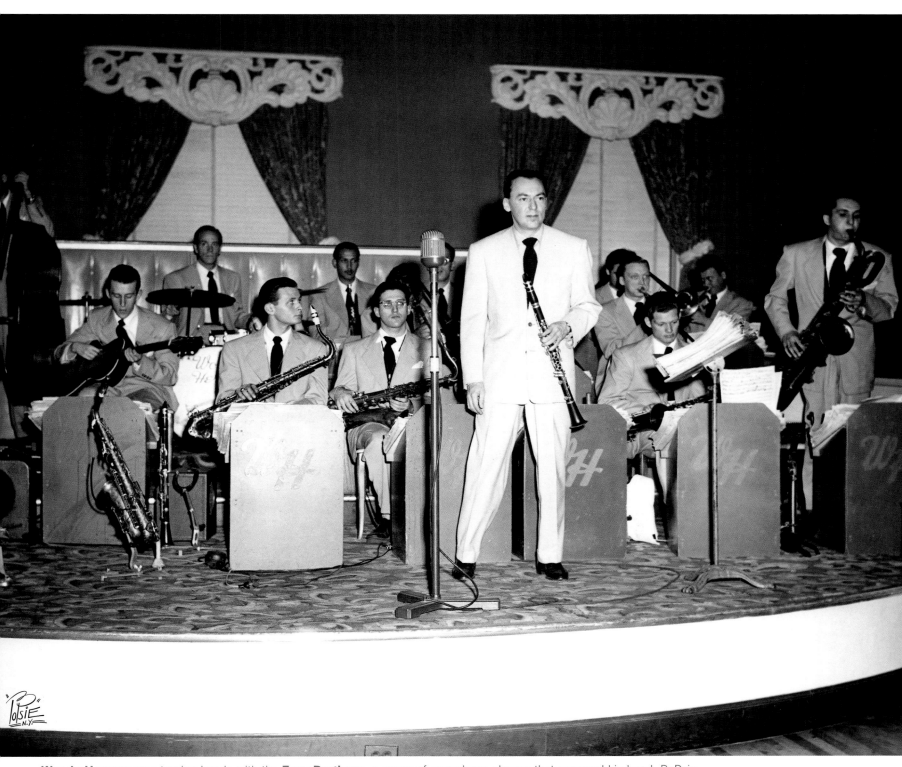

Woody Herman was turning heads with the **Four Brothers**, a group of saxophone players that powered his band. PoPsie captured them during a stint at the Terrace Room in 1948. Many of the players from that section—**Stan Getz, Zoot Sims,** and **Al Cohn**—went on to greater success in the jazz field.

Johnny Otis sat still long enough for PoPsie to click off this shot at the Adam Theatre (Newark, NJ) in 1947. Otis was responsible for launching many careers in the R&B circuit in the late Forties and early Fifties, and even had enough time left over to release one of the biggest hits in the rock era, "Willie and the Hand Jive," for Capitol Records.

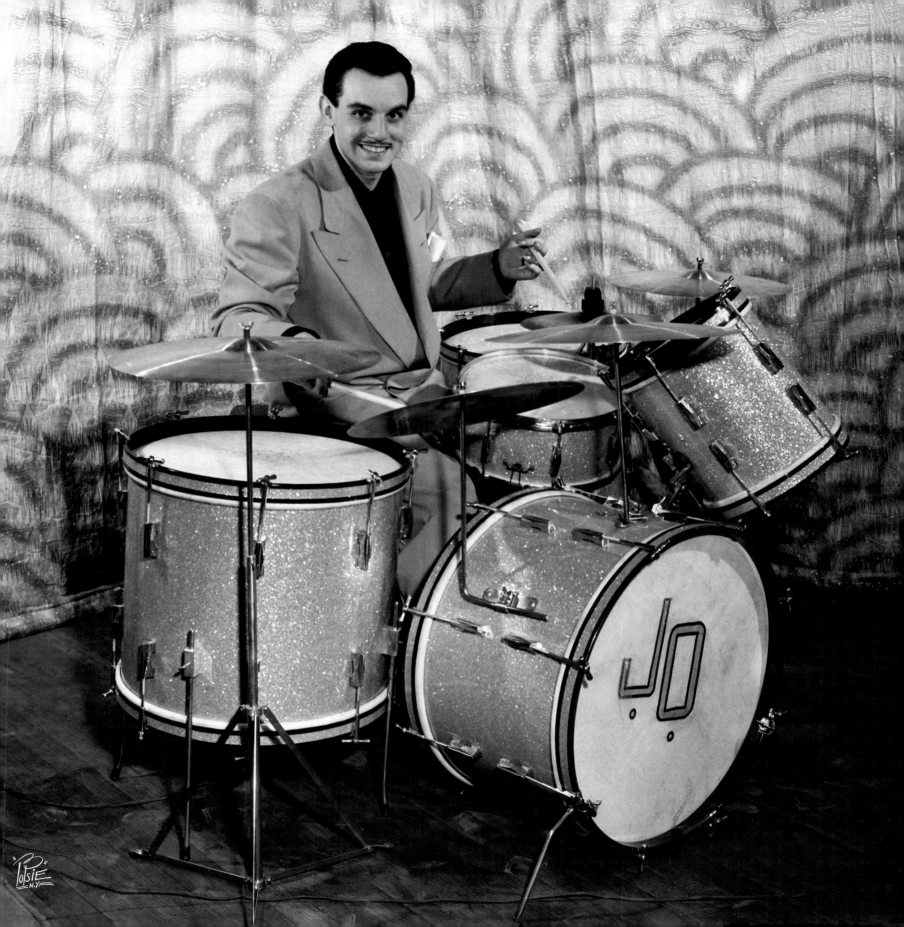

The White Plains County Center was a hot spot for jazz in
the late Forties, and PoPsie took a lot of his first images at
that venue. Here he captures **Mary Lou Williams** at the
piano in 1948. PoPsie made this image part of his portfolio.

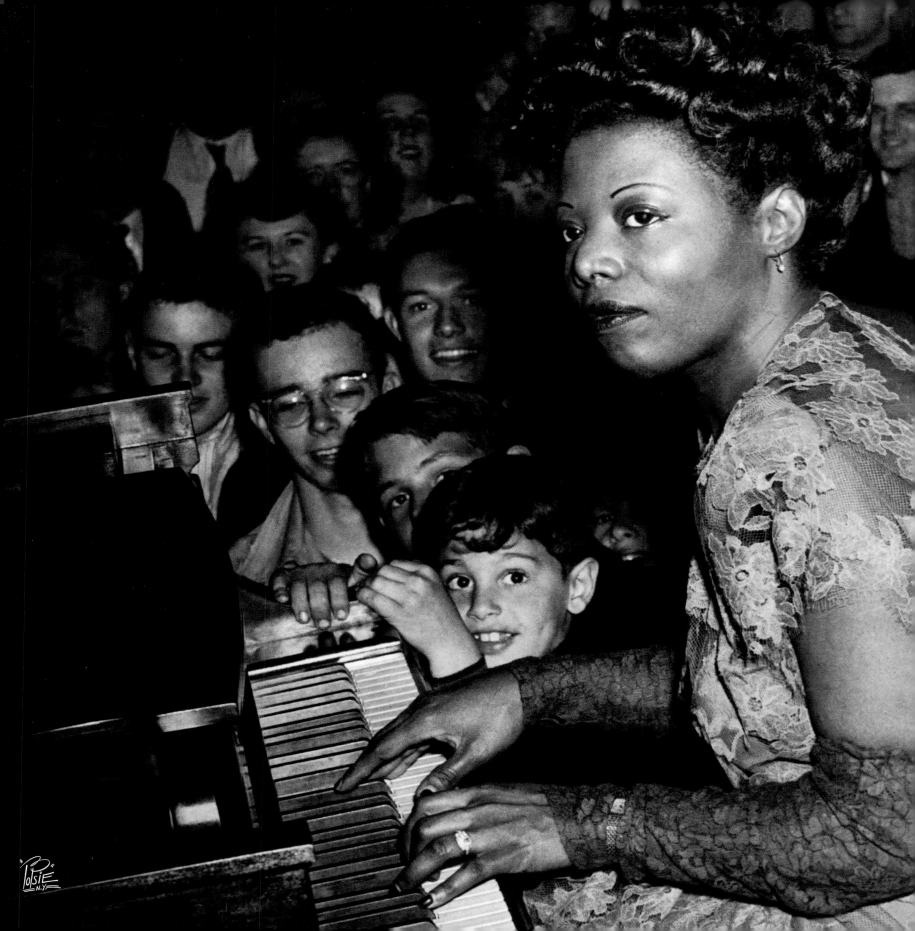

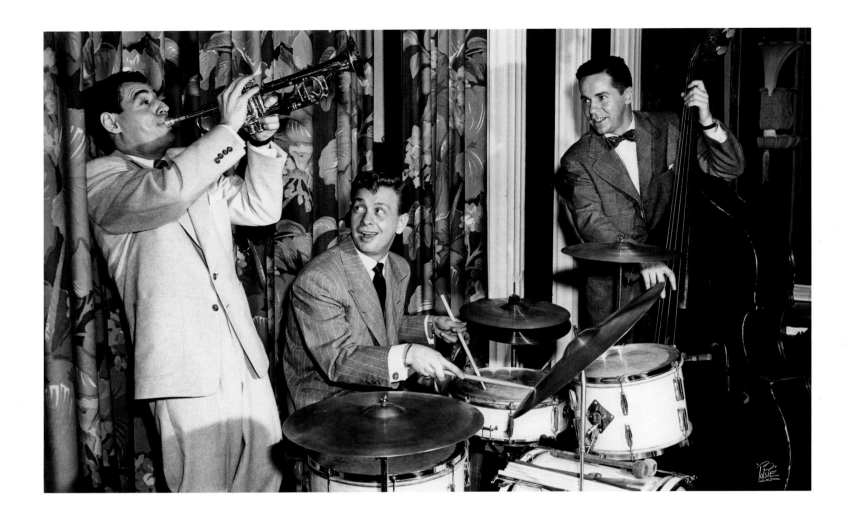

Here is another example of PoPsie's placement... **Mel Torme** (drums) and
Ray Anthony (trumpet) cut it up at New York's Statler Hotel, 1948. Torme
was an accomplished drummer who owned a set of drums given to him by
Gene Krupa.

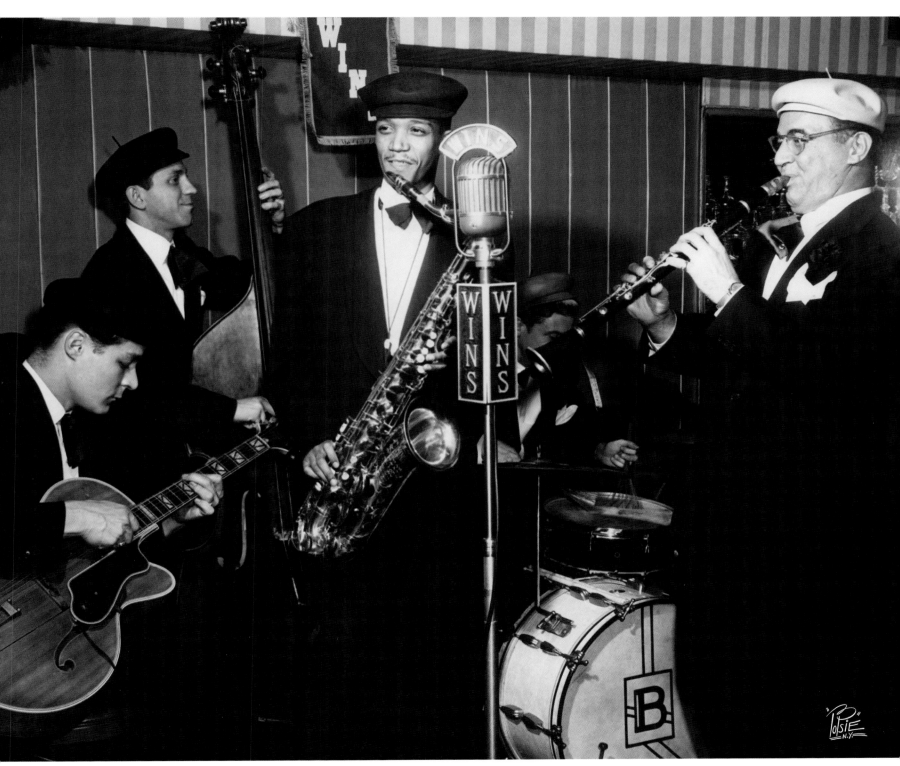

Benny and his band played one last show at the Stork Club on January 8, 1949 before calling it quits for WINS radio. They decided to don berets to emulate the look of Dizzy Gillespie, who was a major player in the world of bebop at the time. Left to right: **Frank Beacher, Clyde Lombardi, Wardell Gray, Benny Goodman.**

As PoPsie's fame grew, so did the opportunities from manufacturers and promoters of music to utilize his services as a photographer. His first studio was located inside Manny's music store, and many a performer received free goods from the manufacturers for promoting their products.

Sonny Payne came to PoPsie to help him promote Gretch drums. PoPsie was happy to help out. This photo was taken at the Savannah Club in New York on October 9, 1948.

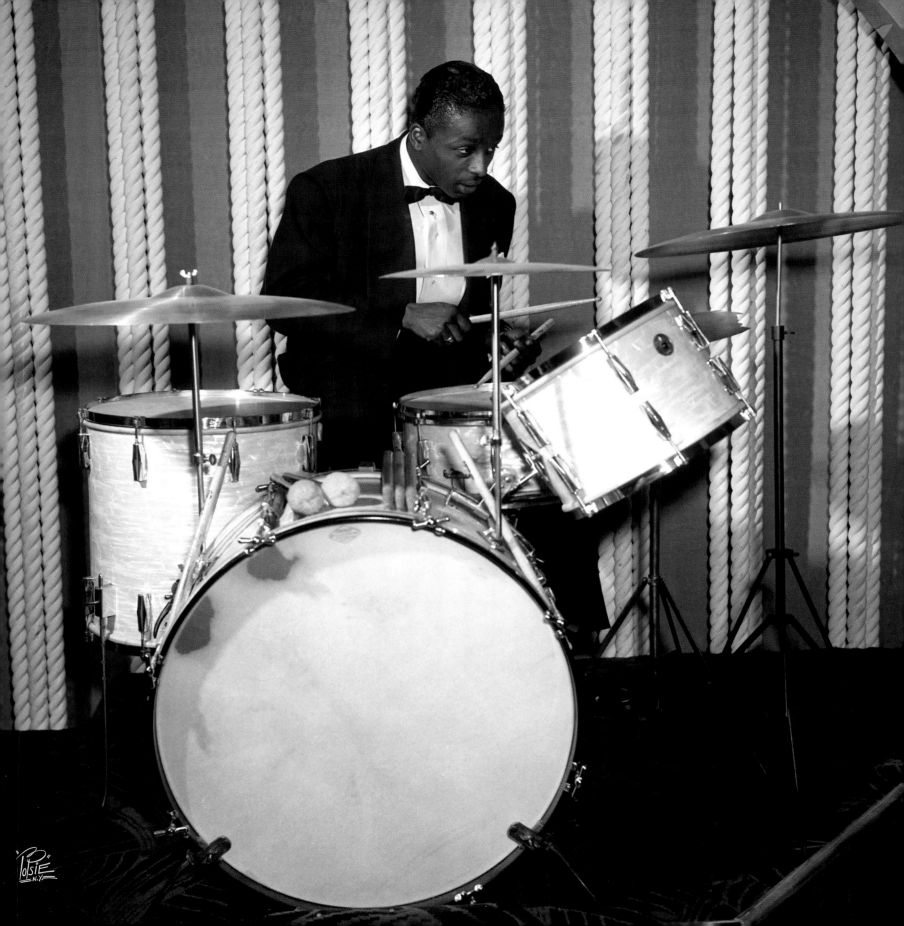

Louie Bellson was a pioneer in the use of the double bass drum in jazz. PoPsie was asked to take a shot of Louie behind his kit to demonstrate his prowess, 1948.

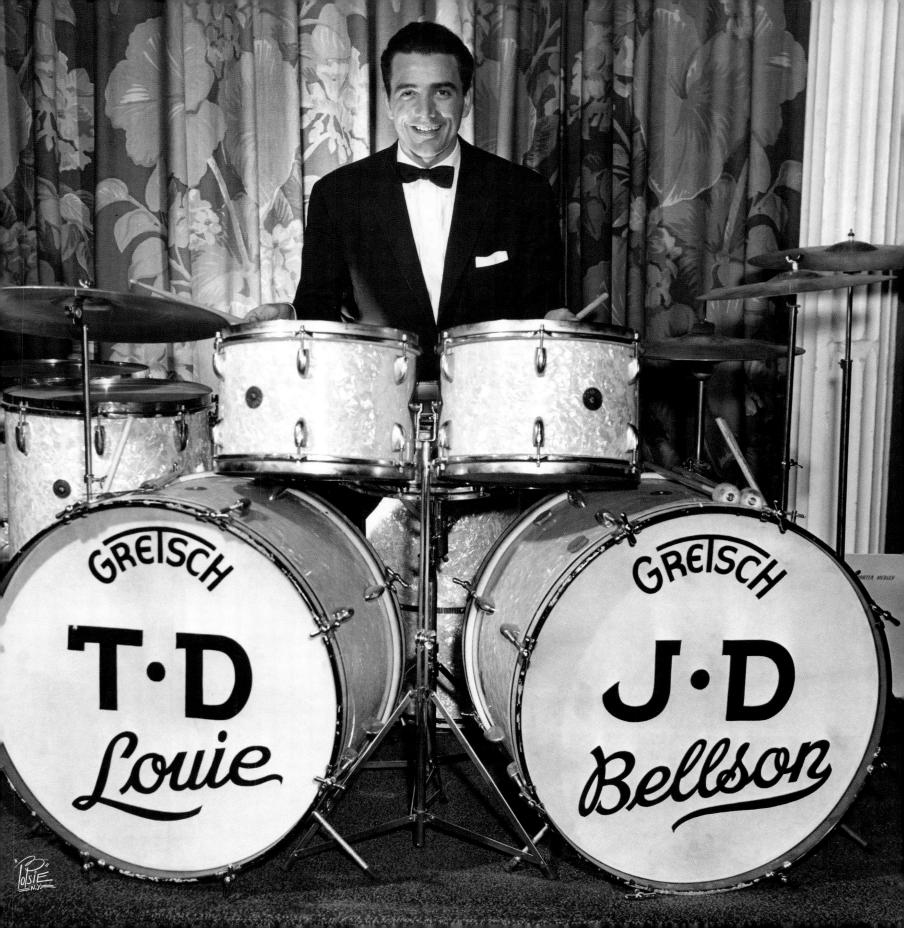

Cavalcade of Bands

New York disc jockey Fred Robbins (WOV, 1280 AM) was the host of a show called *Cavalcade of Bands* that featured performers who did live renditions of their current hits. On June 24, 1949, Kay Starr and friends showed up and did a few numbers for his program. Left to right: **Specs Powell, Chubby Jackson, Kay Starr, Coleman Hawkins.**

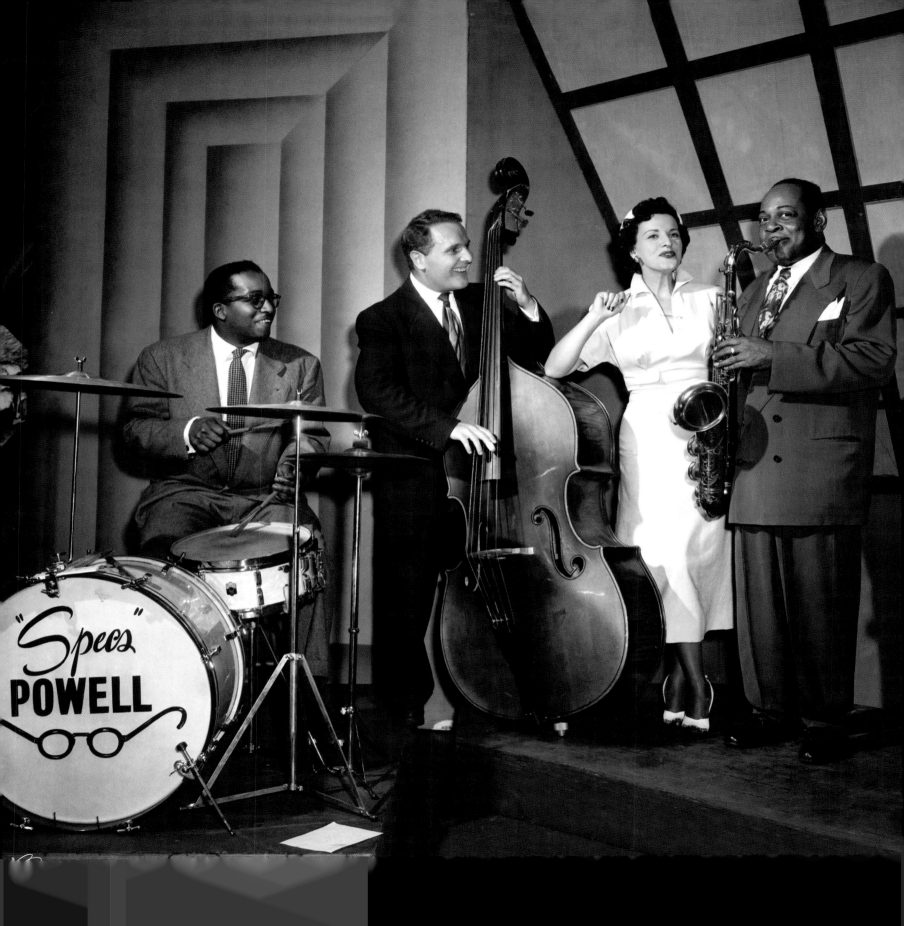

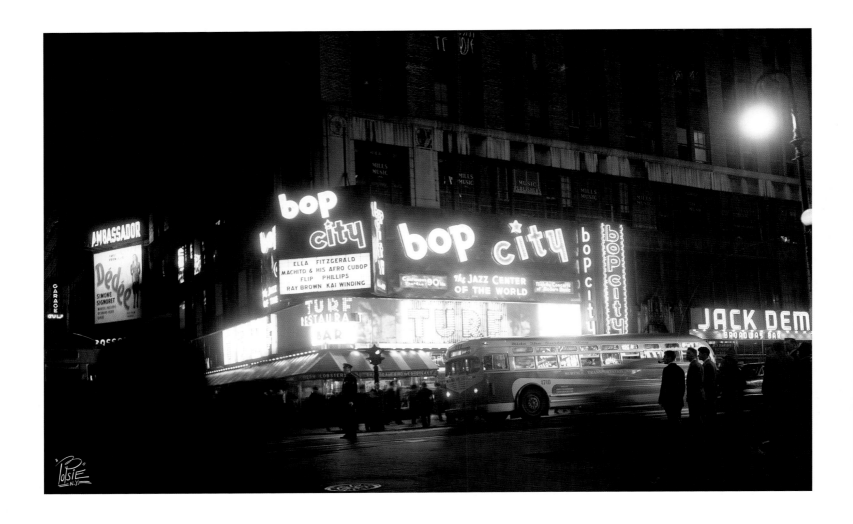

Onstage at New York's Bop City, May 1949:
Gerry Mulligan playing baritone sax (far right) with
Kai Winding on trombone, **Brew Moore** on tenor sax,
and **George Wallington** on piano.

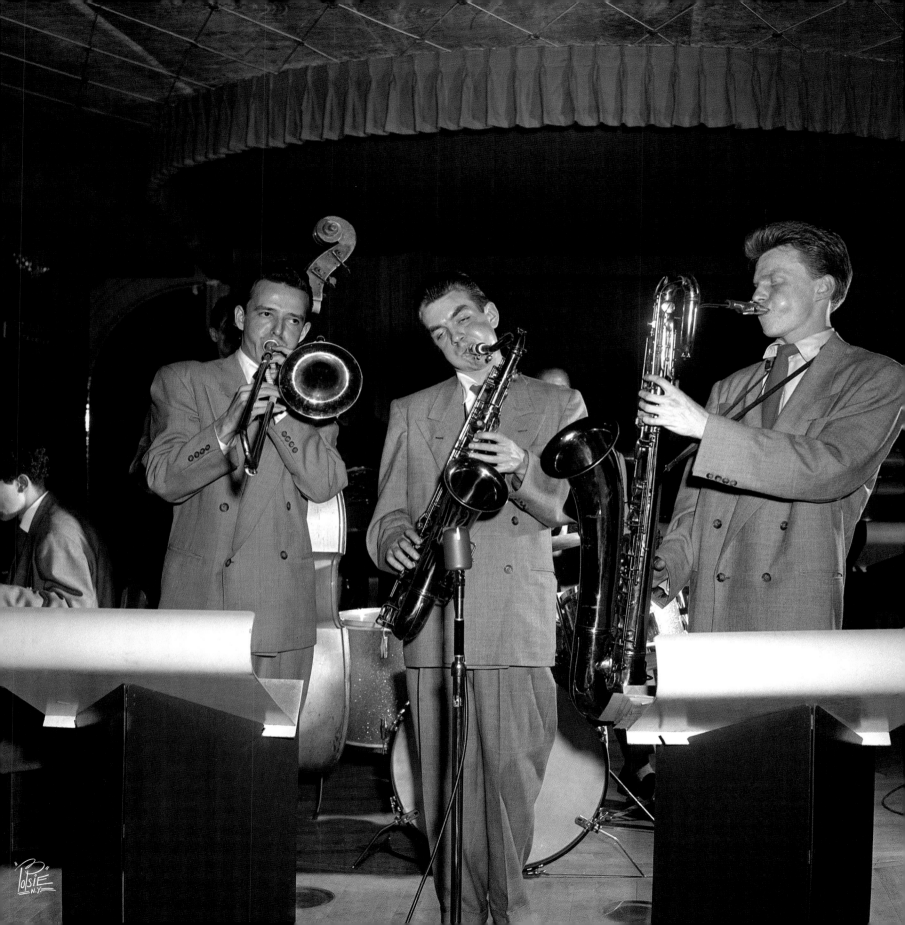

PoPsie captured what most jazz cats did on an almost daily basis...
travel to the next paying gig. For almost 30 years, PoPsie made
frequent trips to Idlewild (now JFK) Airport to chronicle the comings
and goings of any major player who came to New York. He snapped
this photo of **Oran "Hot Lips" Page** on May 17, 1949.

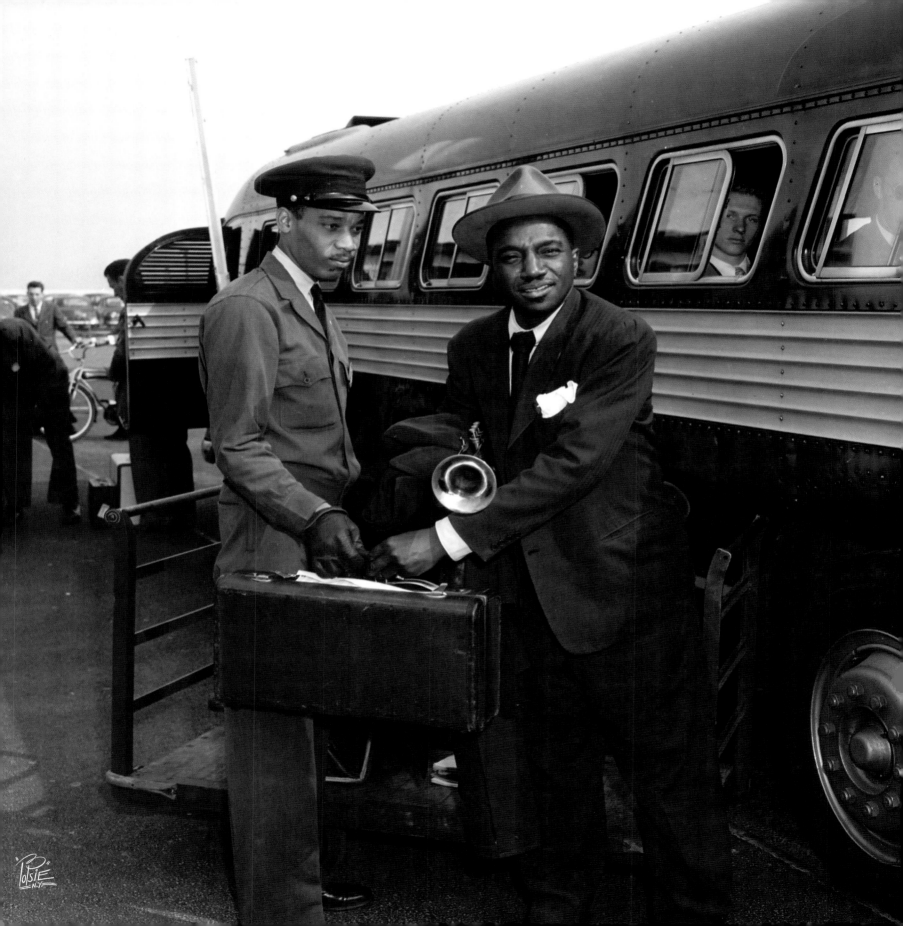

Max Roach was the drummer of Charlie Parker's historic quintet when they appeared at the Three Deuces nightclub. PoPsie decided to get a few shots of Max before he took the stage on October 11, 1949. Max was happy to oblige.

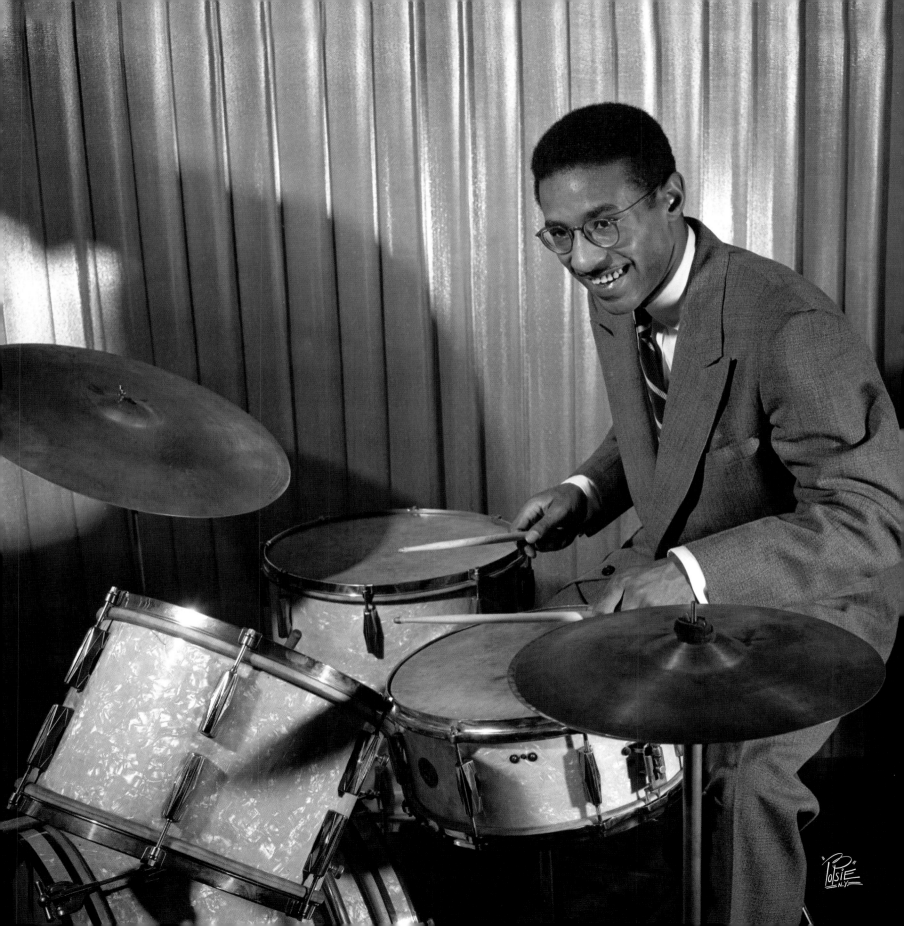

This image was captured after **Coleman Hawkins's** return from a 1949 European tour. Hawkins traveled frequently between continents, making images of his performances hard to come by.

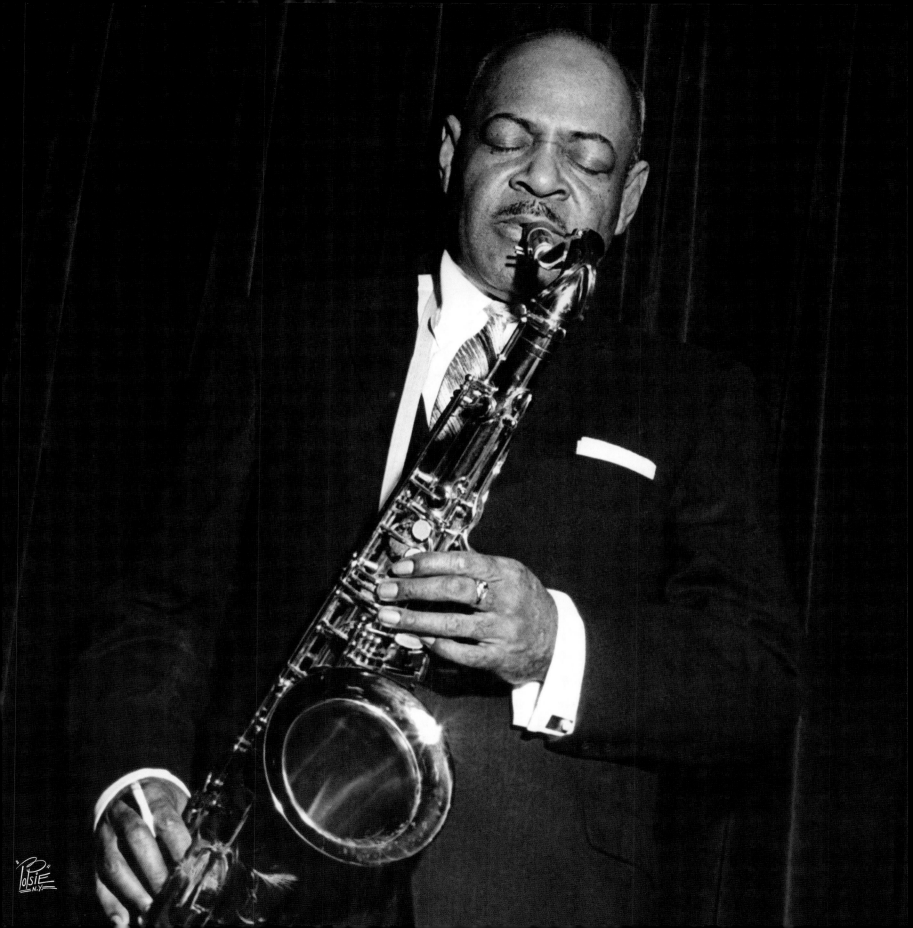

singin' the gospel

This 1949 image of **Mahalia Jackson** was used by
Columbia Records for her collection of recordings
released in 1991. It captures her intensity and shows
why she was known as the world's greatest gospel
singer. It also demonstrates that PoPsie had few
equals as a photographer.

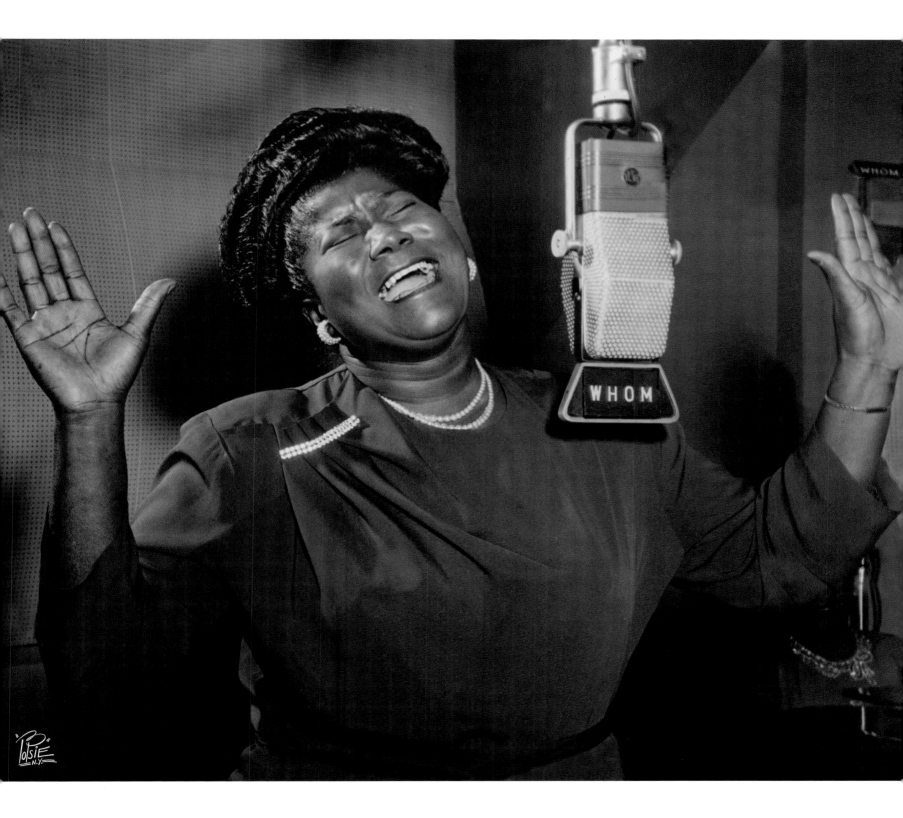

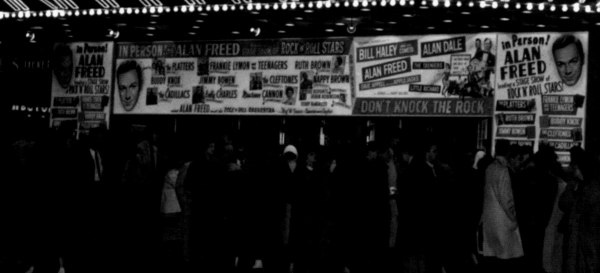

THE FIFTIES

The big band era was rapidly in decline, so PoPsie had to adapt his characteristic form to a whole new style of music—rock 'n' roll. Television was also presenting its own unique challenges to the music industry. PoPsie not only rose to the occasion, but helped the icons of both worlds reach new heights.

Sassy

We start the Fifties with one of our favorite performers. **"Sassy" Sarah Vaughan** had just left Musiccraft and signed a deal with Columbia Records. She wanted PoPsie to commemorate the occasion of her first recording sessions, 1950.

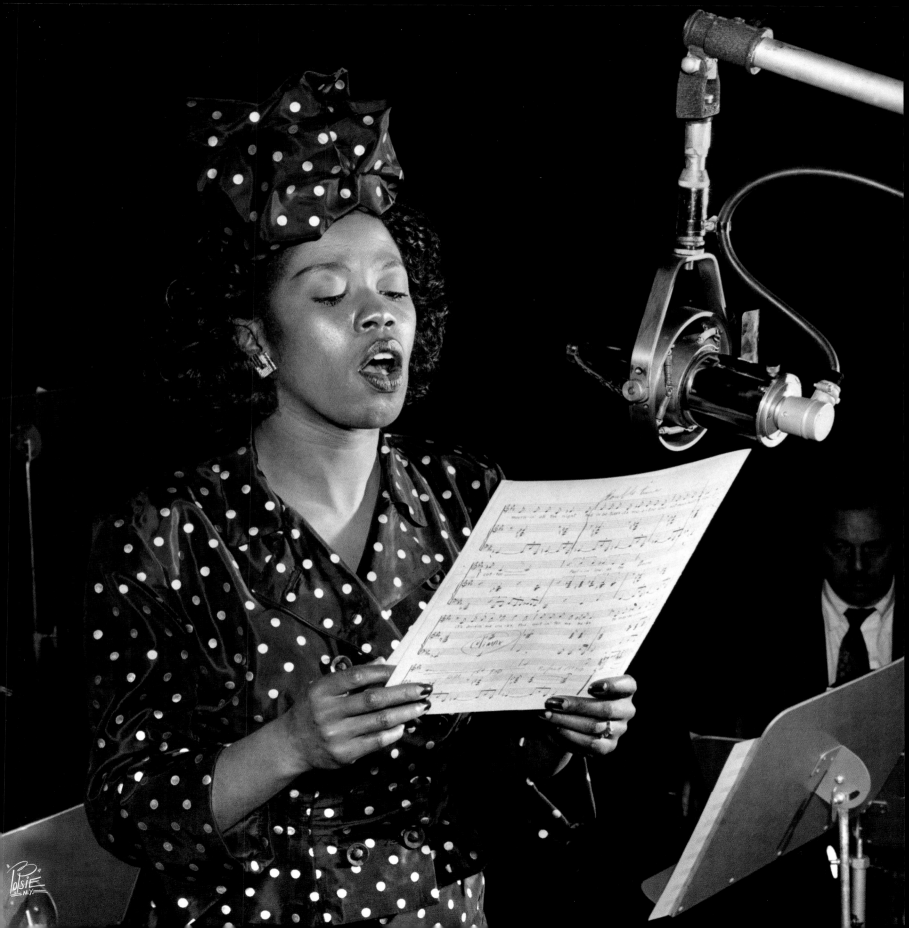

Here's another one of PoPsie's pairings… **Frankie Laine** and **Patti Page**, taken May 17, 1950. PoPsie was asked by Mercury Records to get a few photos of Frankie before he departed to greener pastures at Columbia Records. Frankie and Patti were in the studio working on one of their duets. They took a break just so PoPsie could get this shot.

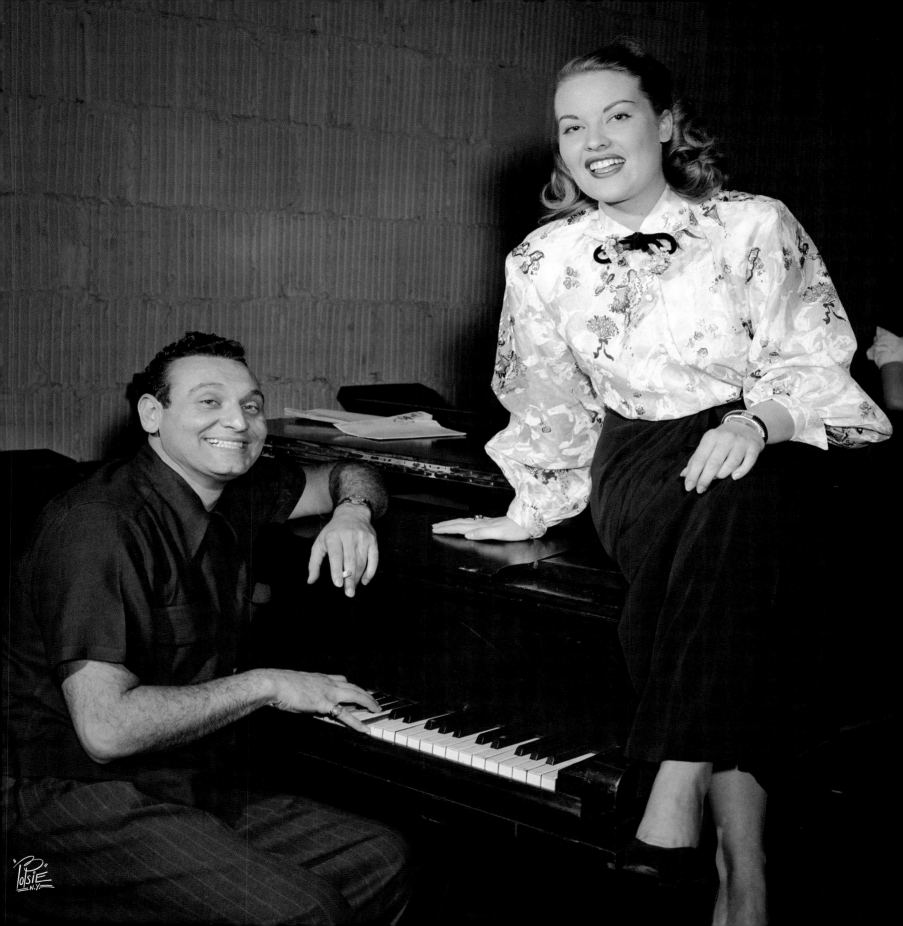

grand ladies of song

Two of the grand ladies of song posed for PoPsie at
Bop City on July 20, 1950. **Ella Fitzgerald** (right)
had an engagement there and **Billie Holiday**
showed up to see how Ella was doing. Billie was not
allowed to perform in New York after 1947: her
cabaret card was revoked after a brush with the law.

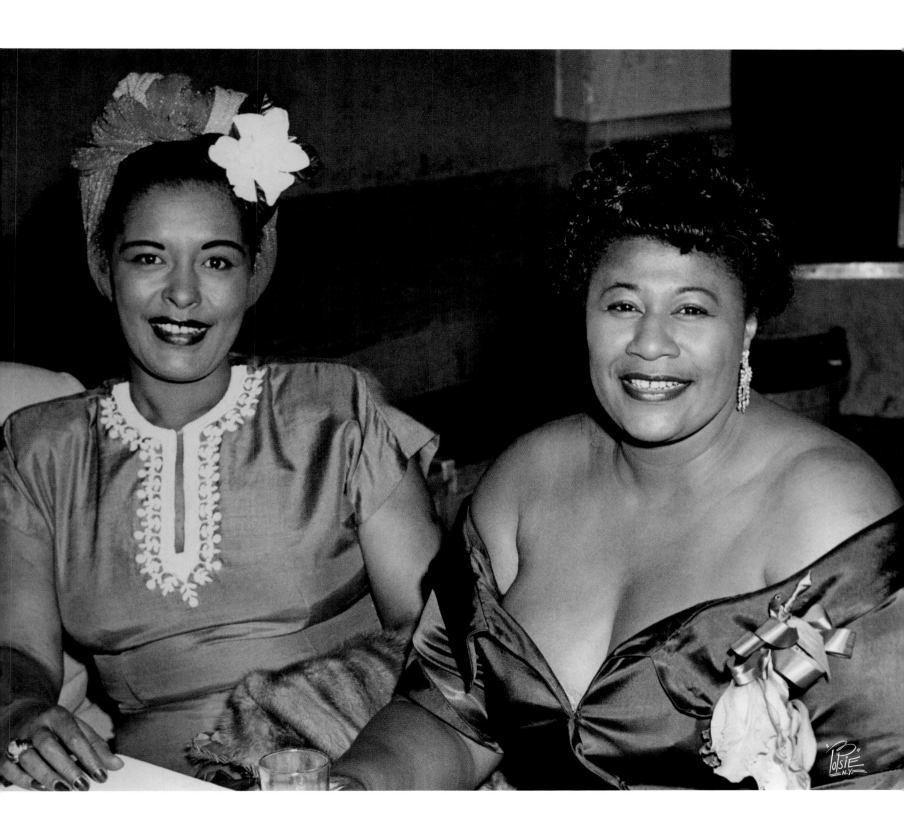

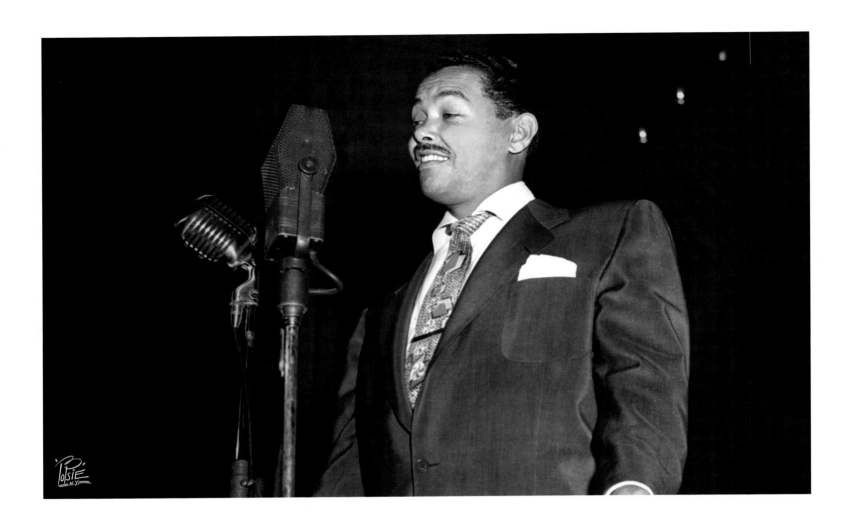

Here's the great "Mr. B," **Billy Eckstine**, singing one of his memorable tunes
at Carnegie Hall, December 1, 1951. Eckstine discovered Sarah Vaughan
and referred her to bandleader Earl "Fatha" Hines. Eckstine and Vaughan had
worked together in his band until its breakup in 1947.

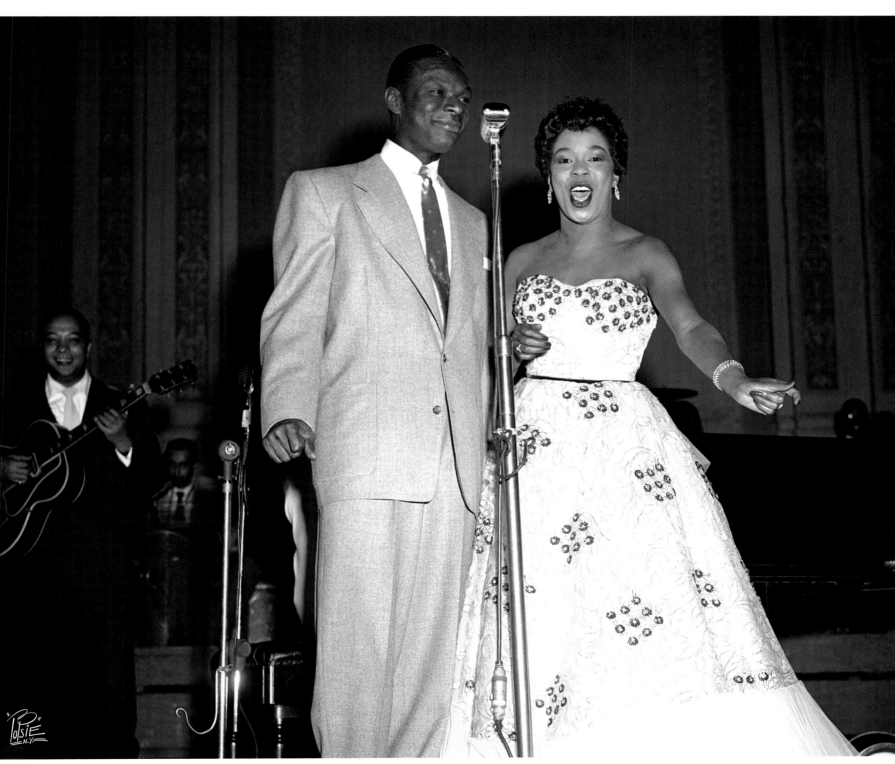

Carnegie Hall was a hotbed of musical activity during the Fifties, and PoPsie was often called there to chronicle what was going on. Two vocal giants, **Sarah Vaughan** and **Nat "King" Cole**, provided the entertainment on September 28, 1951.

Peggy Lee was looking for some new portrait shots to promote her move from Capitol Records to Decca. Of course, she called on her old friend PoPsie, whom she had known from their days with Benny Goodman. This particular shot, taken on February 10, 1952, was used for Peggy's biography, *Fever: The Life and Music of Miss Peggy Lee*, written by Peter Richmond.

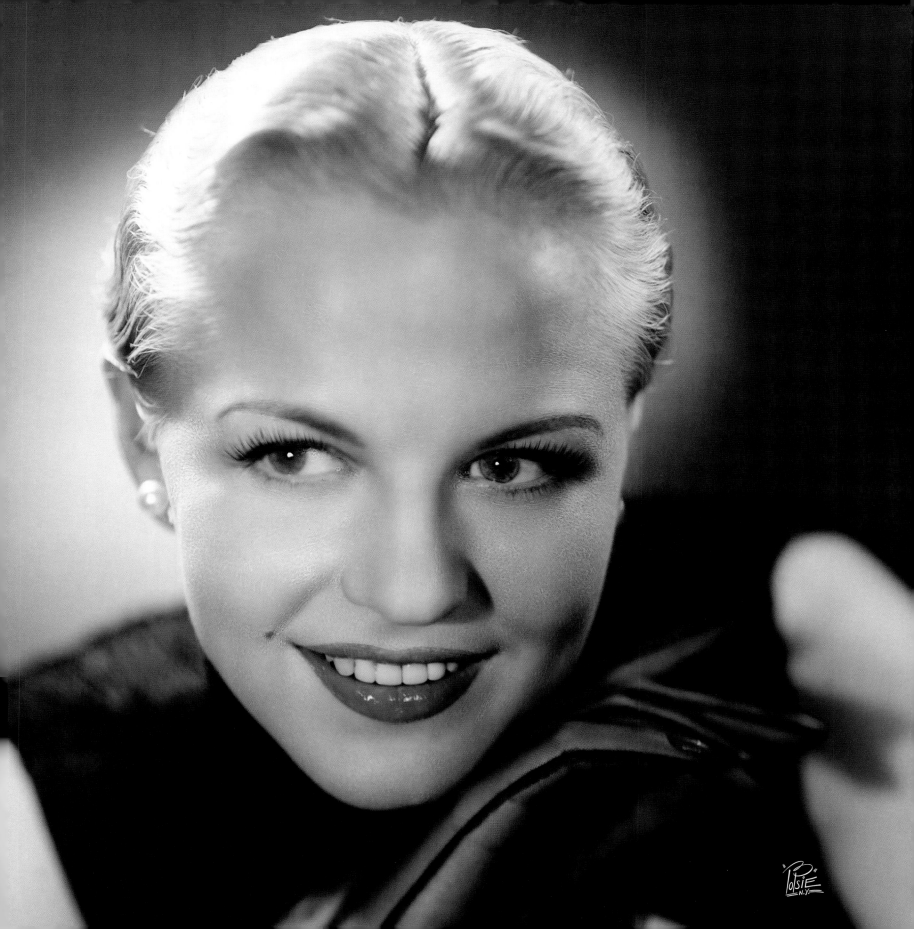

Dexter Gordon was in town, so PoPsie decided
to get a shot of him during a recording session,
September 26, 1950. Dexter was a friend of
Wardell Gray, and PoPsie often bumped into him
while attending shows when Gray was playing
with the Goodman band.

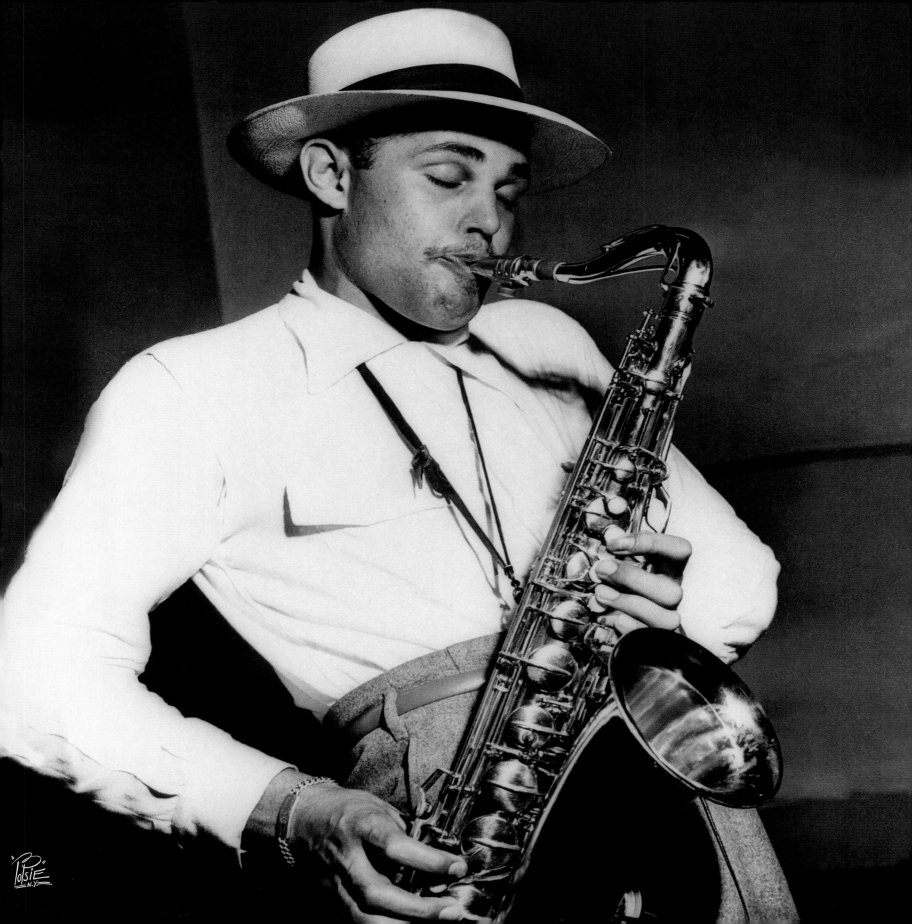

the torch is passed

John Coltrane (left) was a sideman in **Dizzy Gillespie's** band at the time of this January 19, 1951 photo. With his distinctive sound, Coltrane was ready to make his own statement as a sax player. Gillespie was impressed that his influence had reached yet another young player who could make a great splash in the world of jazz. PoPsie was there to photograph the moment when the torch was being passed.

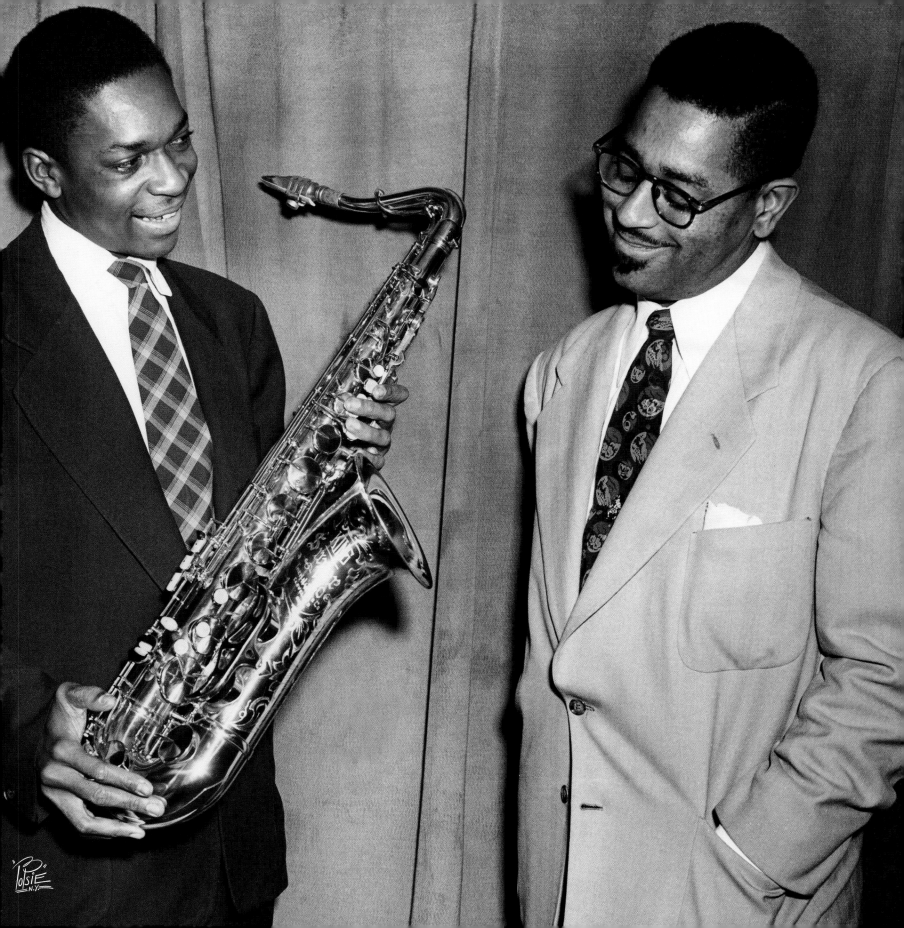

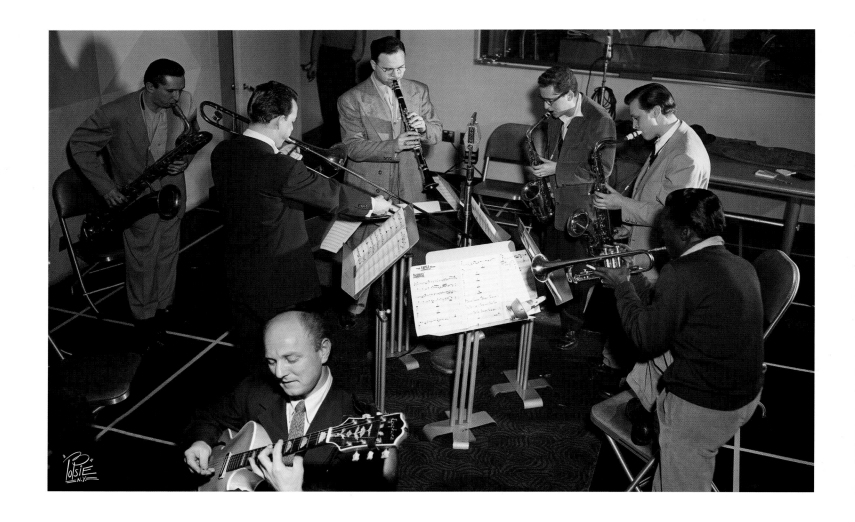

Above: *Metronome* magazine gathered **Miles Davis** (far right) and the other poll winners for 1950 for an informal "Metro All Stars" jam session that was recorded. PoPsie was asked to photograph the January 23, 1951 event for the magazine. A virtual jazz hall-of-fame attended. It was refreshing to see how all of these cats played harmoniously without egos getting in the way.

Opposite page: **Stan Getz** (left) and **Miles Davis**

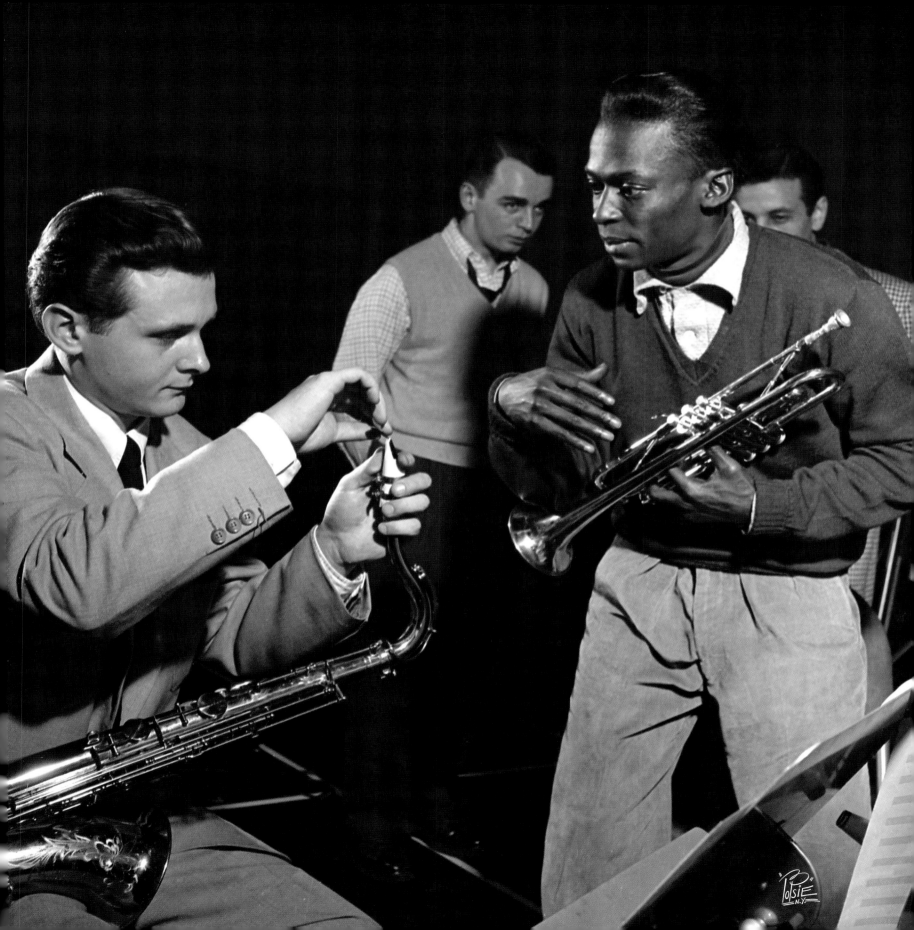

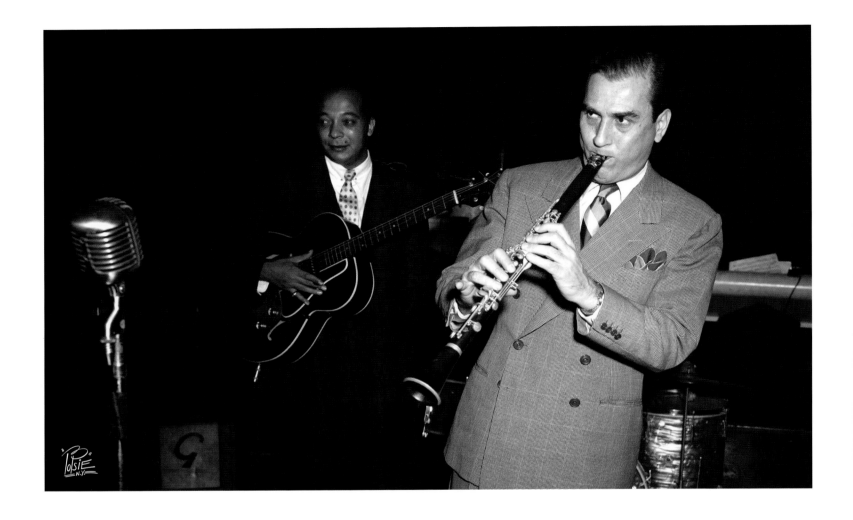

Like fellow clarinetist Benny Goodman, **Artie Shaw** was known as a difficult
person to be around. PoPsie was on hand when Artie came back to the music
business and formed his small band, the Gramercy Five. A few years later,
Shaw quit the business and appeared onstage only occasionally.
This photo was taken at New York's Ice Land on October 2, 1950.

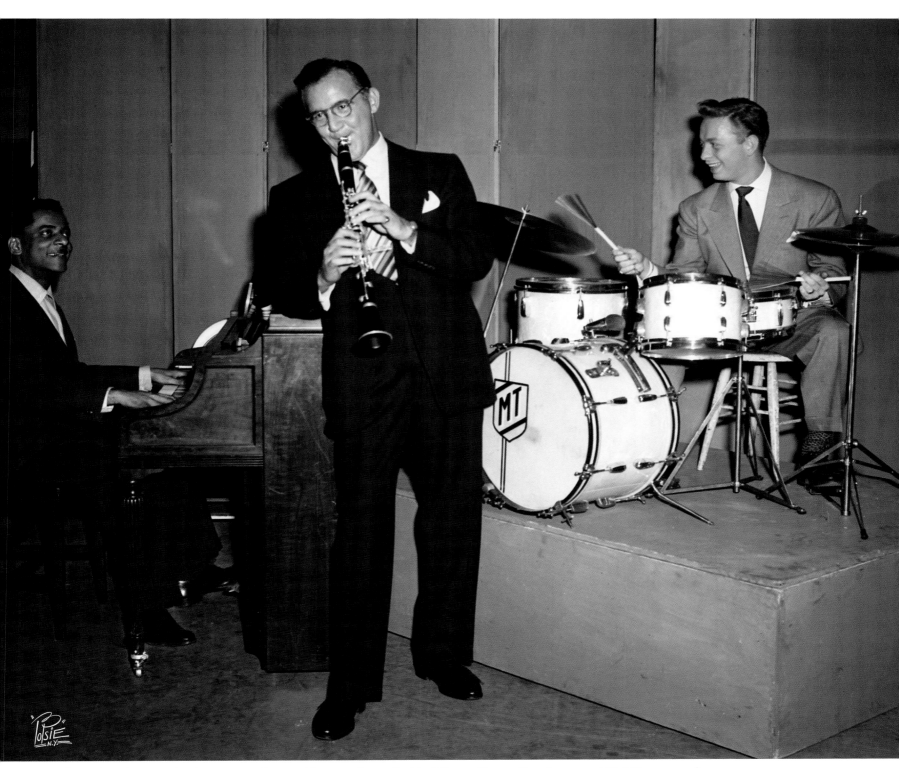

Here's a unique jazz combo that never got around to recording… **Teddy Wilson, Benny Goodman,** and **Mel Torme** used an opportunity as guests on the *Kreisler Show* radio program to have an impromptu jam session, March 21, 1951.

between sets

Max Roach (left) and **Lester Young** were relaxing
between sets at the "Metro All Stars" session when
PoPsie snapped this image on July 9, 1953. PoPsie
had a great rapport with musicians, who accepted him
into their tight fraternity. His time as a band boy paid
off handsomely in the photo business.

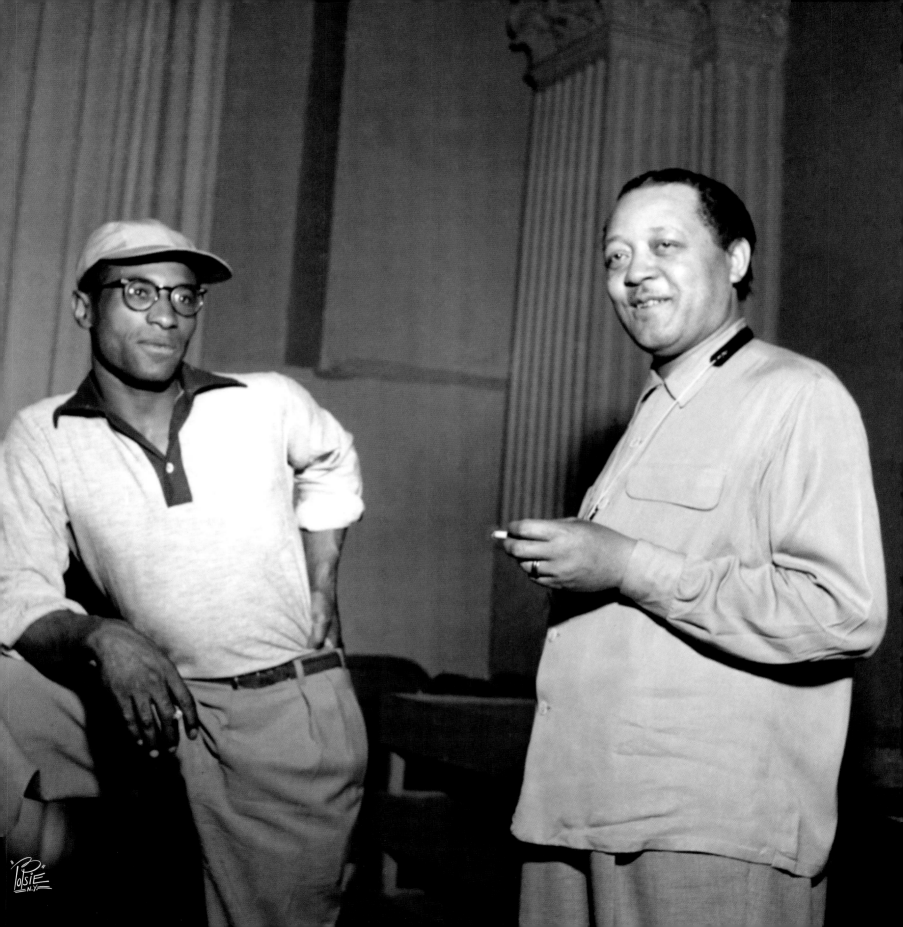

Bird

Fresh off his stint at Massey Hall in Toronto,
Charlie Parker (right) was eager to get back
to New York and sit in with **Lionel Hampton's**
band. This photo, taken at the Band Box on
June 26, 1953, shows him hard at work. A
very appreciative Hampton coaxes him on.

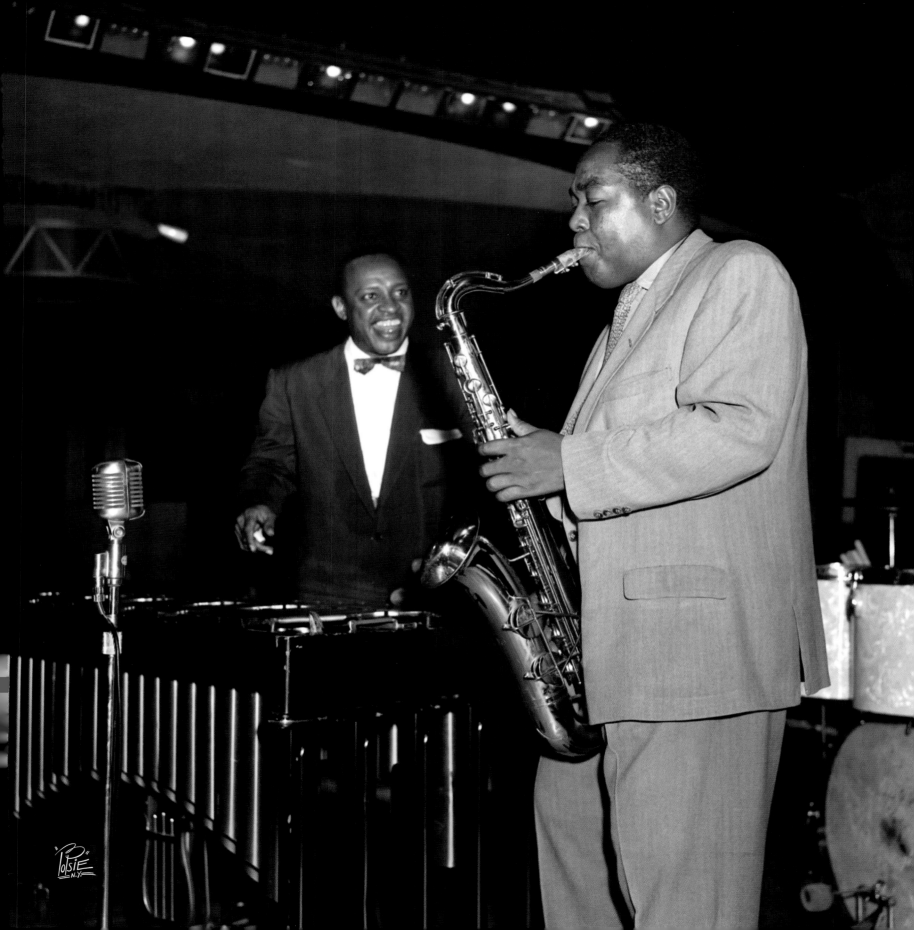

Earl "Fatha" Hines dropped in at Basin Street East with a new small combo in 1952. PoPsie was asked to chronicle the event for *Downbeat* magazine. Hines was one of the most requested pianists in jazz history, but rarely made it to New York on his tours.

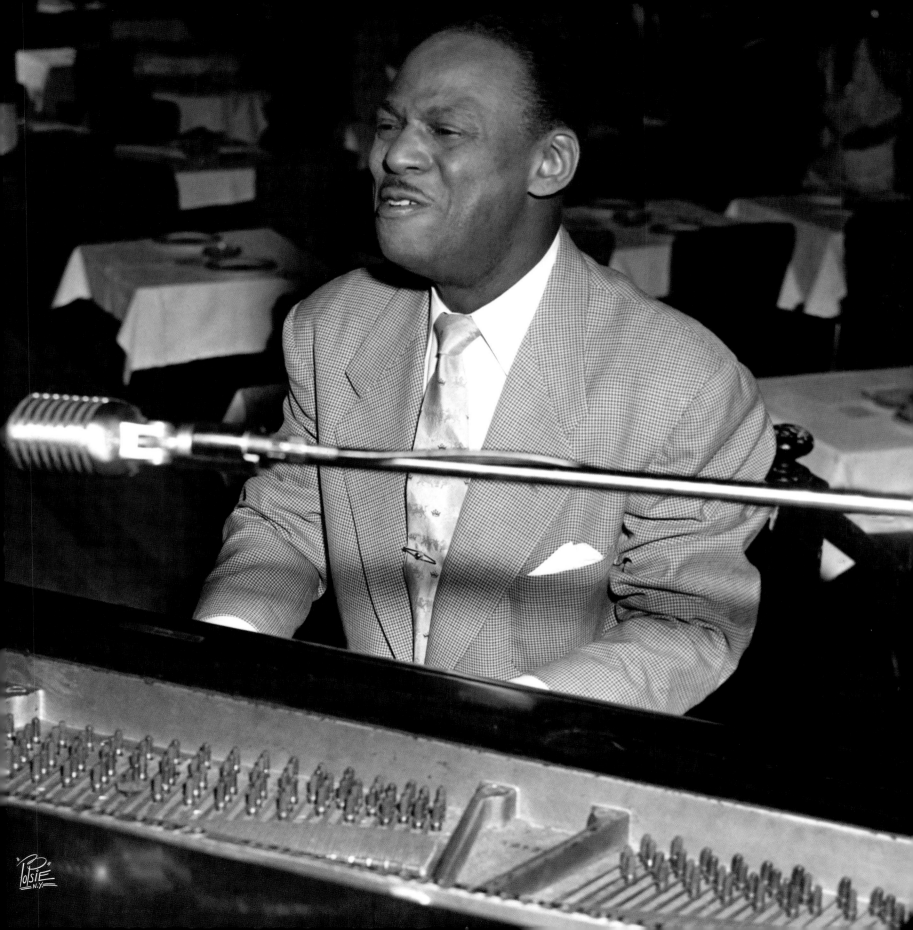

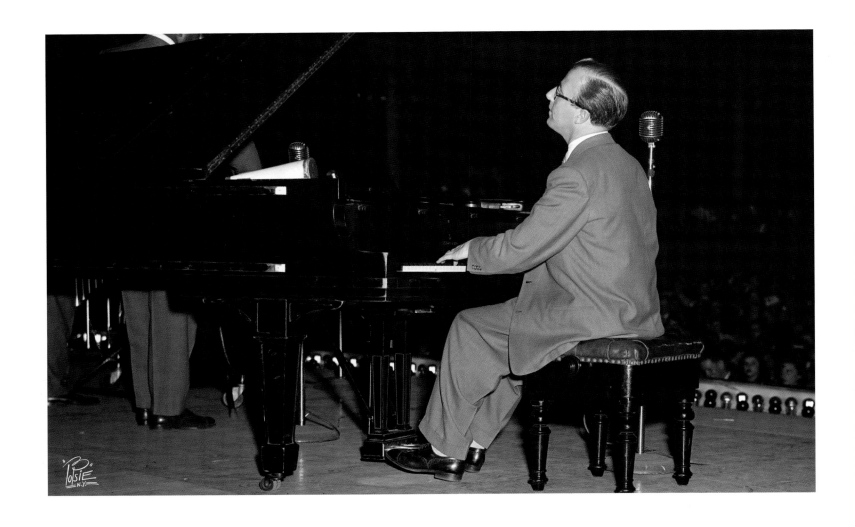

George Shearing was co-featured with Billy Eckstine at a
sold-out Carnegie Hall November 11, 1951.

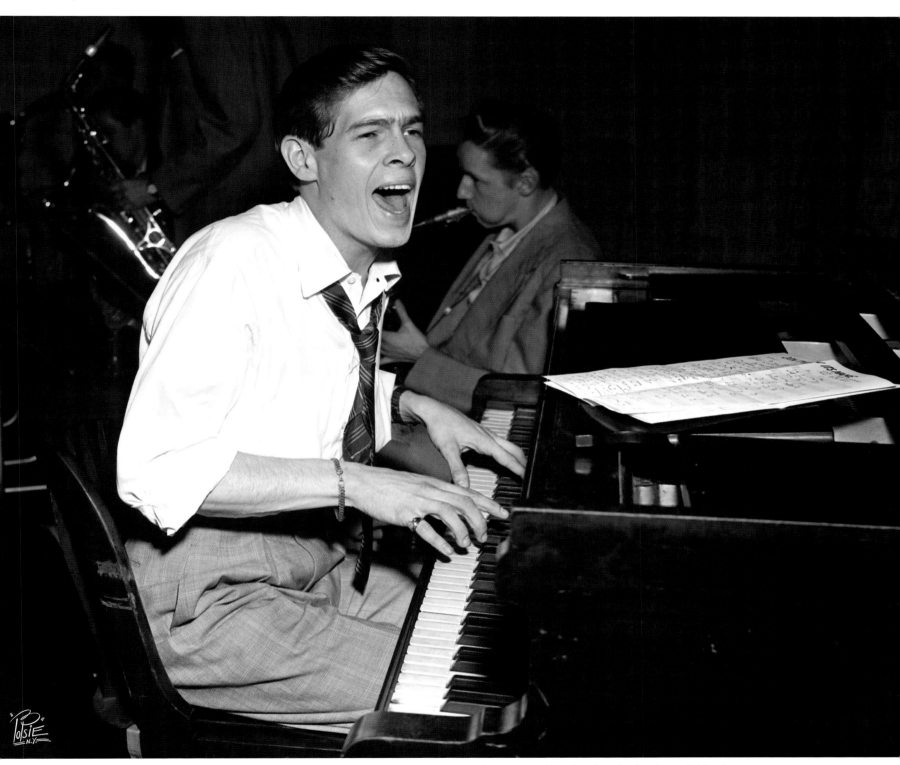

In the history of popular male vocalists, **Johnnie Ray** was the link between Frank Sinatra and Elvis Presley. At the time of this photo—rehearsing at the Paramount Theatre on May 27, 1952—he was on top of the world, with five songs on the charts. Johnnie's over-the-top theatrics drove the fans crazy, but PoPsie got him to slow down enough to capture this timeless image.

Liberace was the hottest entertainer in the world in 1953. His television show was ranked #1 and he sold millions of records. When he performed live at Carnegie Hall on September 25, the hottest photographer in the business was called in to capture the event. Liberace's brother George is shown playing the violin.

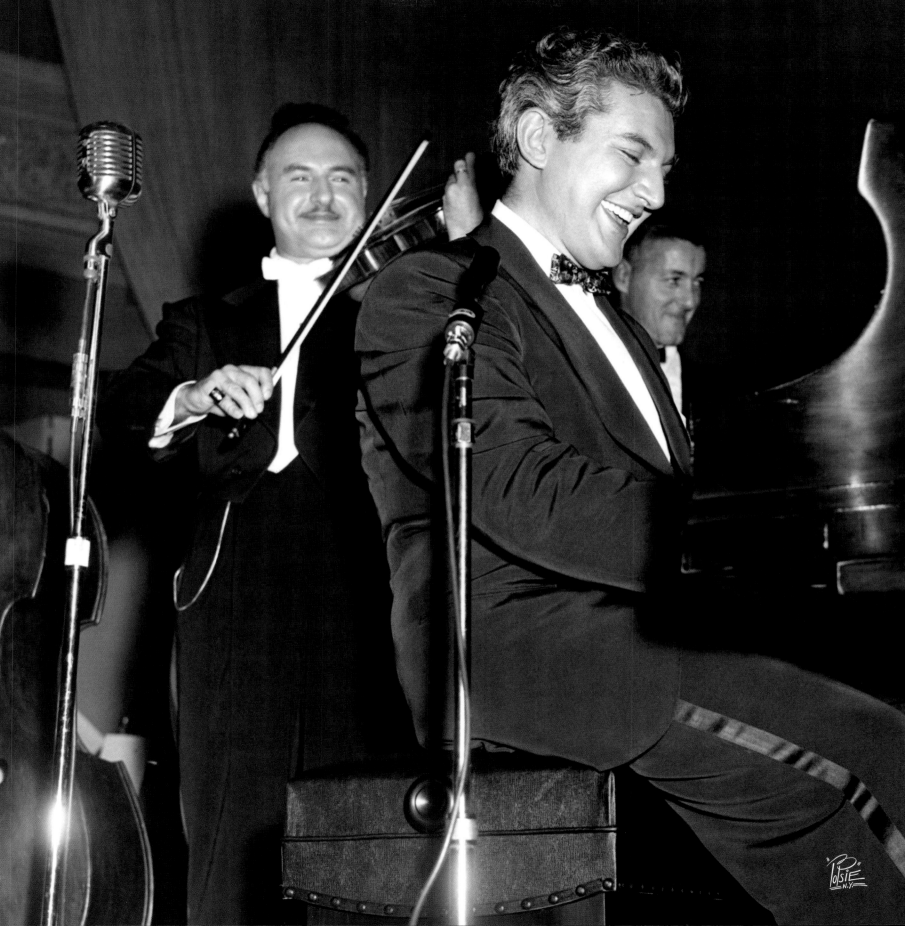

When **Marian McPartland** set up her residency at the Hickory House on 52nd Street in 1952, little did she realize that she and her trio—photographed here on February 23, 1954—would be there until 1960. McPartland was often cited by other musicians as one of the best pianists in the business. They frequently attended her shows and would sit in with the band as well.

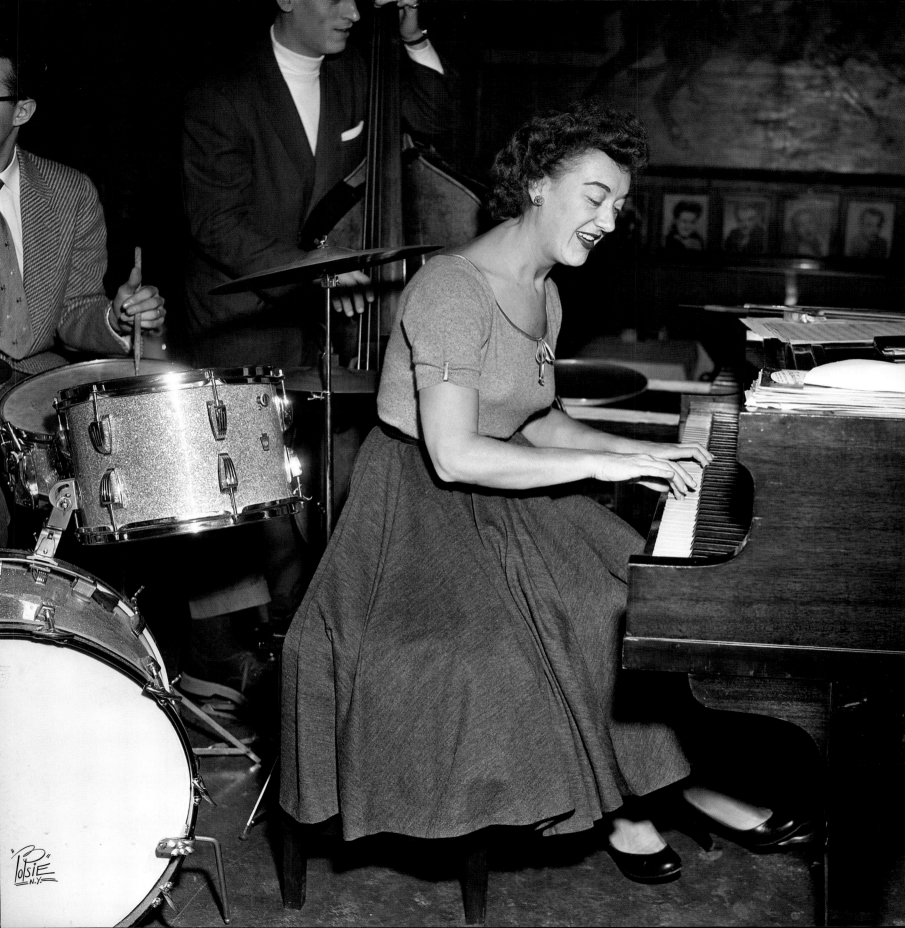

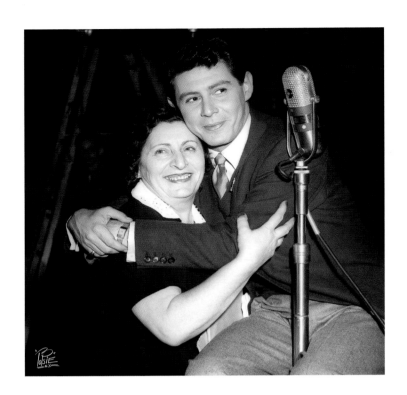

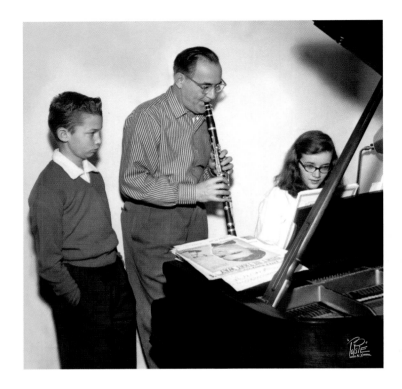

Above left: **Eddie Fisher** shares a tender moment with his mother on *Coke Time with Eddie Fisher* in March 1954. The TV program aired from 1953 to 1957.

Above right: Uncle **Benny Goodman** with daughter **Rachel** and yours truly, **Mike Randolph**, waiting for my turn to play the piano, 1955.

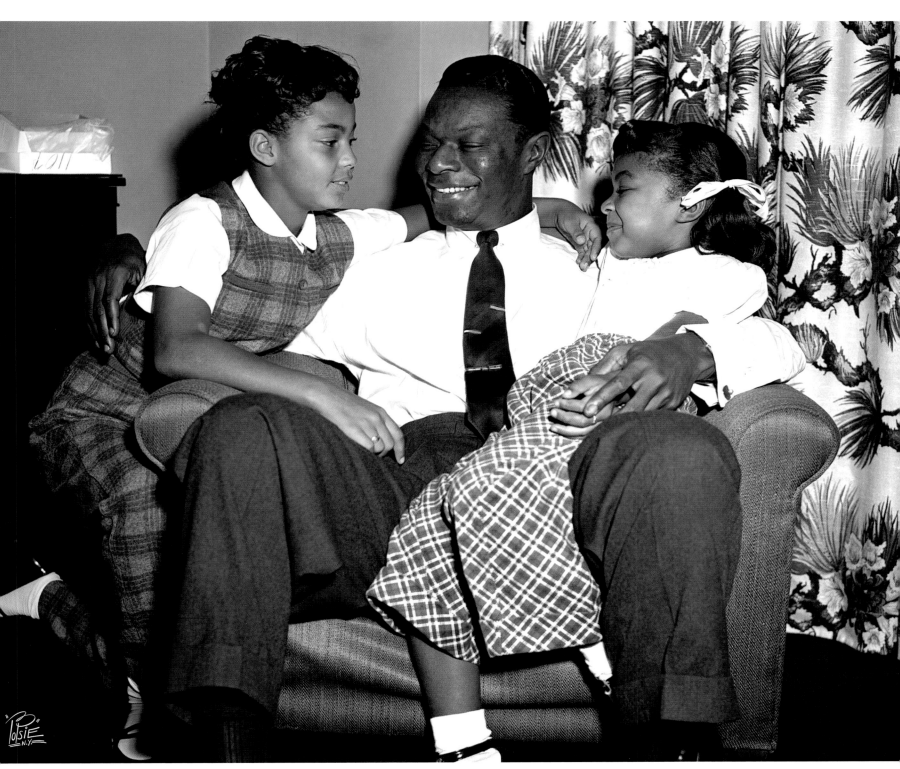

Nat "King" Cole takes a break from his busy schedule and spends some quality time with his daughters **Carole** and **Natalie** (right) at his New York City apartment, November 21, 1954.

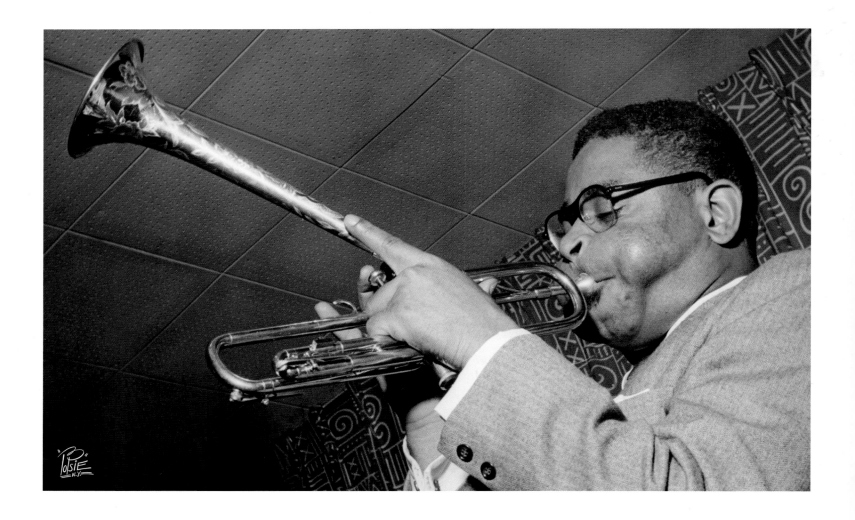

Birdland was one of the hotbeds of jazz in 1955. PoPsie was on hand many times as the biggest names in the field created history. Here, **Dizzy Gillespie** makes one of his many visits to this historic venue.

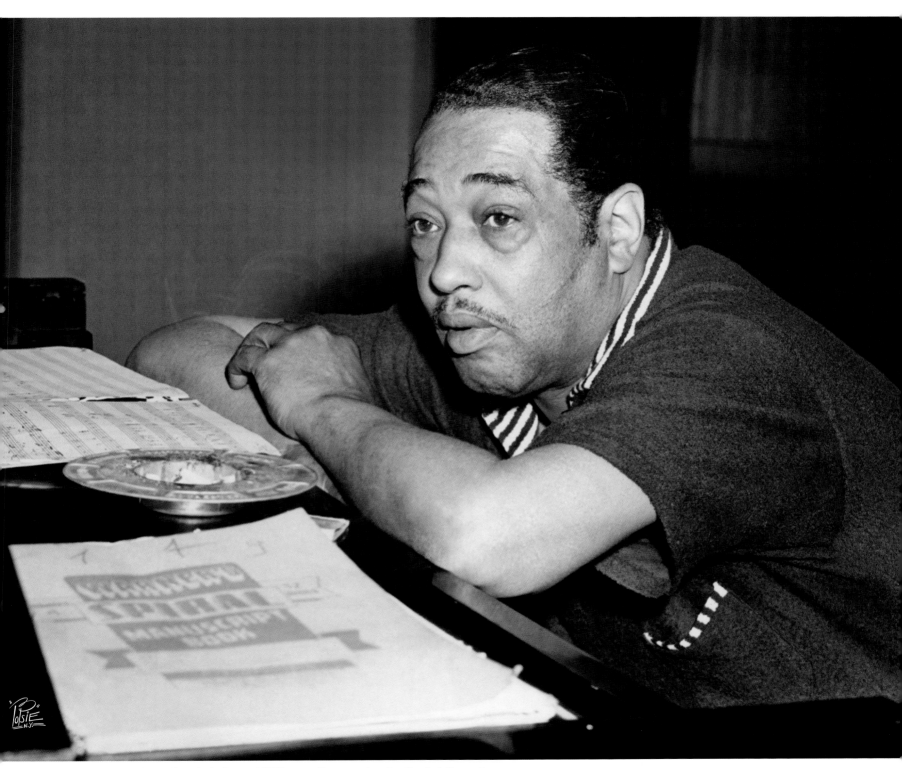

Duke Ellington takes a break during a 1956 recording session for Capitol Records.

Count Basie enjoys the harmony during
a performance at Basin Street East,
February 29, 1956.

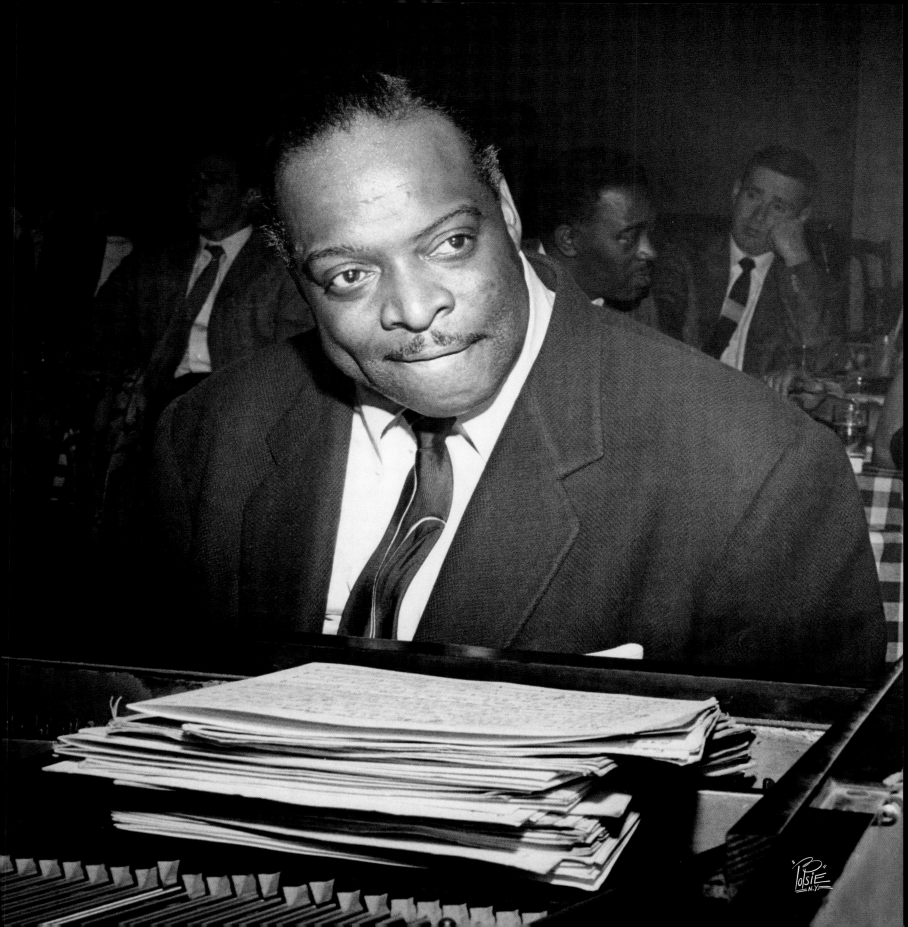

Buddy Rich relaxes backstage during rehearsals
for Norman Granz's "Jazz at the Philharmonic"
tour, September 19, 1955.

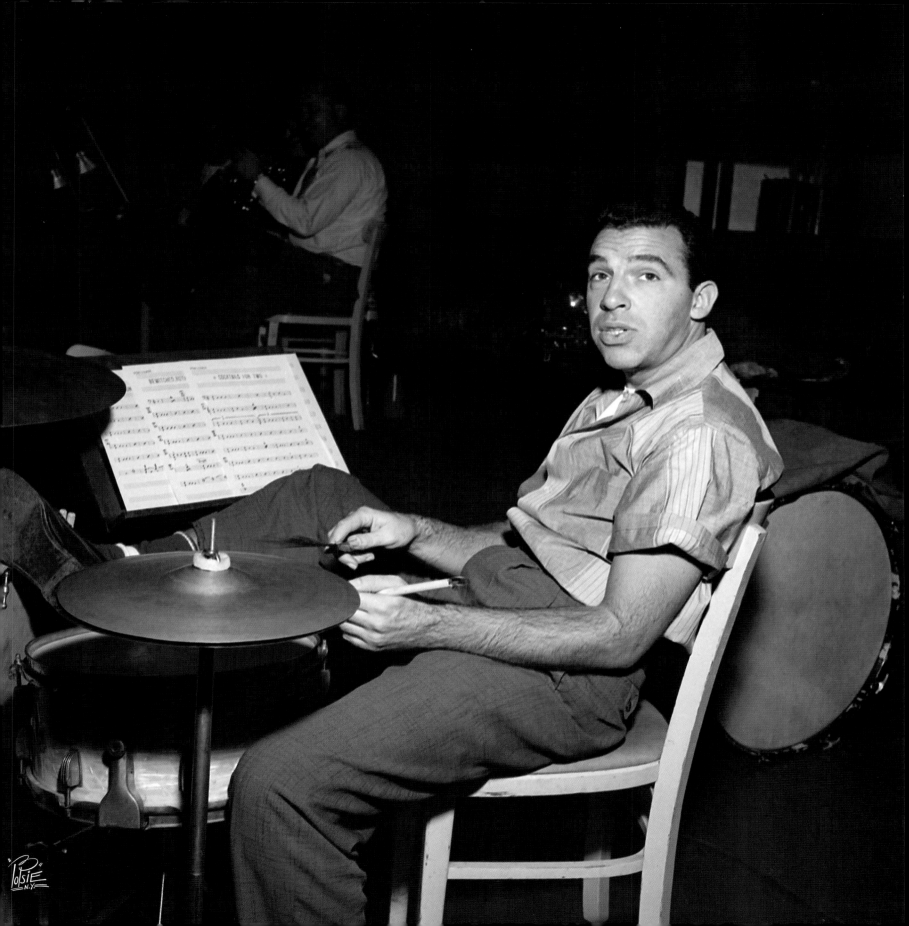

Jazz Messengers

Café Bohemia was where PoPsie caught up with one of the earliest lineups of the Jazz Messengers, December 29, 1956. This shot features **Art Blakey** (drums) and **Horace Silver** (piano). Silver soon departed to form his own band, while Blakey kept the Jazz Messengers active well into the Seventies.

Julie London was photographed by PoPsie during her debut at the Cameo Club on January 5, 1956. She performed with the Bobby Troup Trio during her visit to New York City. Julie later married Bobby in 1959, and they ended up working together on the TV show *Emergency*.

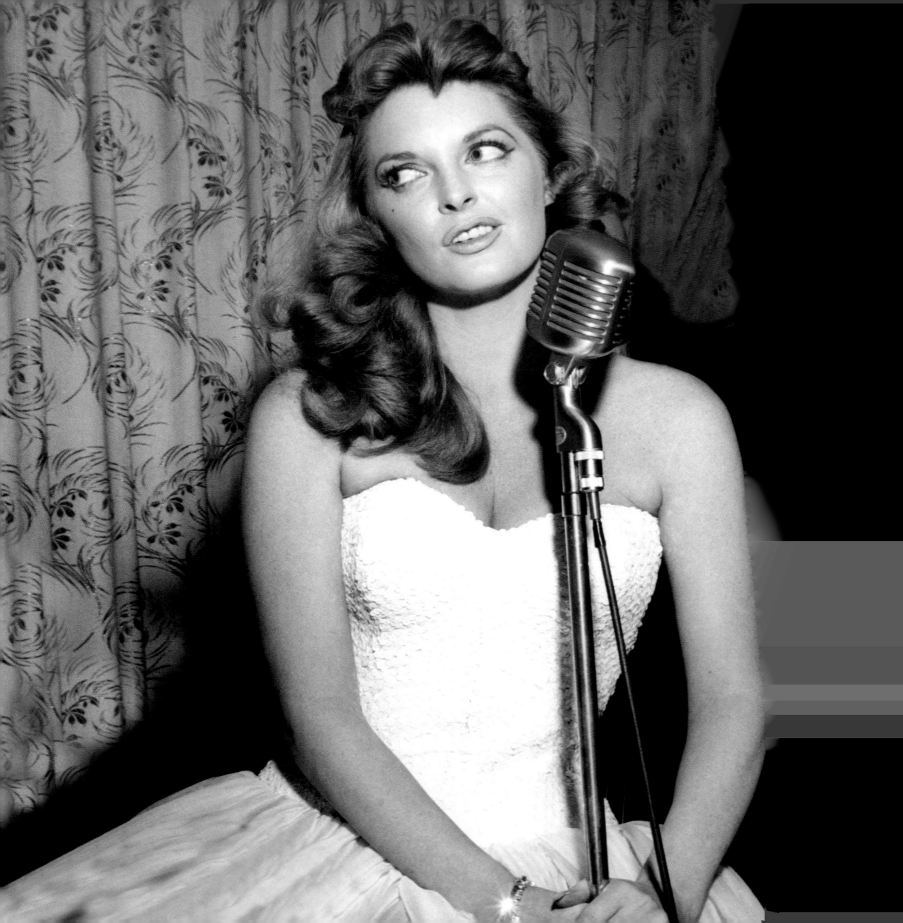

Above left: **Perry Como** lets PoPsie know where he plans to spend the holidays during a break on his TV show at NBC studios, New York, 1955.

Above right: PoPsie's old boss **Woody Herman** catches up on some light reading at the Statler Hotel, February 24, 1955.

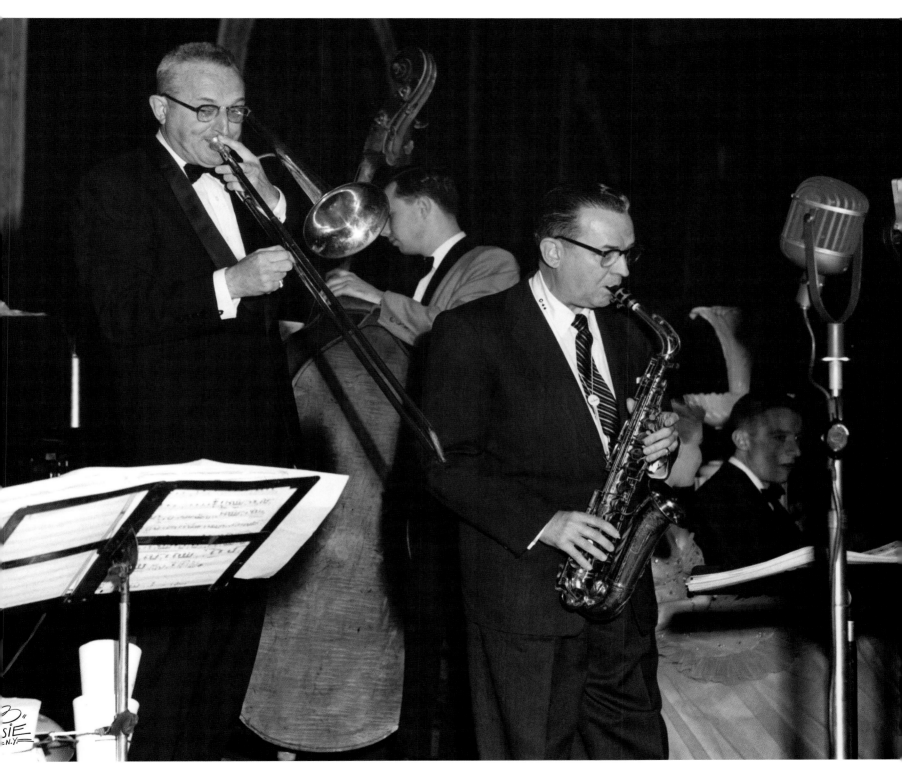

In 1953, the fabulous **Dorsey Brothers** reunited when **Jimmy** (right) joined **Tommy's** band. During the 1955-56 season, the brothers had their own television program on CBS. *Stage Show* gave them nationwide coverage.

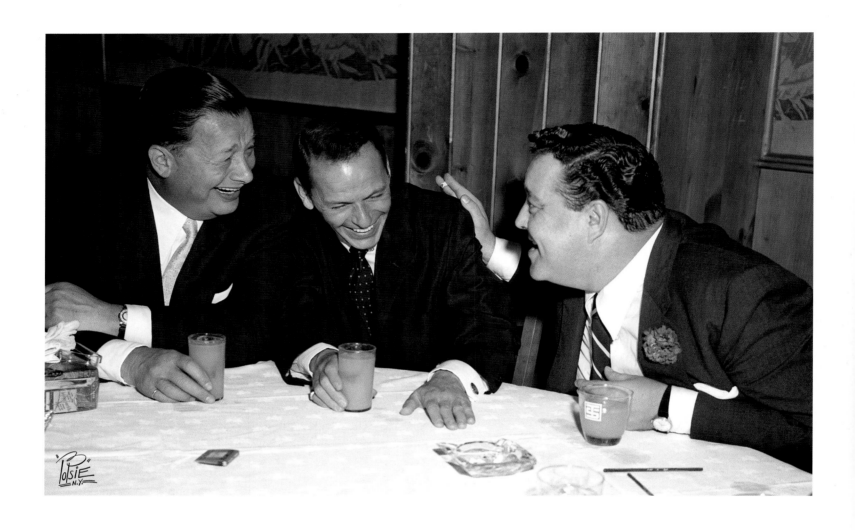

Frank Sinatra was the de facto mayor of New York in the Fifties. He often made late-night visits to Toots Shore's place to unwind with his old pal Jackie Gleason. Sinatra also made visits to the various radio stations to promote his new movie or recording.

Above: **Toots Shore, Frank Sinatra, Jackie Gleason**, Toots Shore restaurant, August 16, 1956.

Opposite page: **Frank Sinatra**, WINS radio station, May 25, 1951.

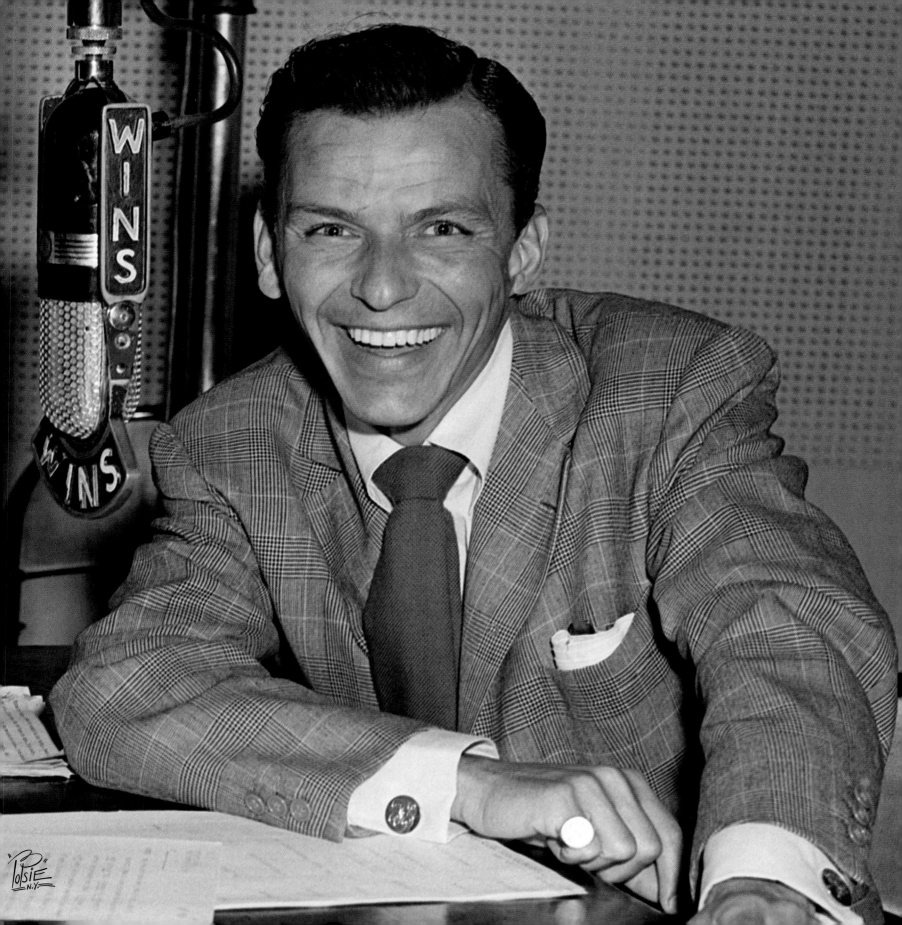

the King

Elvis, his band, and the **Jordanaires** work out an arrangement during a recording session at the RCA Victor Studio, July 2, 1956. PoPsie provided the images for *Elvis Presley*, the King's first LP, later that year.

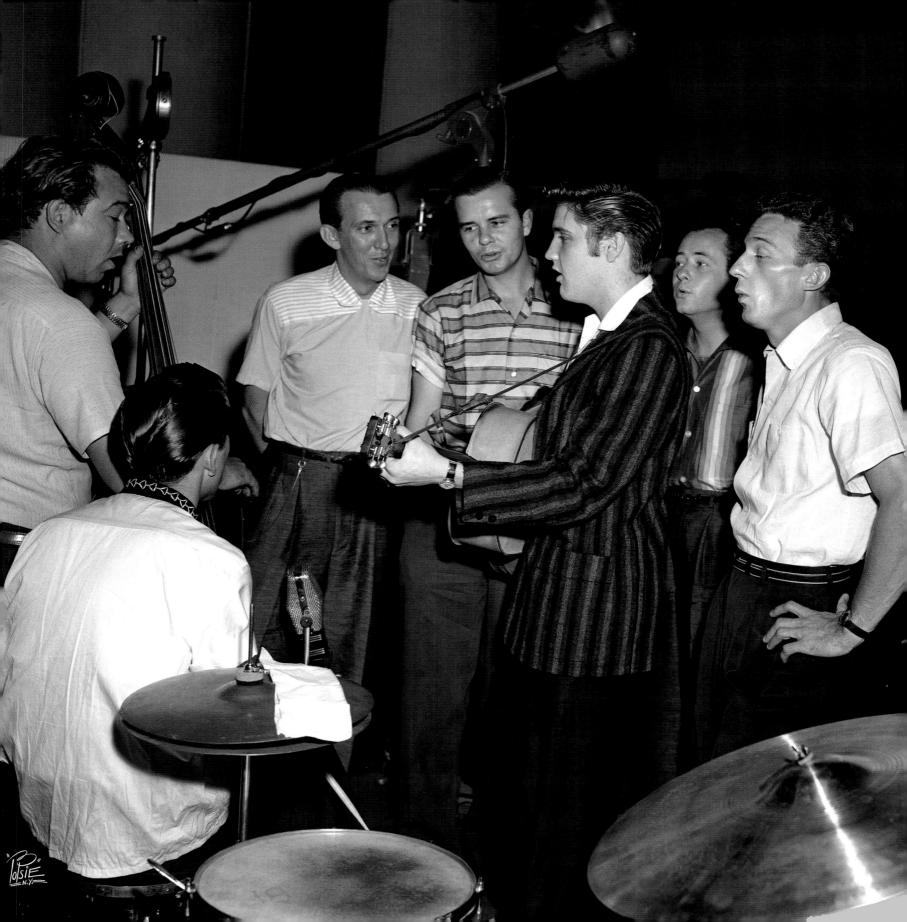

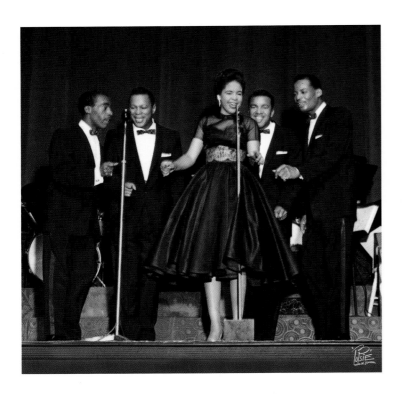 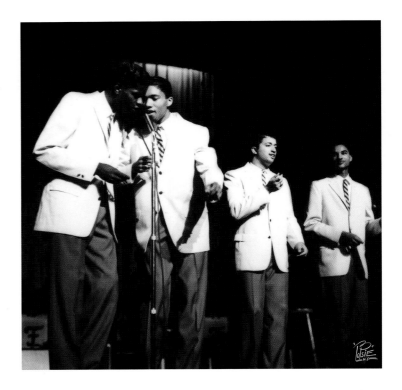

Alan Freed attracted the best of the best. Both the **Platters** (left) and the **Cleftones** (right) kept the fans coming to his yearly shows. The Platters appeared on Freed's show on February 22, 1957; the Cleftones sang the very next day.

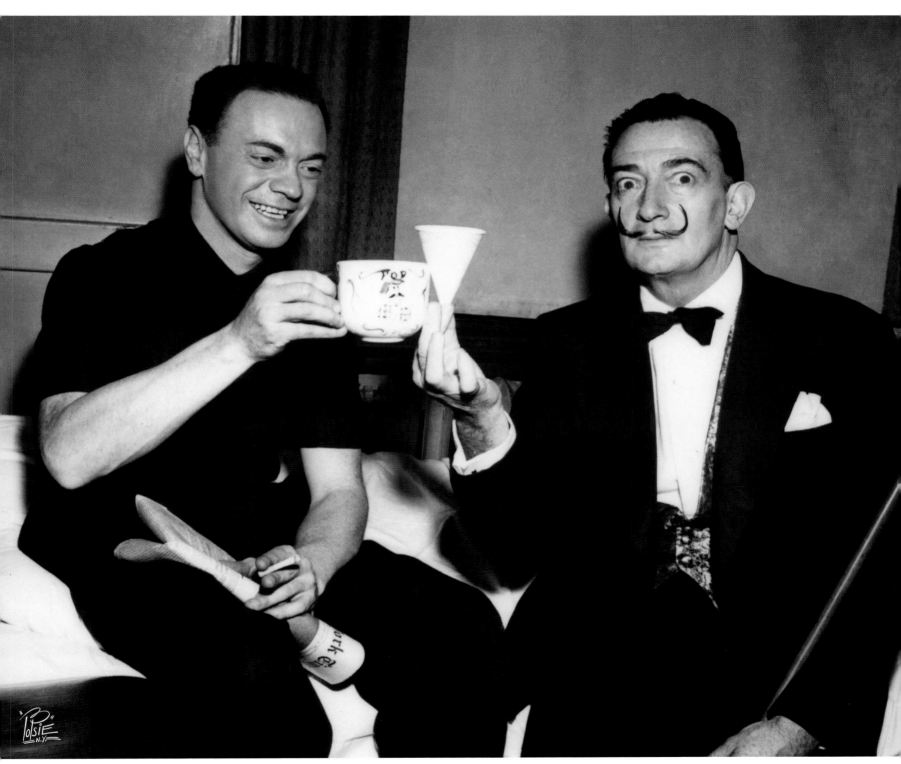

PoPsie outdid himself with this duo: the surrealist painter **Salvador Dali** (right) meets the master of "The Big Beat," **Alan Freed**. Dali met Freed backstage on February 22, 1957, before one of Freed's shows. We're still wondering how PoPsie created this photo opportunity.

Mr. Excitement

Even "Mr. Excitement" himself, **Jackie Wilson**, performed at Alan Freed's 1957 shows. Freed had one of the top-rated programs on WINS radio, and his influence was felt by record labels and agents who made sure to have their biggest acts show up.

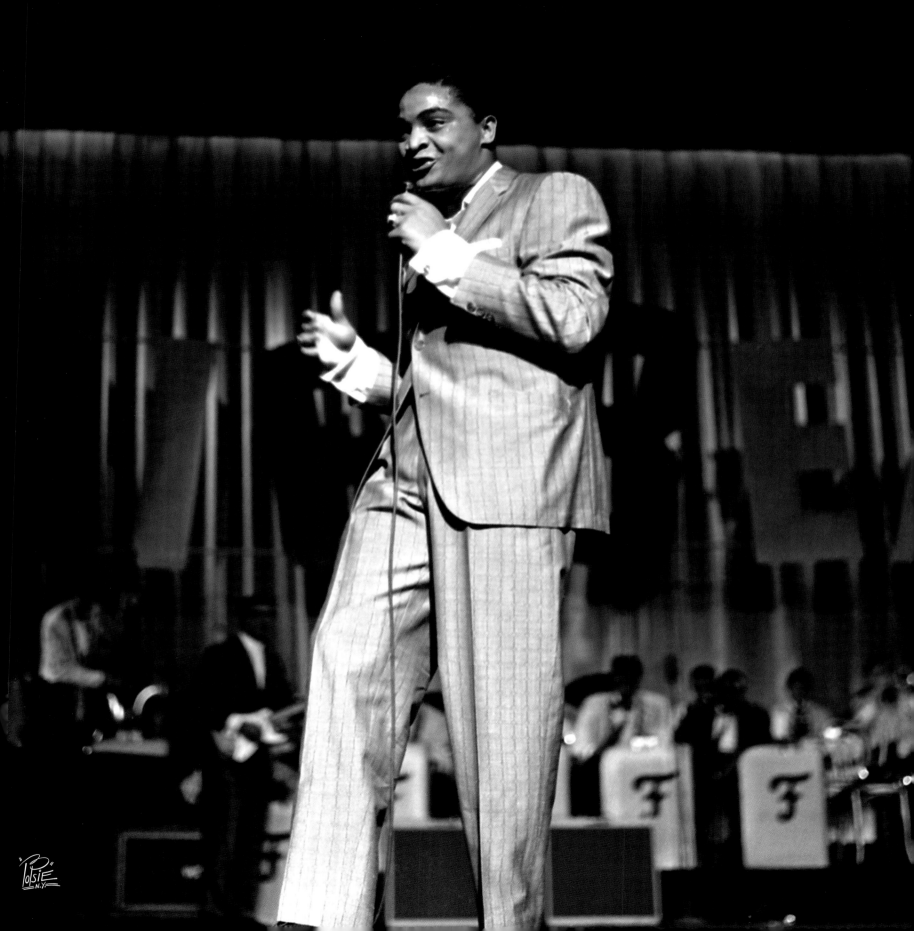

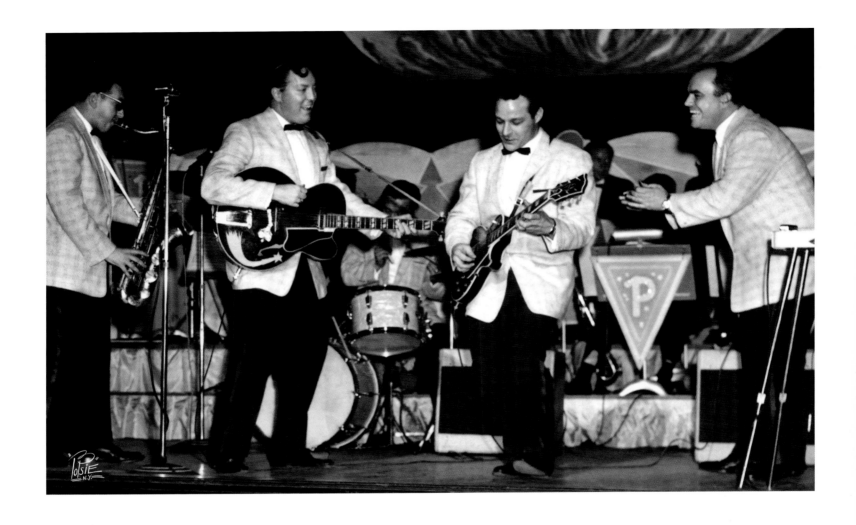

By the late Fifties, rock 'n' roll was taking up a major portion of PoPsie's time.
The latest hot groups were constant subjects.

Above: **Bill Haley and His Comets**, Brooklyn Paramount, 1958.

Opposite page: the **Coasters**, August 16, 1958.

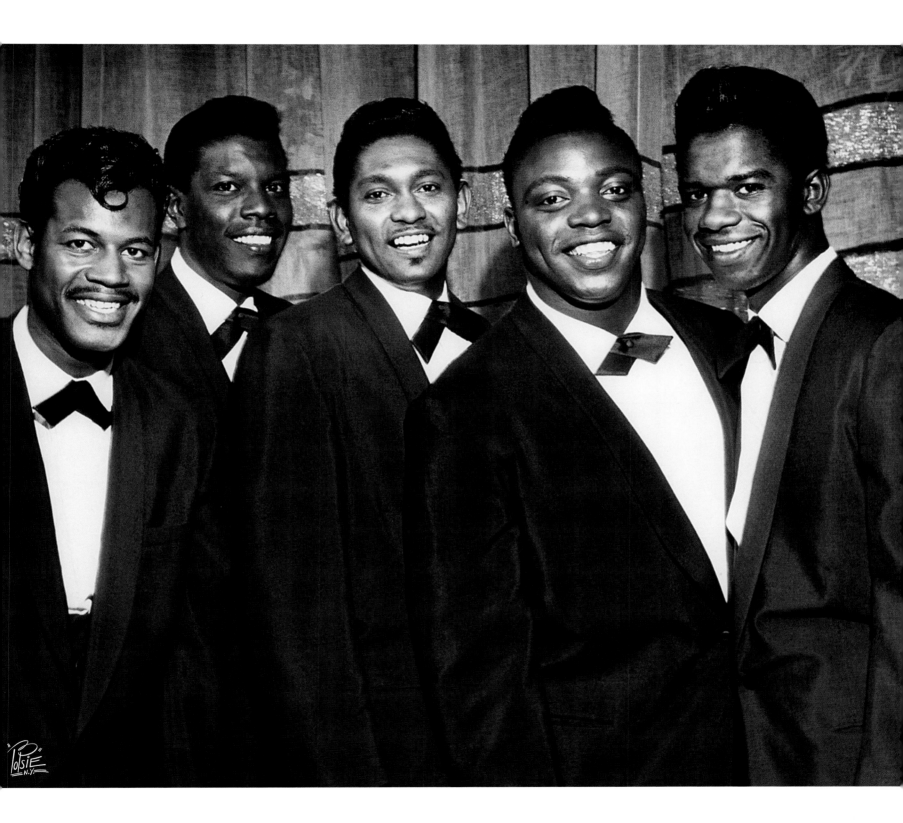

PoPsie made time for the labels and performers who were just starting out and needed a boost. **Johnny Maestro** (center) **and the Crests** used PoPsie when they needed their portraits done in 1959.

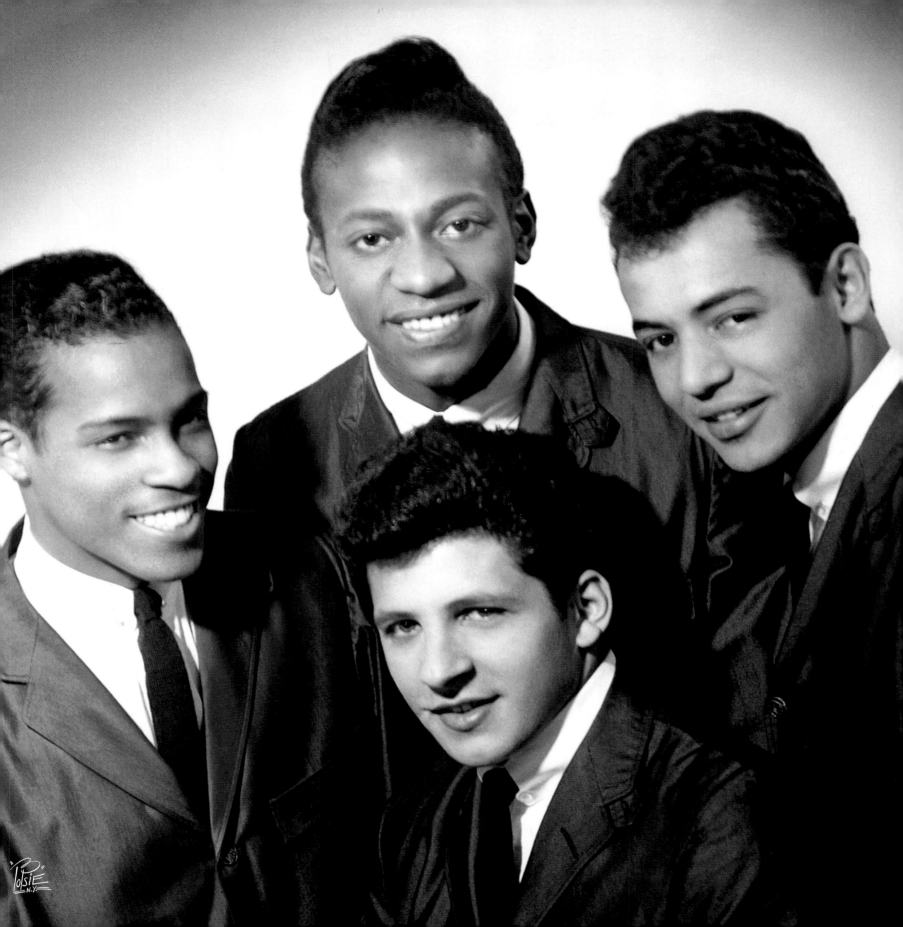

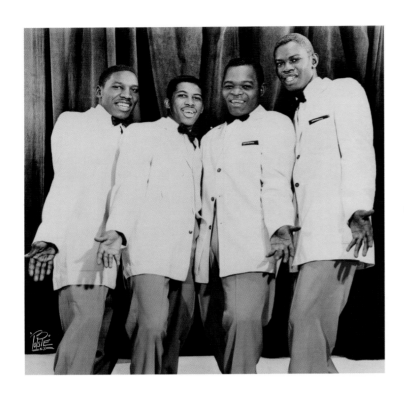

Above left: Atlantic Records kept PoPsie busy with their requests for
photos of their marquee groups. The **Drifters**, photographed here on
February 2, 1959, had constant change within their ranks.

Above right: The fledgling Jamie label in Philadelphia called PoPsie. Jamie
had its biggest star, Rock 'n' Roll Hall of Fame member **Duane Eddy**,
pose for a session on September 17, 1958.

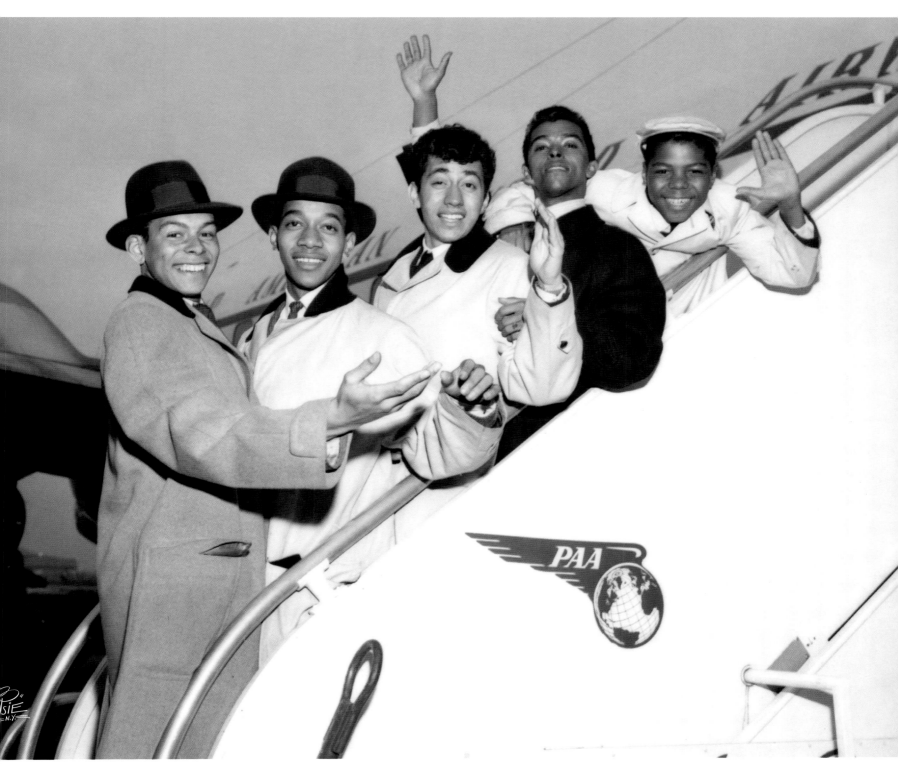

PoPsie photographed the **Teenagers** in 1957, before they left for their first and only European tour. Little did they realize that plans were already afoot to break **Frankie Lymon** (far right) away from the group. By the time they returned from Europe, Lymon had already been given material to sing by himself, and the Teenagers were relegated to finding a new lead singer.

Chances are...

The biggest label of them all, Columbia,
utilized PoPsie's services by asking
Johnny Mathis, their biggest star at
the time, to pose for a session, 1959.

Not to be outdone by Columbia records, RCA asked PoPsie to take care of its hottest property, **Harry Belafonte**, here photographed in October 1959. Belafonte had one of the biggest-selling LPs that year, *Belafonte at Carnegie Hall.*

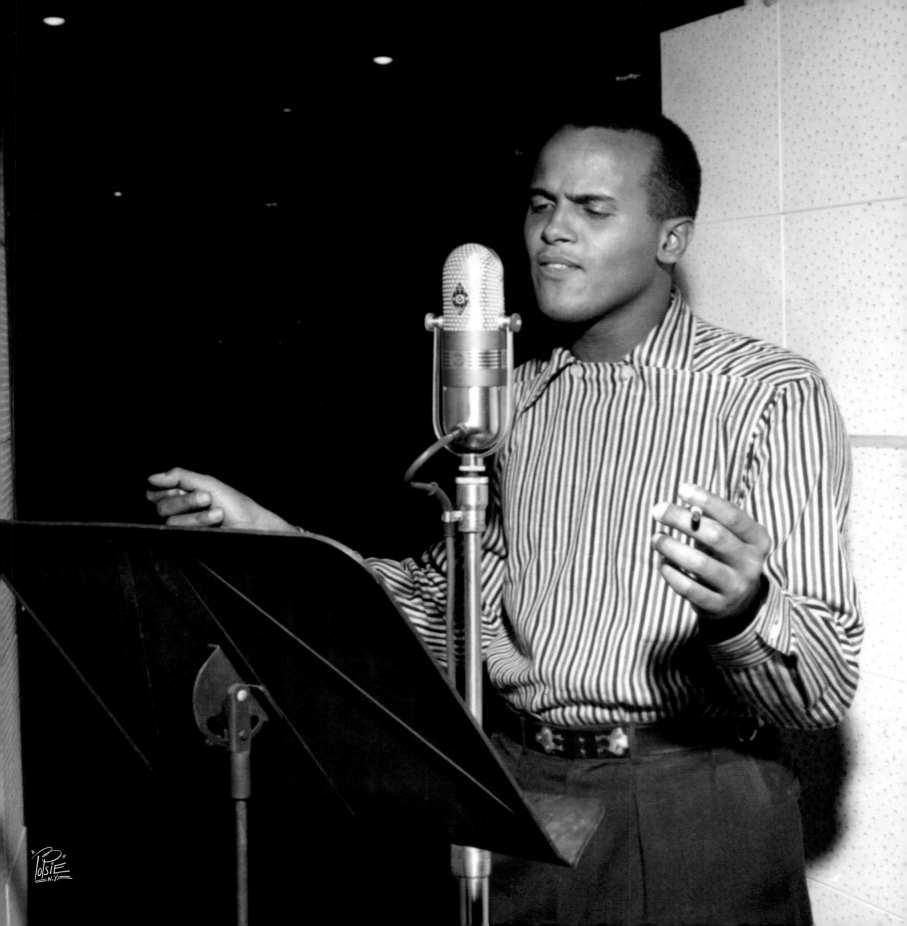

THE SIXTIES

By the beginning of the Sixties, music had morphed from a small cottage
industry into a mega corporate business. PoPsie was challenged by a slew
of new photographers who worked cheaper, but he still was the only
logical choice due to his knowledge and insight of the music world.
He was still the indisputable king of music photography.

The **Crystals** were one of many
groups that Phil Spector brought
to PoPsie to have photographed in
PoPsie's new studio, located next
to the Brill Building, 1960.

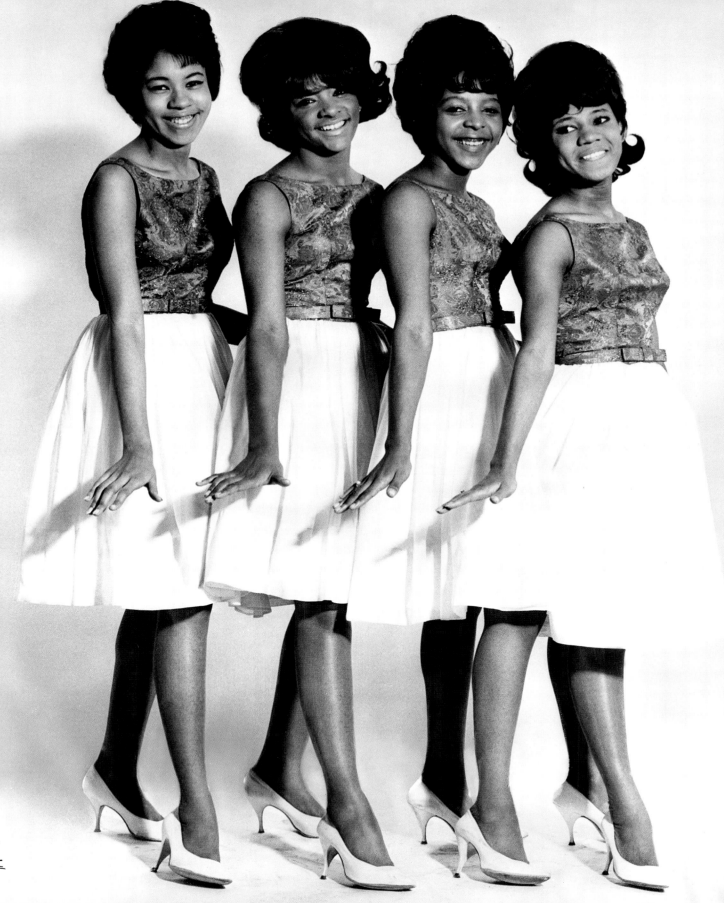

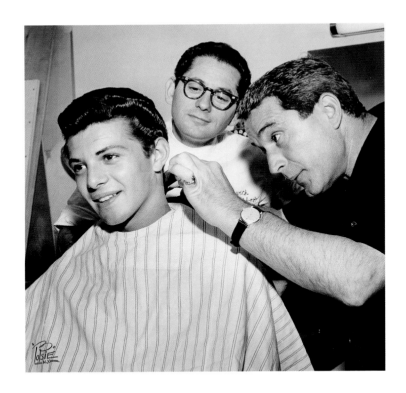

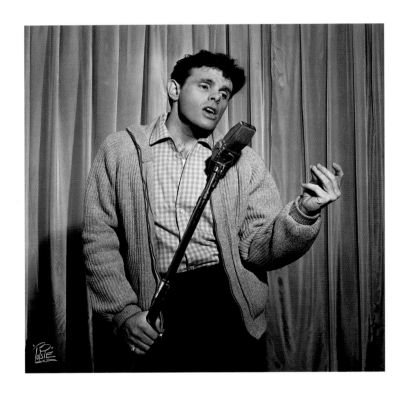

Above left: PoPsie was a fixture at rehearsals for *The Perry Como Show* during the early Sixties. On Thursday nights, Perry would run through that week's performances and make adjustments. On this particular week in 1962, **Perry Como** helped **Frankie Avalon** with a haircut. Como had been a barber before he was a crooner.

Above right: **Del Shannon** was at work waxing a follow-up single to "Runaway" when PoPsie caught up with him on January 1, 1962.

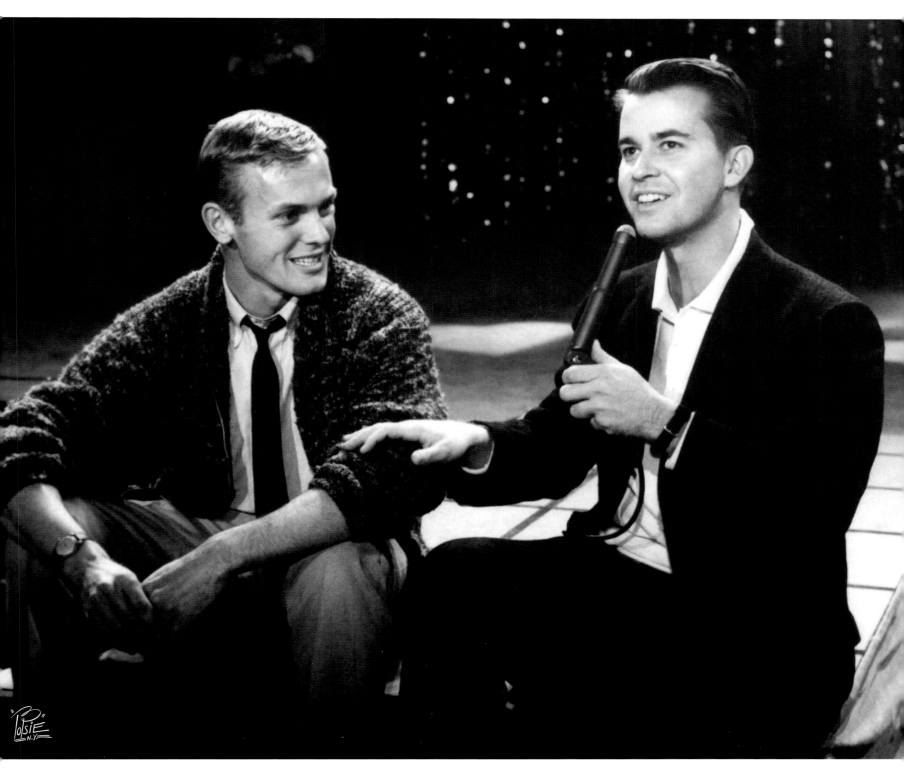

Television networks made good use of PoPsie. He often was called to the studios of the "Big Three" to catch the parade of rising stars. Here, **Tab Hunter** (left) chats it up with **Dick Clark** during a 1960 network special that PoPsie photographed for ABC.

two musical giants

Louis Armstrong (left) and **Duke Ellington**
took time out during Louis's appearance at
Basin Street East in 1961 to pose for PoPsie.
It was very rare to find these two musical
giants at the same place at the same time.

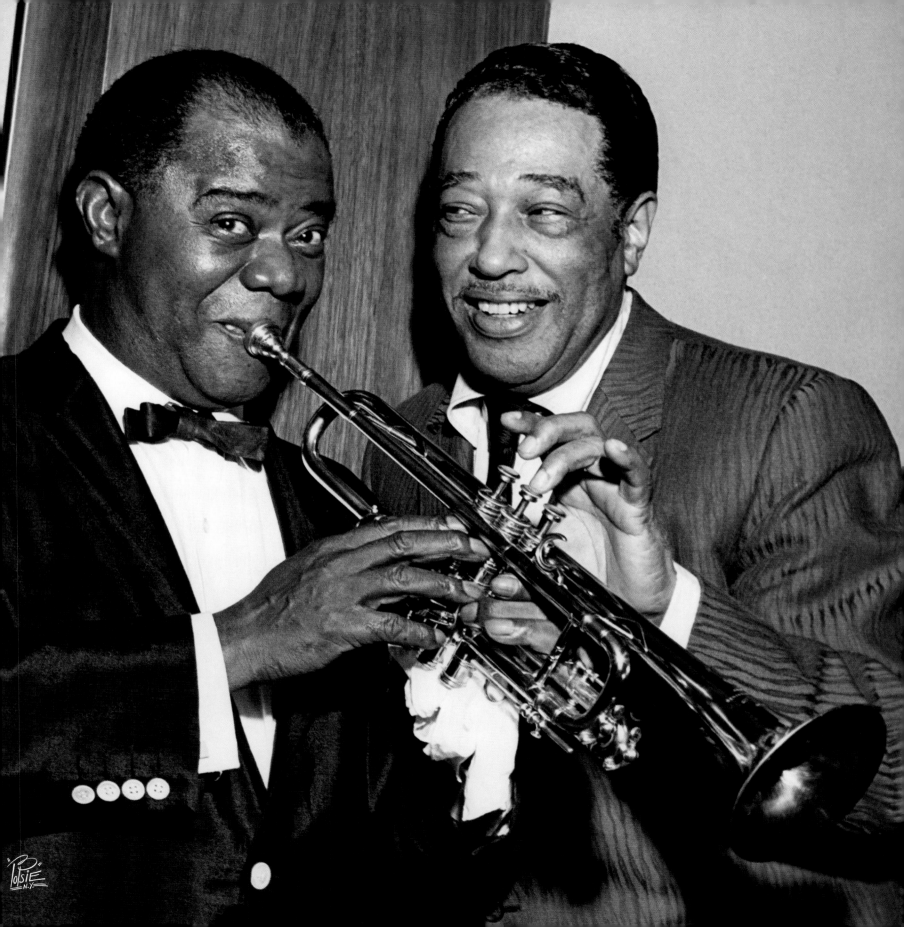

The **Shirelles** do their part for world peace at
the United Nations building, March 21, 1961.

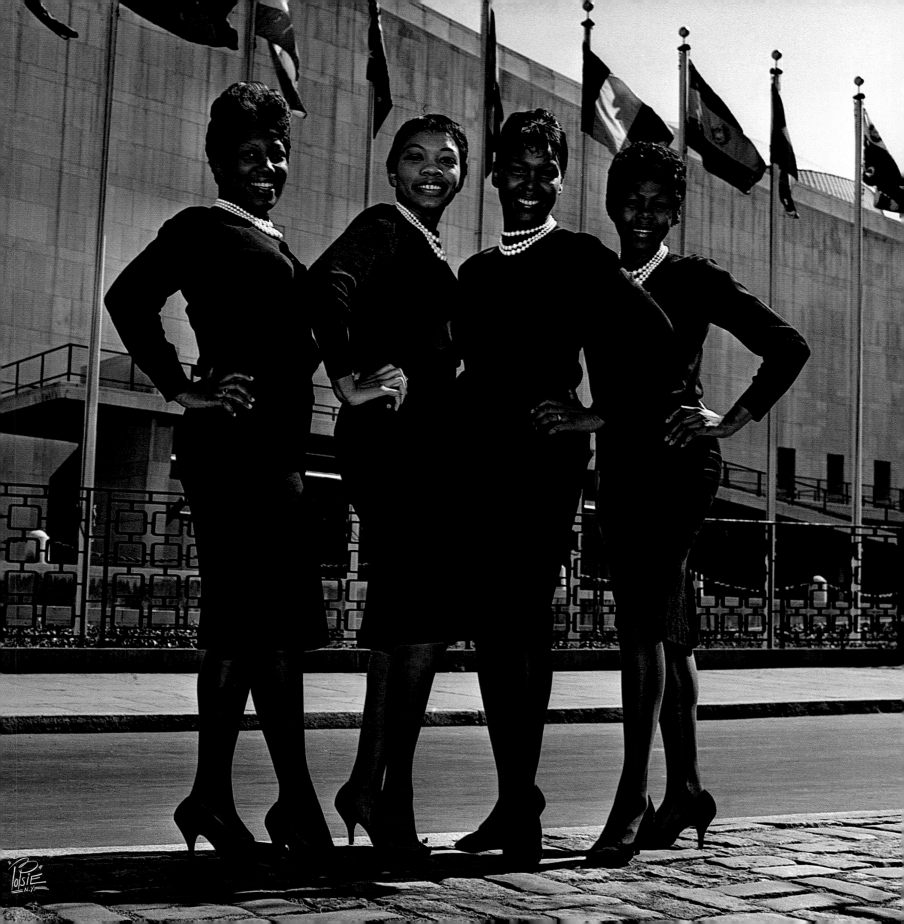

girl group sound

The **Ronettes** were just getting started when photographed for Colpix Records during a recording session on February 6, 1962. They were later rediscovered by Phil Spector and became one of the best examples of the "girl group" sound.

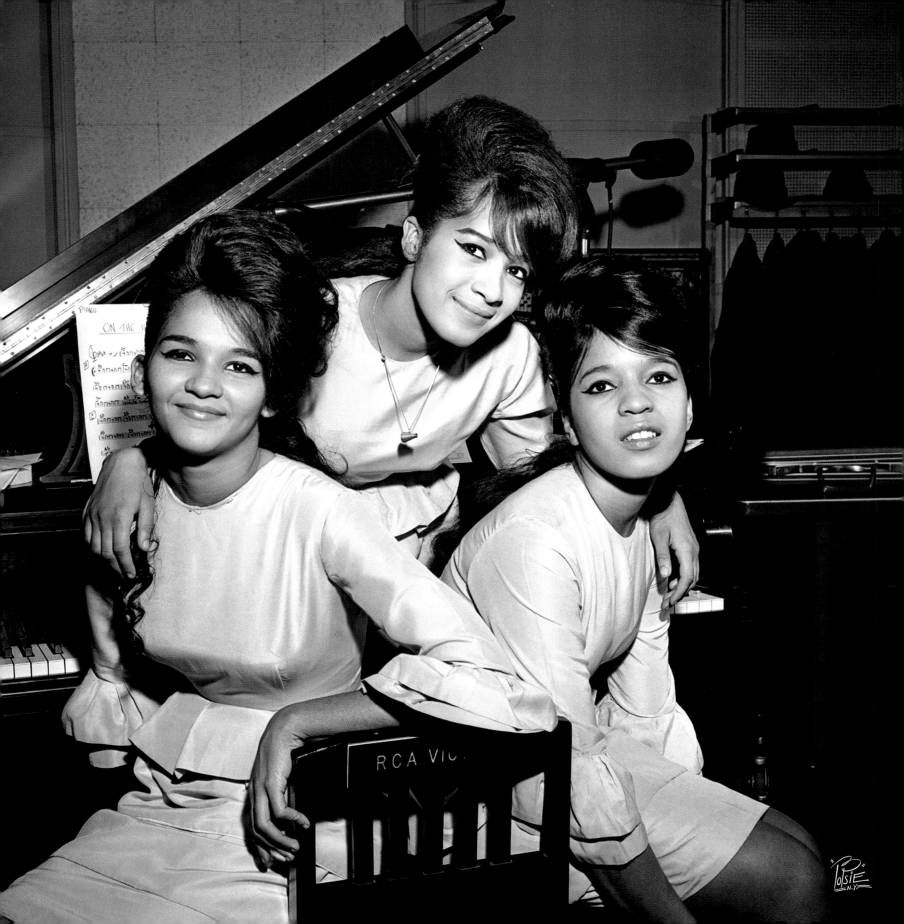

The Locomotion

Little Eva Boyd was another rags-to-riches story in the long history of American music. Her leftfield hit, "The Locomotion," was one of the biggest smashes of 1962. Don Kirshner asked his old friend PoPsie to provide the promotional image of the gang who made the hit possible. PoPsie had fun putting together the October 16, 1962 shoot and came up with a one-of-a-kind image for Aldon Music.
Left to right: **Don Kirshner, Al Nevins, Little Eva, Gerry Goffin, Carole King**.

PoPsie's old friend **Peggy Lee** shares a moment
backstage with **Jimmy Durante** in 1963.

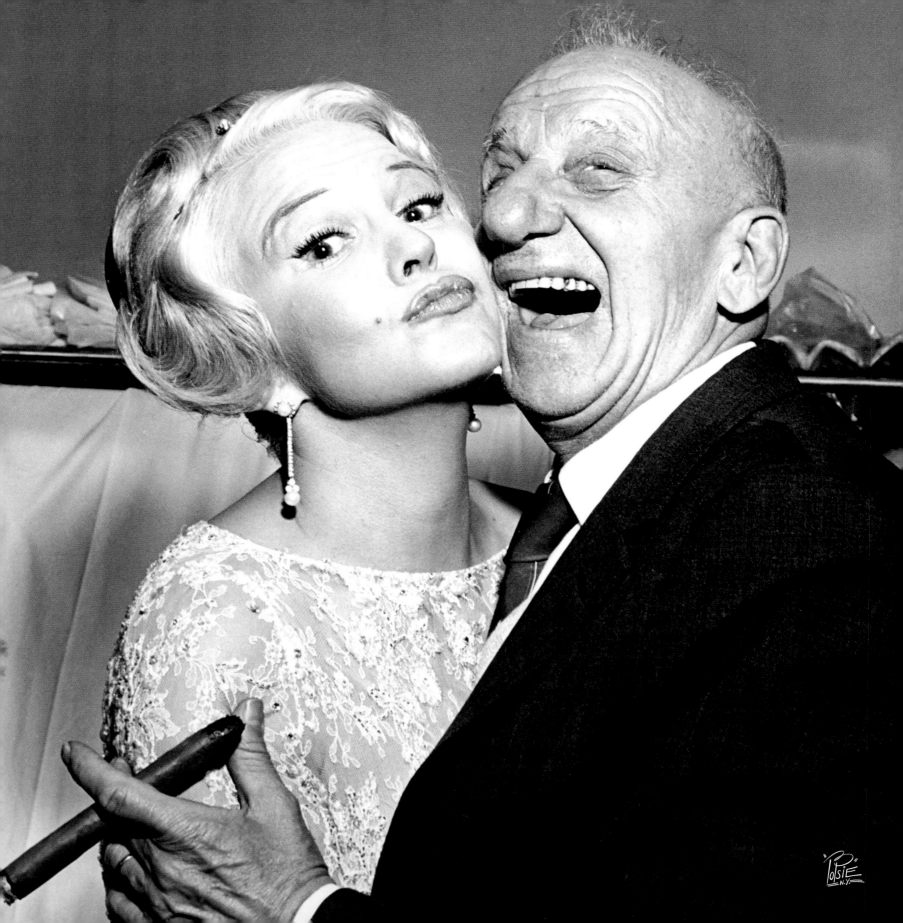

Funny Girl

Barbra Streisand looks on intensely while taking a break during
the cast recording of *Funny Girl,* April 5, 1964. This recording is
considered the breakthrough moment of her career. Her portrayal
of Fanny Brice garnered a Tony nomination for best actress and
later won an Academy Award.

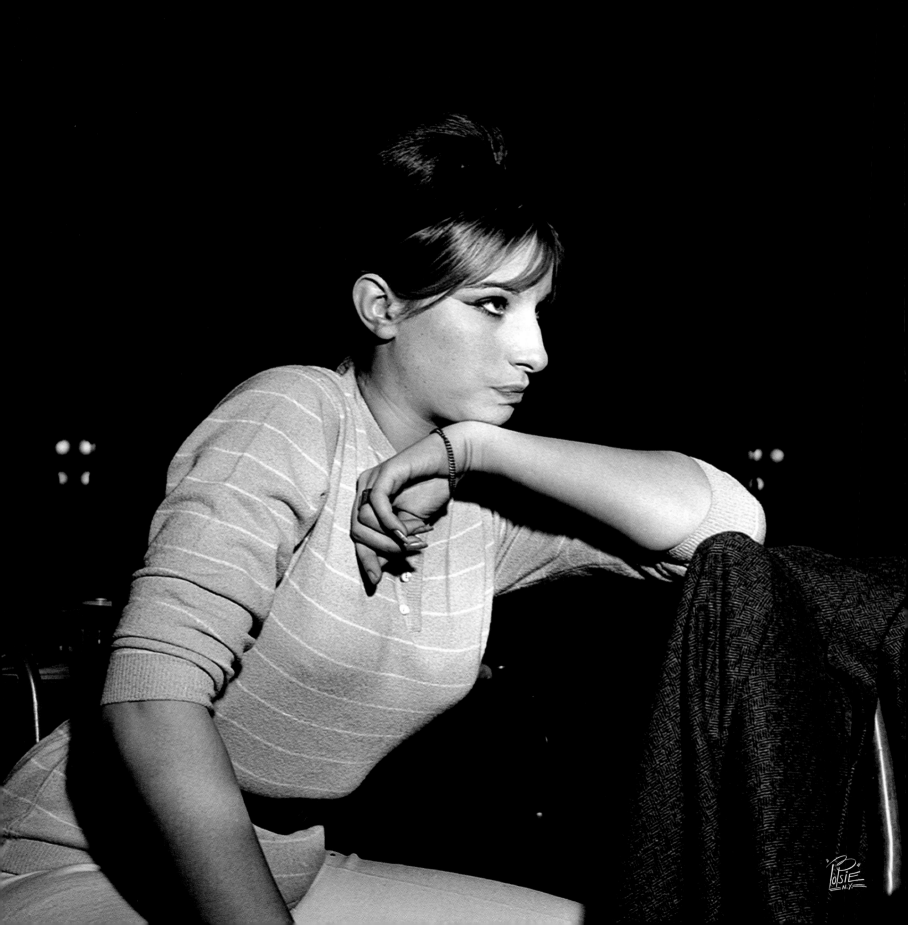

Motown Records came to PoPsie and asked to have
many of their acts photographed for use on
promotional material. This rarely seen portrait of
Marvin Gaye, taken on June 5, 1963, was the
product of one of two photo sessions of Marvin done
by PoPsie. The other was with Gaye's wife Hazel
Gordy, the sister of Motown boss Berry Gordy.

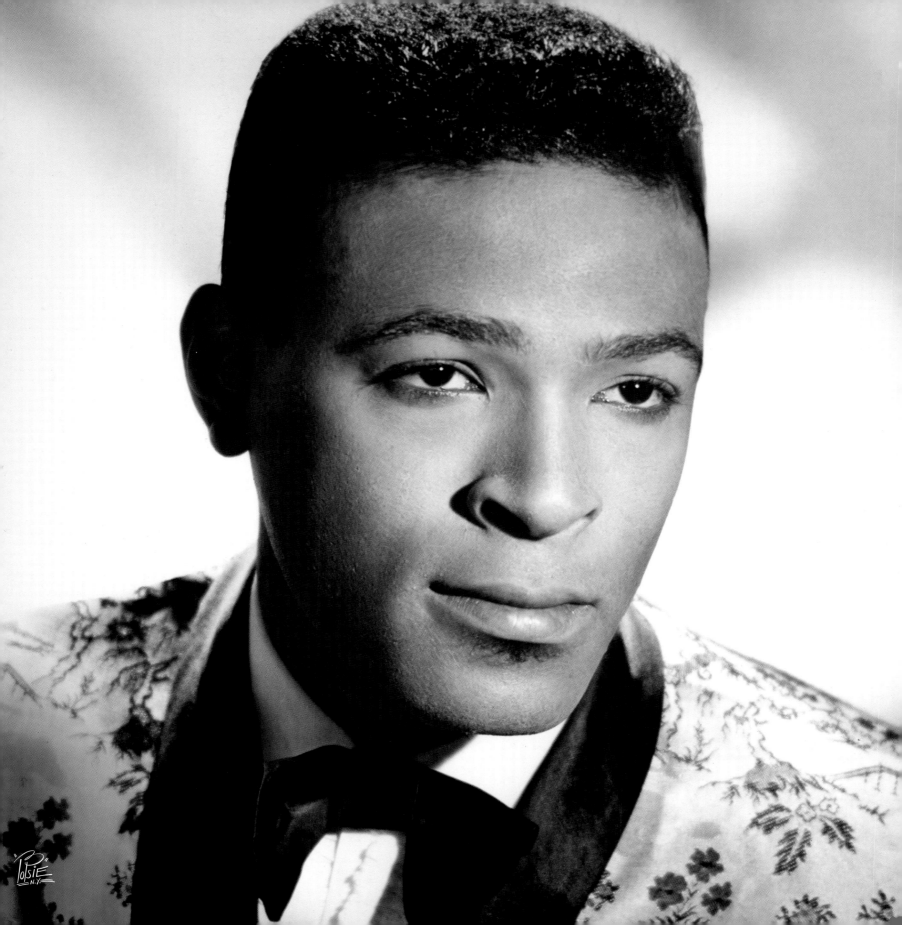

When she was signed to Columbia Records, **Aretha Franklin** came to PoPsie for a few portraits to help her career along. This one dates from June 7, 1963. The portraits couldn't offset the poor material the label presented her. She met PoPsie again in 1967, when she signed with Atlantic Records. This time, she left her mark on the recording industry.

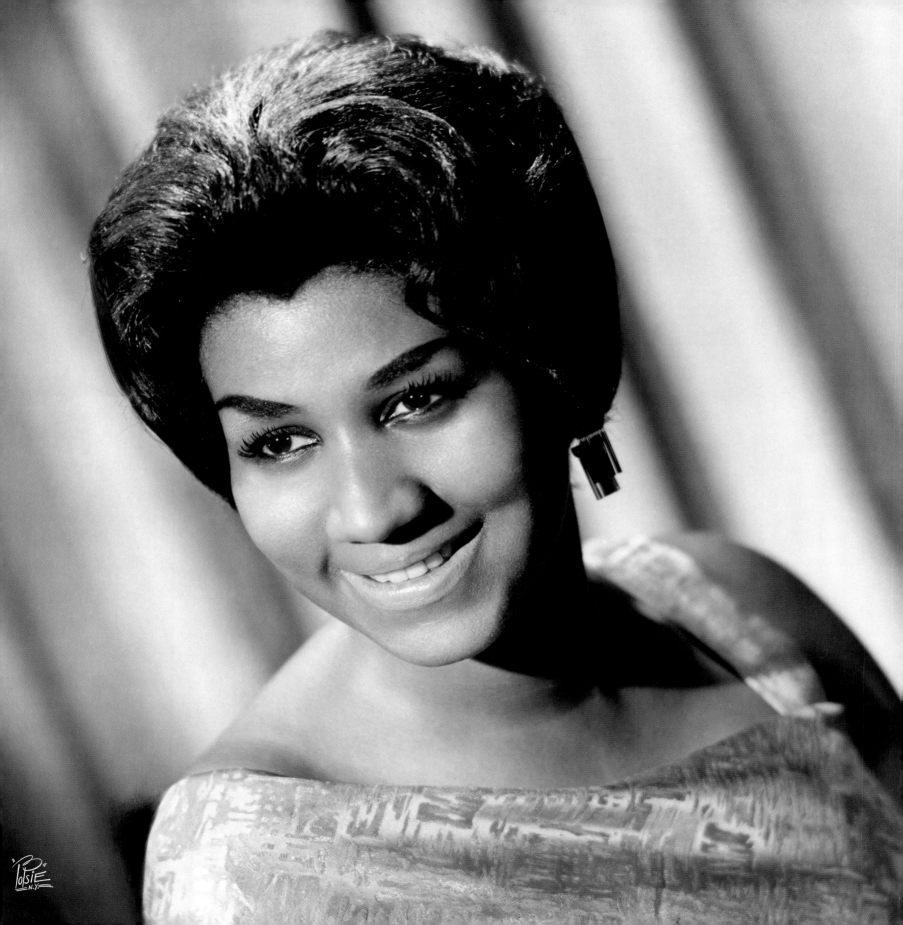

PoPsie photographed **Jan & Dean** (Jan Berry and Dean Torrence) as they performed on one of Murray "The K" Kaufman's shows at the Brooklyn Fox, 1963.

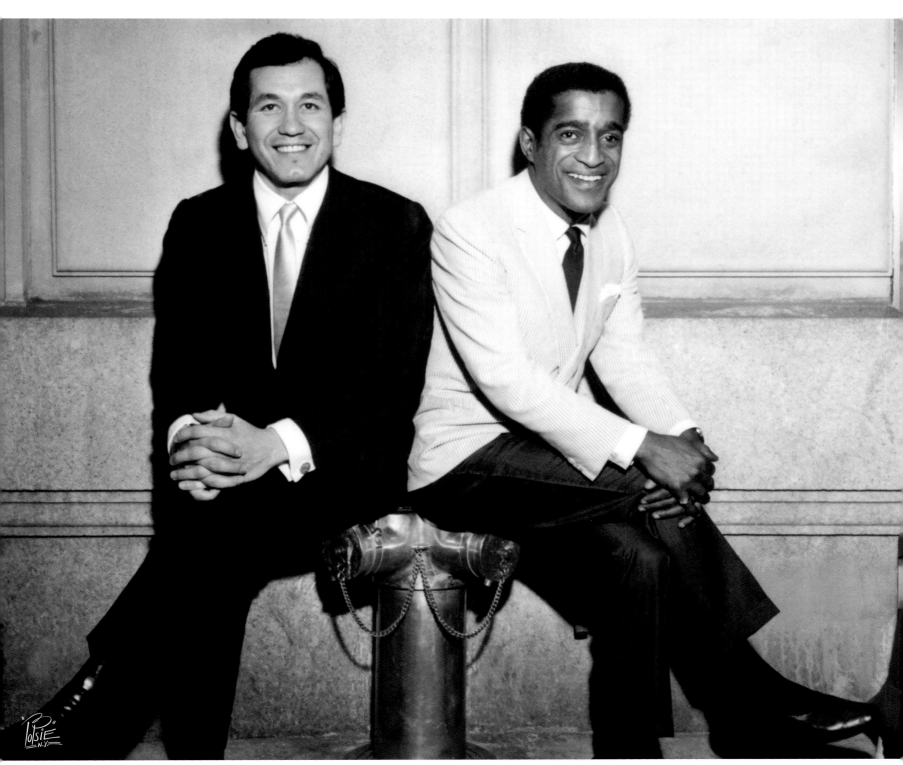

We have another PoPsie pairing with **Trini Lopez** (left) and **Sammy Davis, Jr.** conveniently utilizing a fire hydrant as a stool, May 27, 1964.

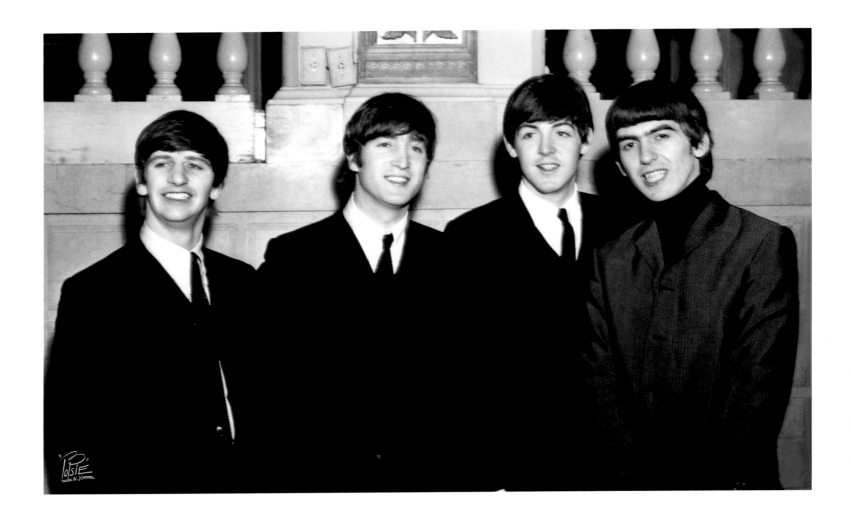

Just as Elvis had done almost a decade before, the **Beatles** had PoPsie take the photographs that would legitimize their ascension to the throne as the kings of rock 'n' roll. Above, the Beatles survey the many events taking place during the Capitol Records party at the Plaza Hotel on the evening of February 10, 1964. Left to right: **Ringo Starr**, **John Lennon**, **Paul McCartney**, **George Harrison**.

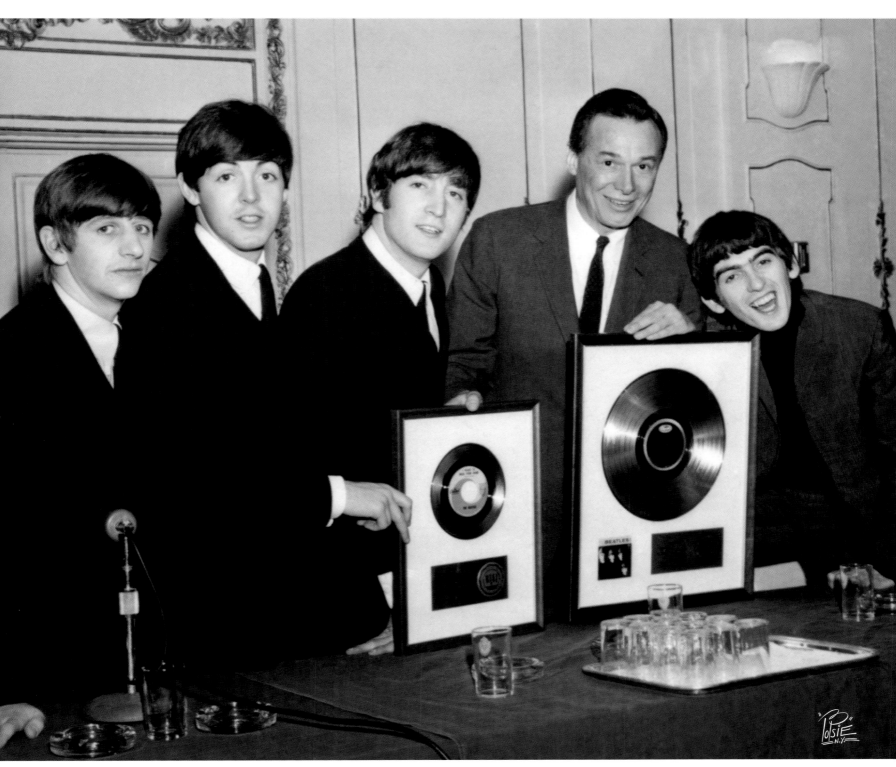

Capitol Records president **Alan Livingston** and the **Beatles** celebrate their success in America with the simultaneous presentation of both a gold single (for "I Want to Hold Your Hand") and a gold LP (for *Meet the Beatles*). At the time, February 10, 1964, such a feat was virtually unheard of.

first U.S. tour

The **Rolling Stones** made their first U.S. tour in 1964. When they arrived in the States on June 1, they were greeted at JFK Airport by hundreds of screaming fans. PoPsie photographed them at that time, but the session lacked something. The next day, he invited them down to Broadway and snapped this photo in front of his studio. Left to right: **Mick Jagger**, **Keith Richards**, **Brian Jones**, **Charlie Watts**, **Bill Wyman**.

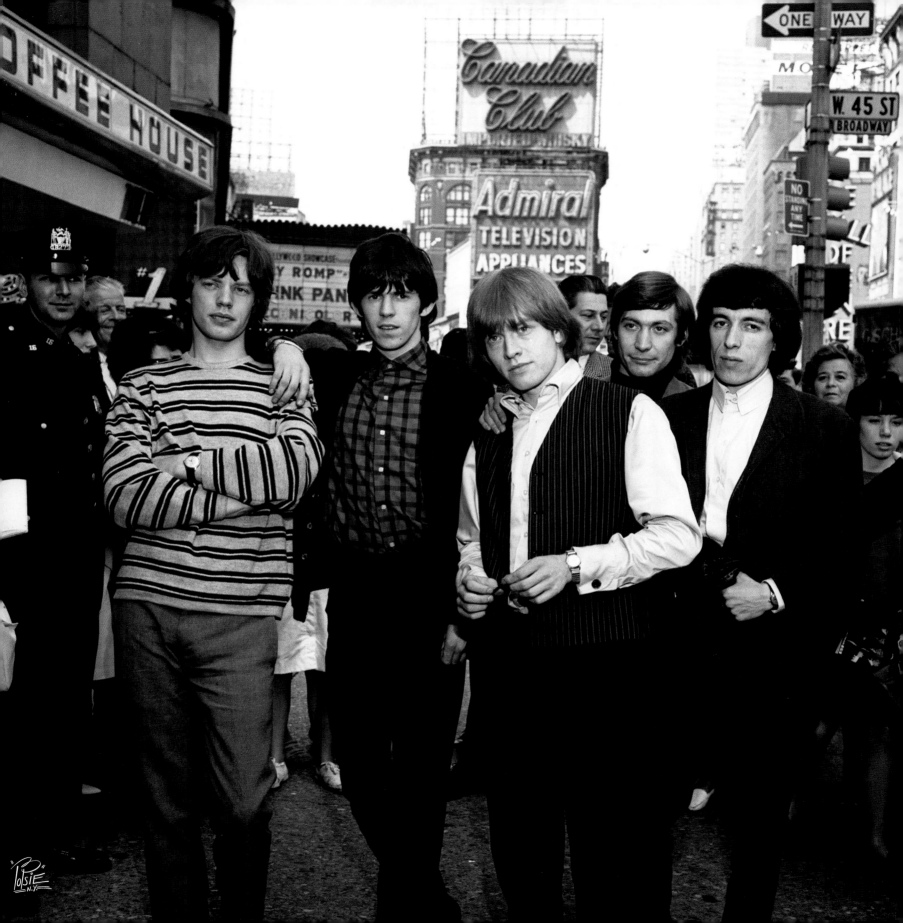

The Unsinkable Molly Brown, aka **Debbie Reynolds**, makes a promotional appearance in New York City, July 15, 1964.

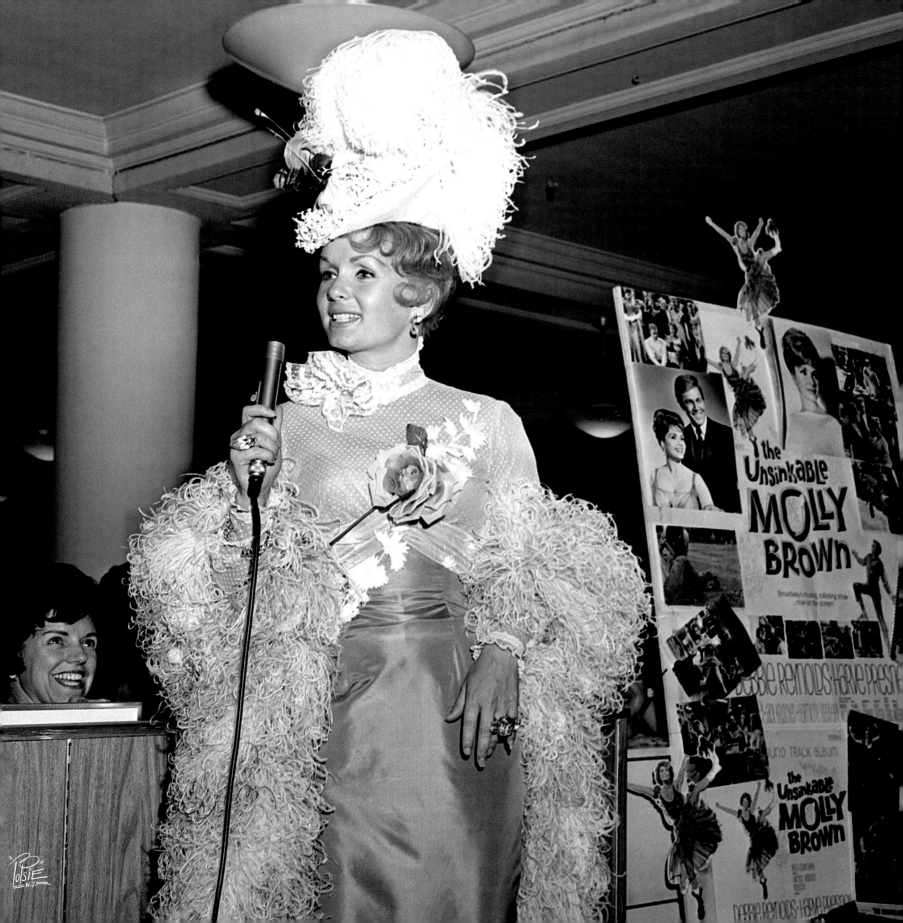

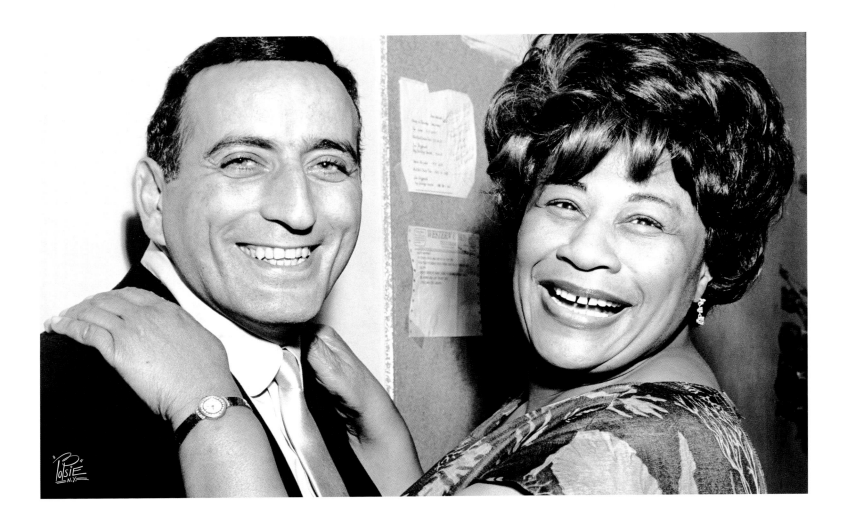

Tony Bennett and **Ella Fitzgerald** provide another
opportunity for a PoPsie pairing, backstage during
one of Bennett's shows, May 14, 1964.

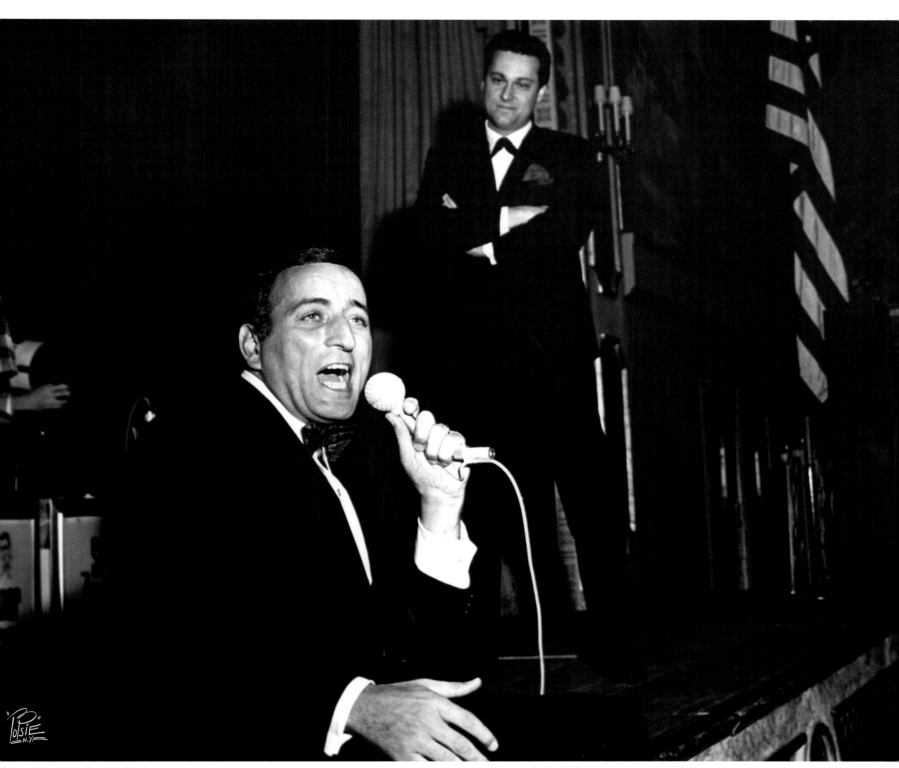

PoPsie photographed the first 15 GRAMMY Awards® programs in New York City for the National Academy of Recording Arts & Sciences®, capturing thousands of moments for all of the trade magazines. In this shot, taken at the 1964 GRAMMY Awards® dinner, **Jack Jones** (right) seems impressed with **Tony Bennett's** unique vocal stylings.

Dusty Springfield takes a break and smiles for PoPsie during a session for Philips Records. She was recording "I Wanna Make You Happy," September 29, 1964.

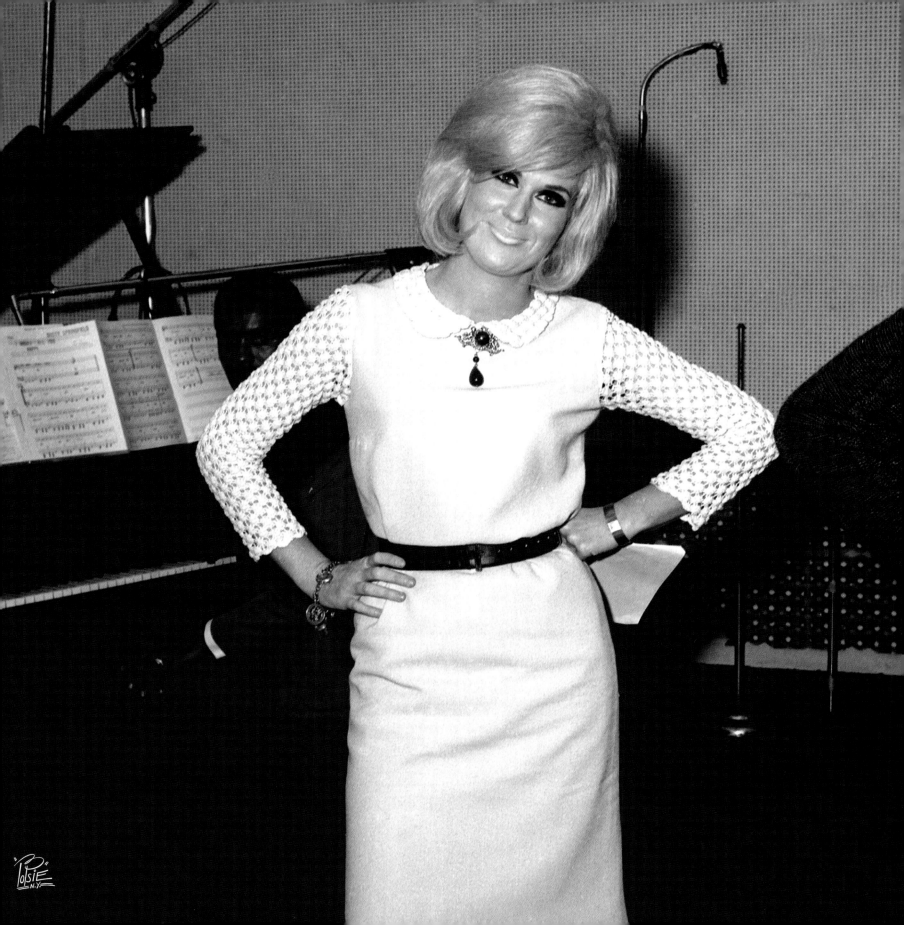

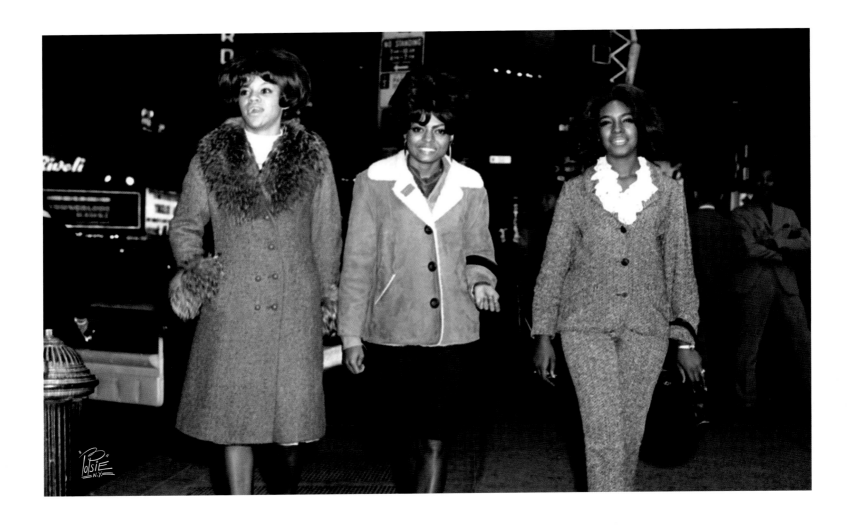

On November 13, 1964, the **Supremes** paid a visit to Times Square to see how their latest release was doing. They took a stroll with PoPsie on Broadway, and he snapped a few shots on their way to a local record store.

Once there, the Supremes—**Florence Ballard, Mary Wilson, Diana Ross**—are happy to find their records in stock. The album that Diana is holding is currently worth hundreds of dollars because the original cover was changed in early 1965.

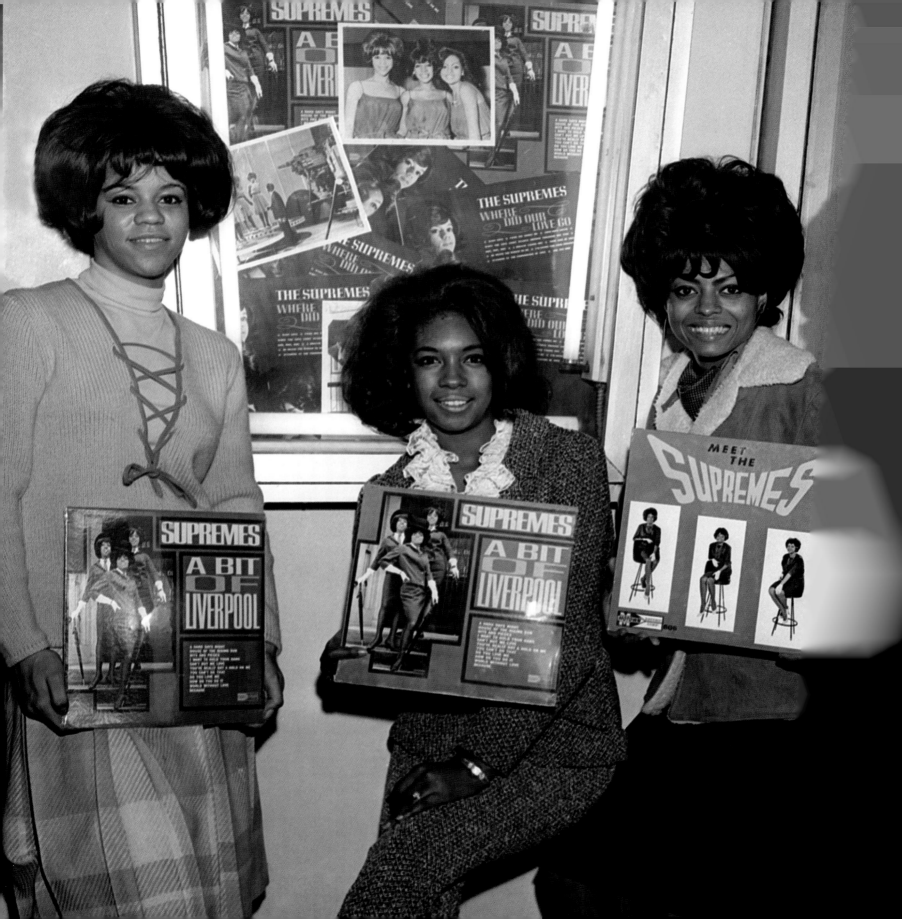

the British Invasion

1965 proved to be very lucrative year for British acts making their way across the ocean. PoPsie photographed the **Animals** on January 19, while they were in New York as part of their U.S. tour.

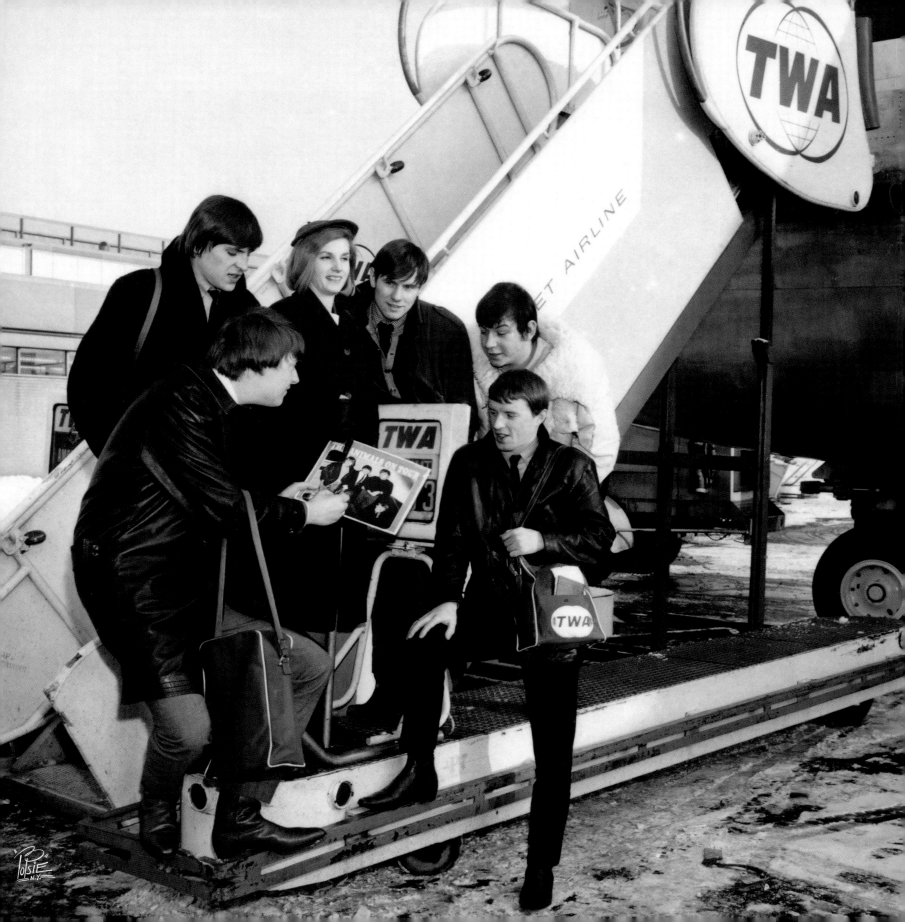

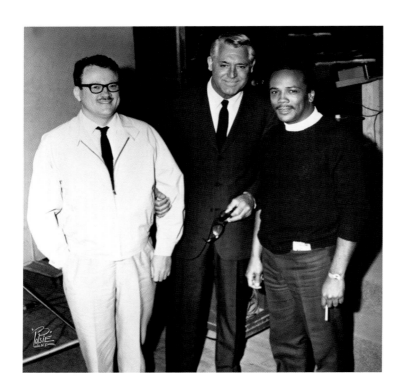

Above left: **Jean "Toots" Thielemans**, **Cary Grant**, and **Quincy Jones** take a break from recording tracks for the movie *Walk, Don't Run* (1966). The film was the last in Cary's long career, so he wanted Quincy and Toots to make sure he went out on the right note.

Above right: **Astrud Gilberto** adds her sultry vocals to a performance by **Gary Burton** and **Stan Getz** (right), August 19, 1964.

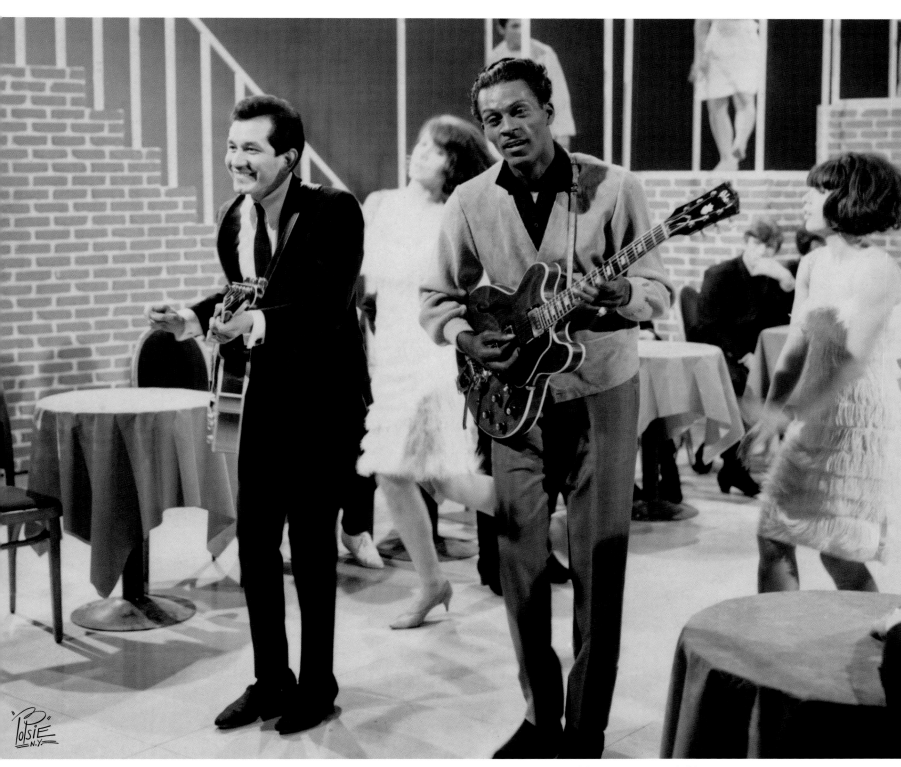

NBC had PoPsie photograph some of the rehearsals for the *Hullabaloo* television program. In May 1965, **Trini Lopez** (left) and **Chuck Berry** paid a visit to the show, and PoPsie photographed them working on "Memphis."

I Got You Babe

Atlantic Records had PoPsie commemorate
Sonny & Cher's first gold record, "I Got You Babe,"
for *Cashbox* magazine on August 17, 1965.

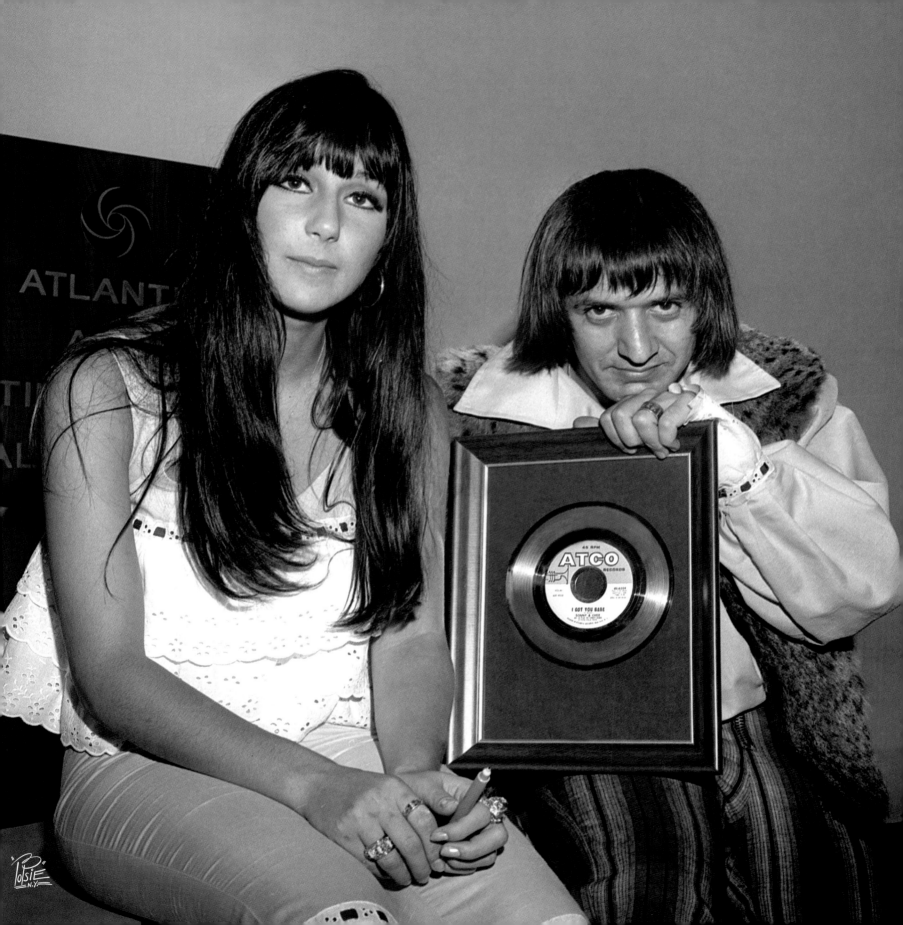

The **Young Rascals** were the hottest act
in New York. PoPsie caught up with them
at the Phone Booth on October 14, 1965.
Soon after this appearance, they were
signed to Atlantic Records.

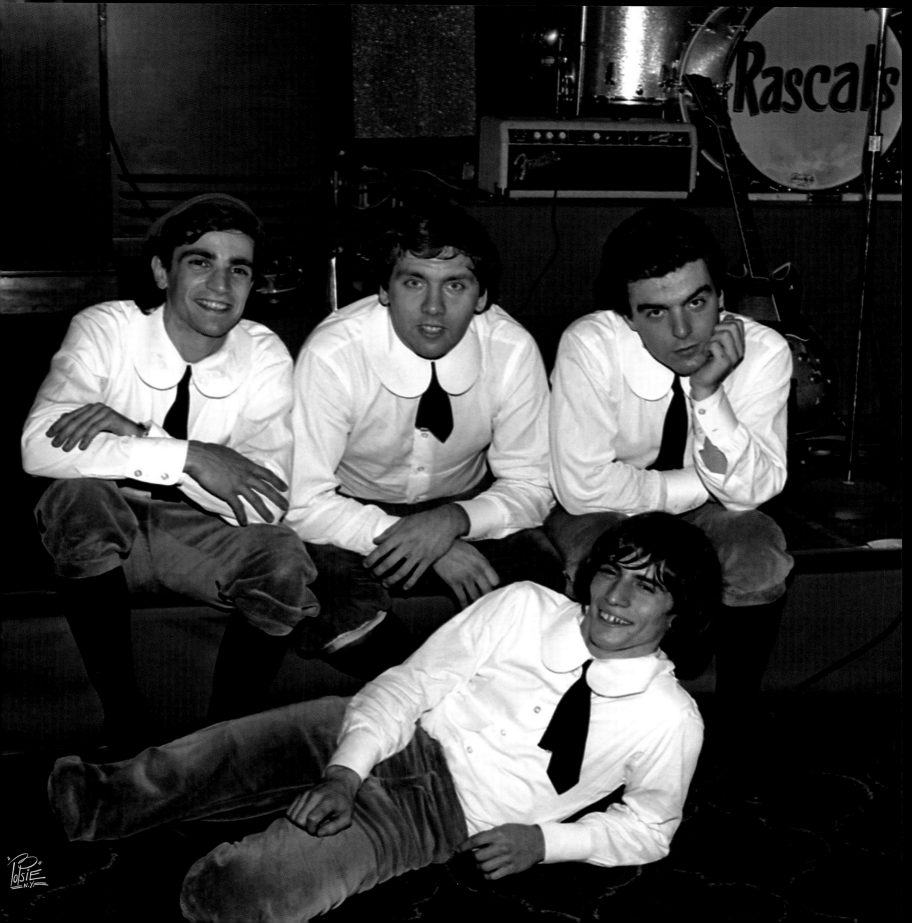

Take Five

PoPsie still found time to catch up with
some of the bigger names in jazz when they
visited New York. In 1965, **Dave Brubeck**
was still hot with his quartet.

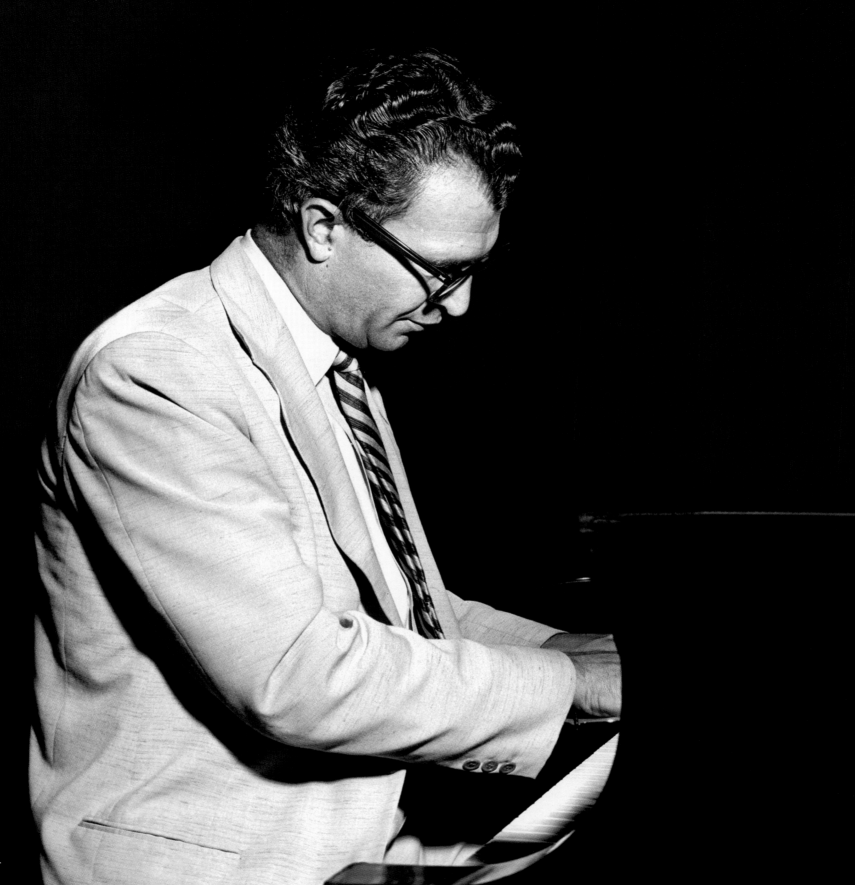

Erroll Garner entertains the crowd
with his unique style at the St. Moritz
Hotel, New York, November 3, 1965.

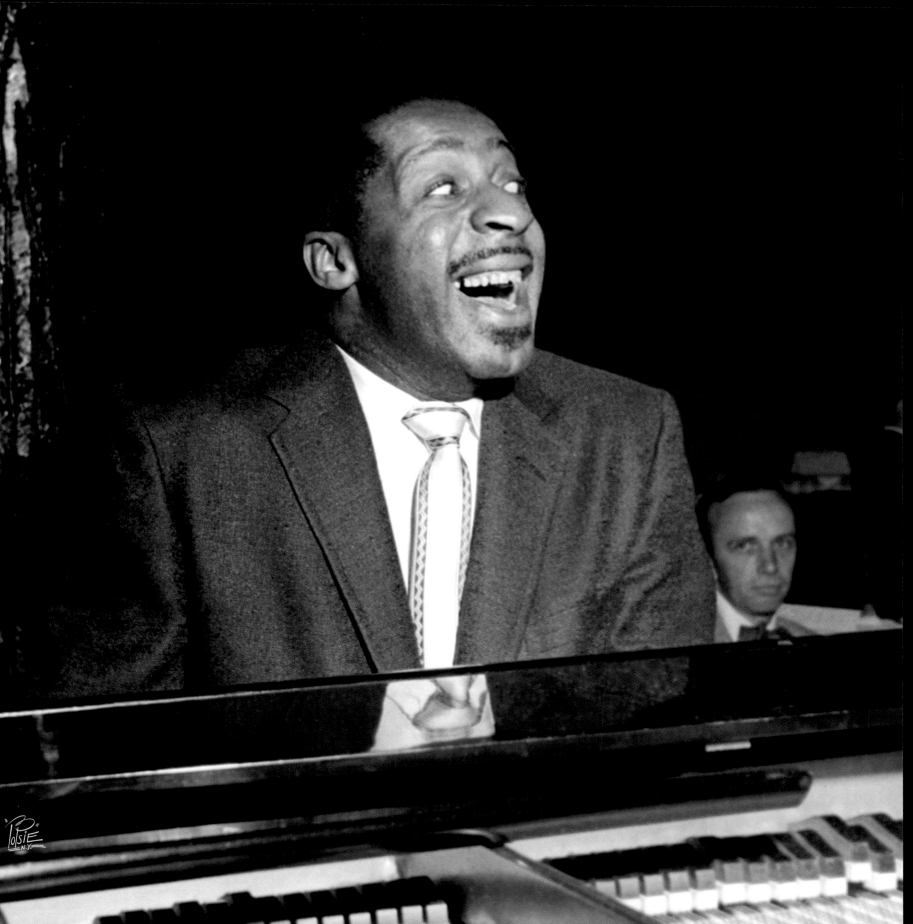

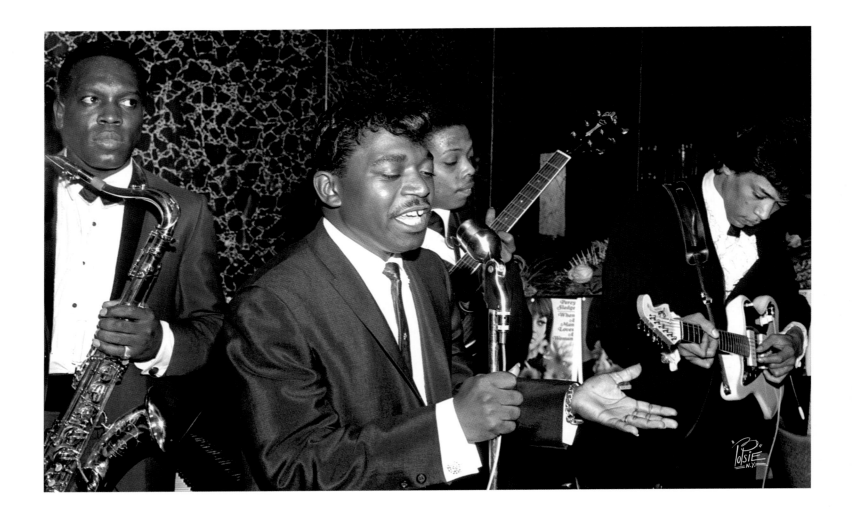

Sometimes history played out in the background of PoPsie's photo shoots. On May 5, 1966 PoPsie was asked to photograph a record release party for Percy Sledge, a new act signed to Atlantic Records. The show at the Prelude Club that evening featured Sledge, Esther Phillips, Wilson Pickett, and the King Curtis band, which featured a guitarist who played the instrument with a different approach—upside down. About a year later, Jimi Hendrix set the world on fire with his bombastic performances.

Above: The headliner, **Percy Sledge**, performing his timeless classic, "When a Man Loves a Woman." The cover of the album can be seen far right, between **Cornell Dupree** and **Jimi Hendrix**. **King Curtis** is on the far left.

Opposite page: **Wilson Pickett** is supported by **Jimi Hendrix**.

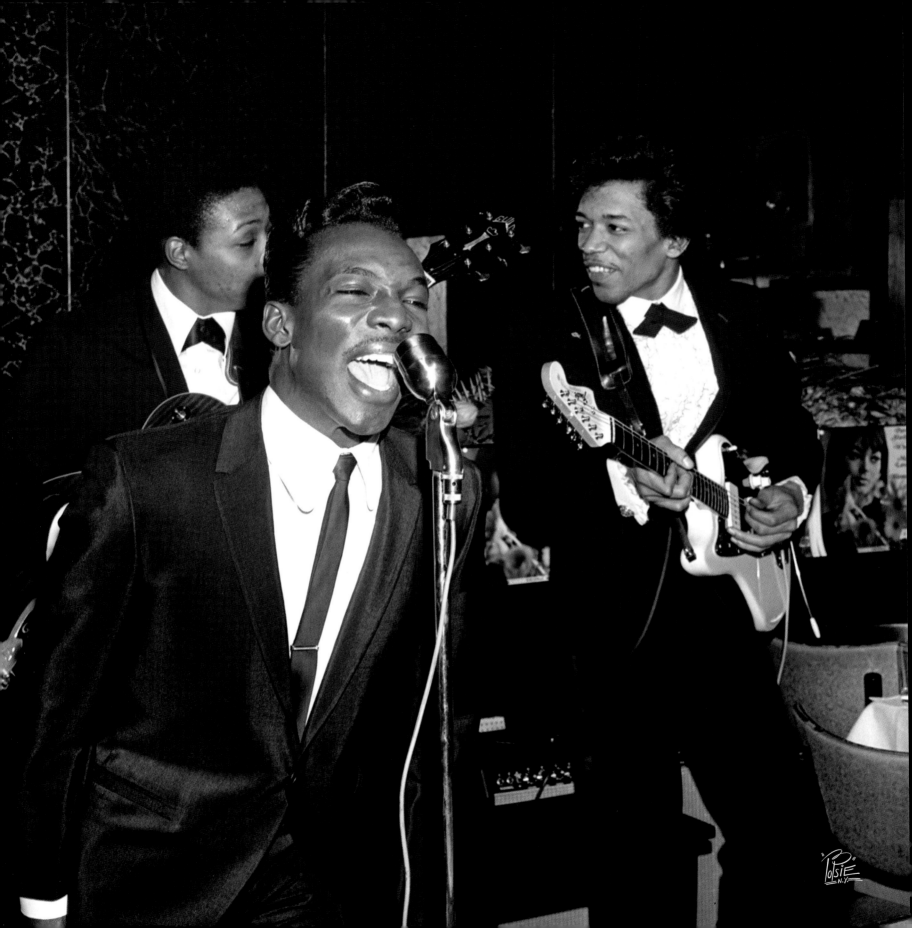

No retrospective of the decade can be
complete without a photo of "Uncle"
Benny Goodman. This photo is from a
portrait session on April 22, 1966.

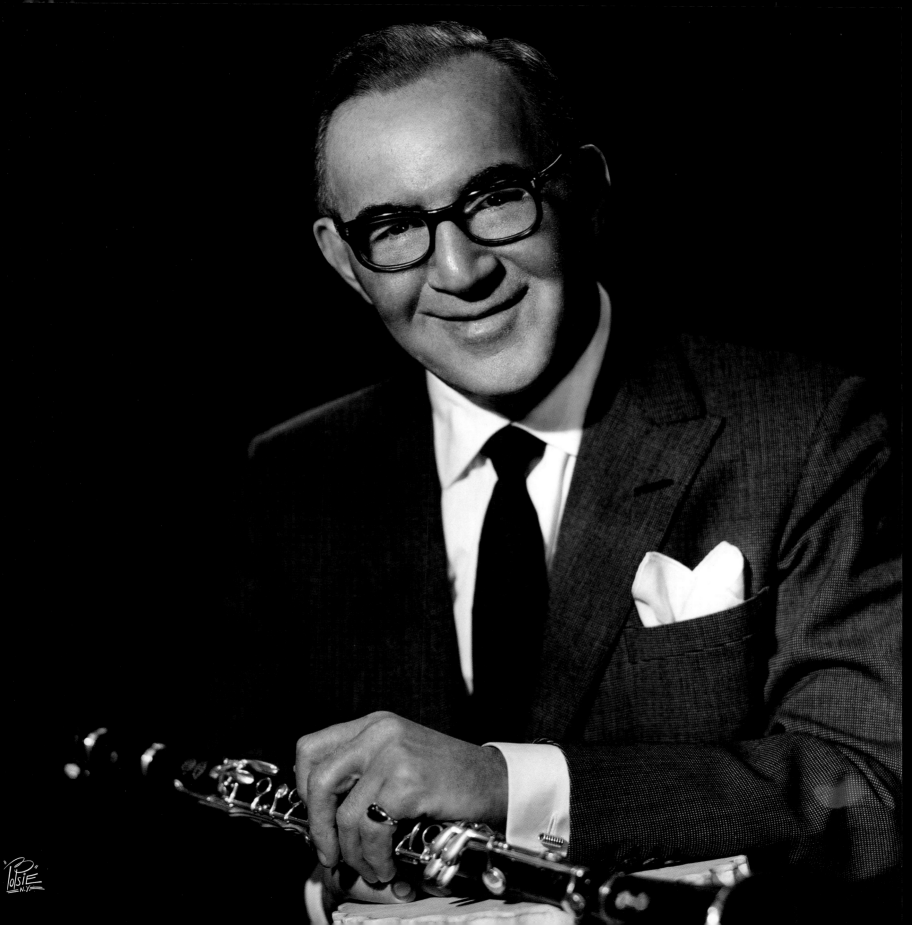

the Latin scene

PoPsie's photos were also used to promote the
fledgling Latin music scene. Tico Records often used
PoPsie to provide promotional photos like this shoot at
a local record store on October 11, 1966. Left to right:
**Celio Gonzalez, Tito Puente, La Lupe, Candido,
Ricardo Ray**.

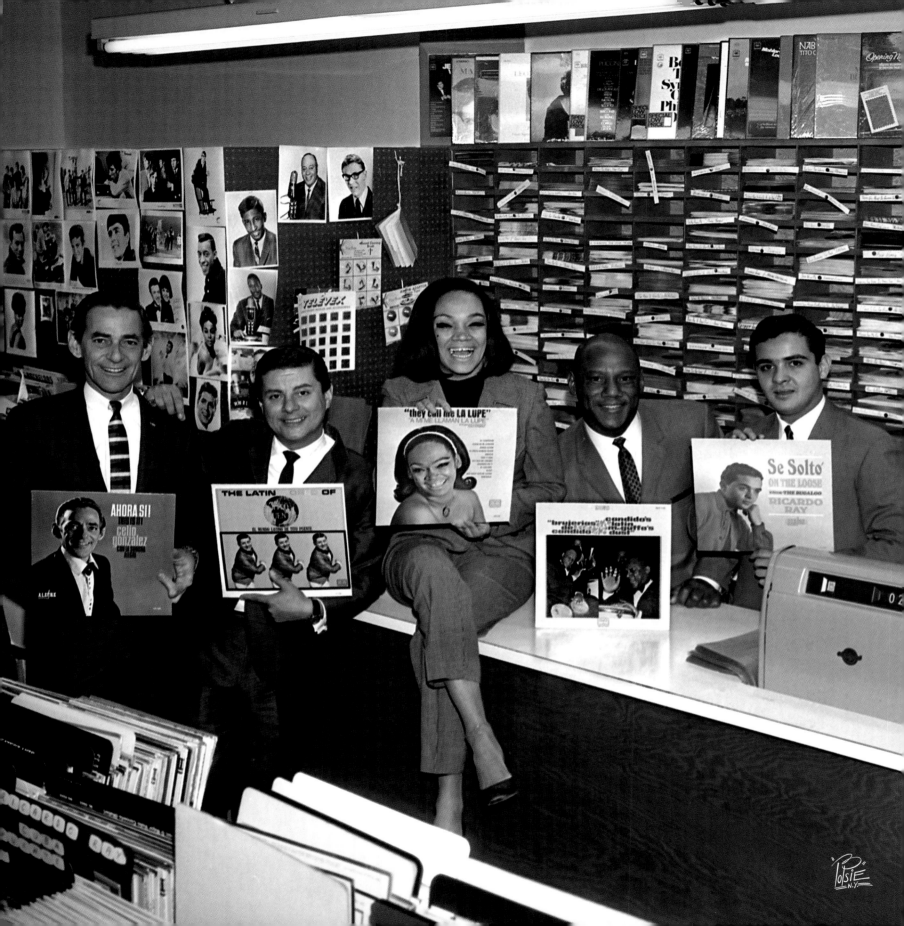

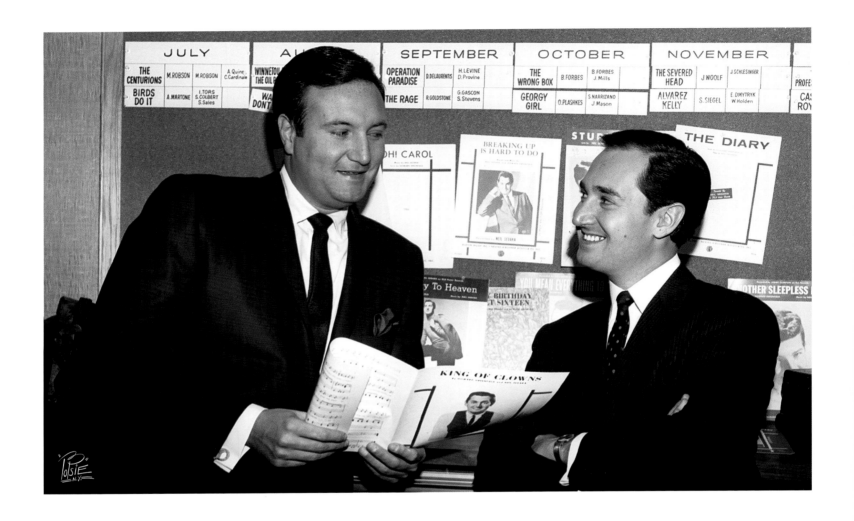

Don Kirshner (left) and **Neil Sedaka** review the sheet music
for Neil's "King of Clowns," April 1, 1966.

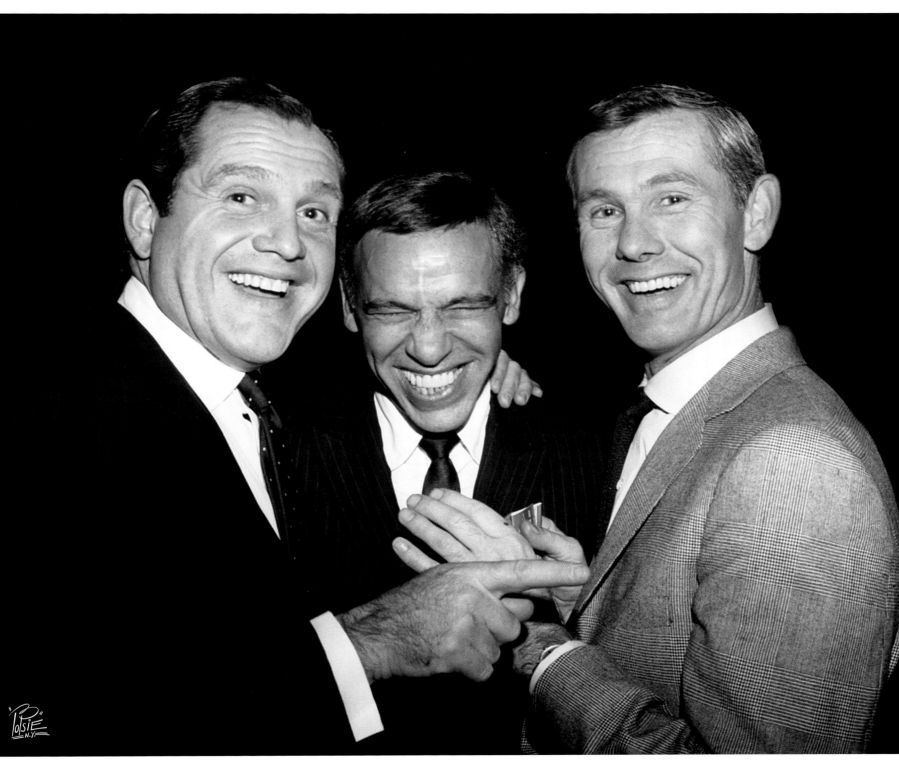

Here we have a PoPsie trio shot… Comedian **Alan King**, drummer **Buddy Rich** and the king of late night television, **Johnny Carson**, mug it up at New York City's Basin Street East, November 9, 1966.

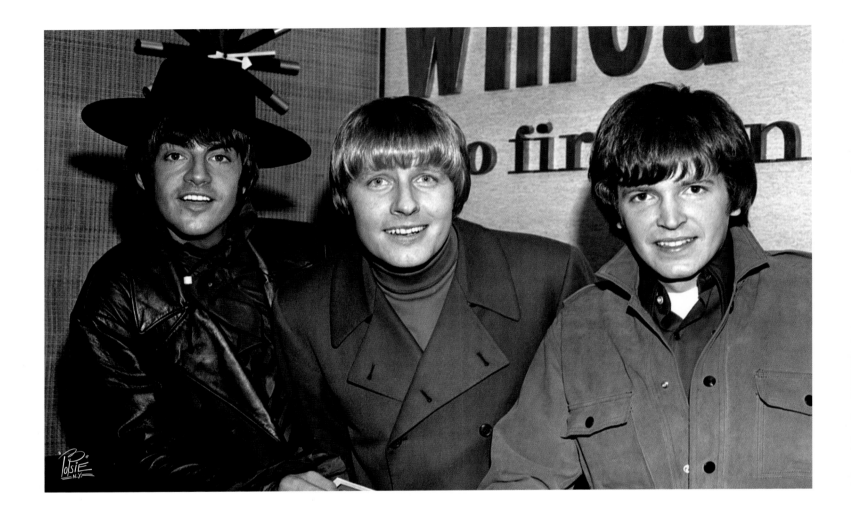

Paul Revere and the Raiders arrive at the studios of WMCA radio,
April 28, 1967. Jim Valley left the group shortly after this appearance.
Left to right: **Mark Lindsay**, **Paul Revere**, **Jim Valley**

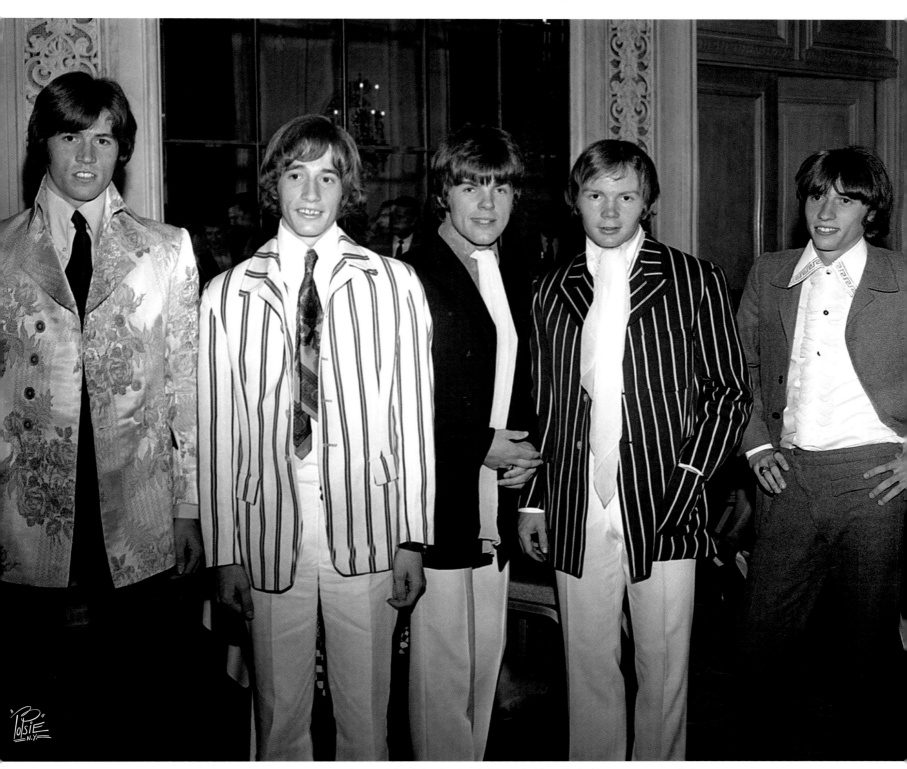

The British Invasion was still at full steam when the **Bee Gees** visited the St. Regis Hotel in New York City to promote their first album, July 5, 1967. Left to right: **Barry Gibb**, **Robin Gibb**, **Vince Melouney**, **Colin Peterson**, **Maurice Gibb**.

The Association makes a rare East Coast appearance to help promote *Billboard* magazine, February 24, 1967.

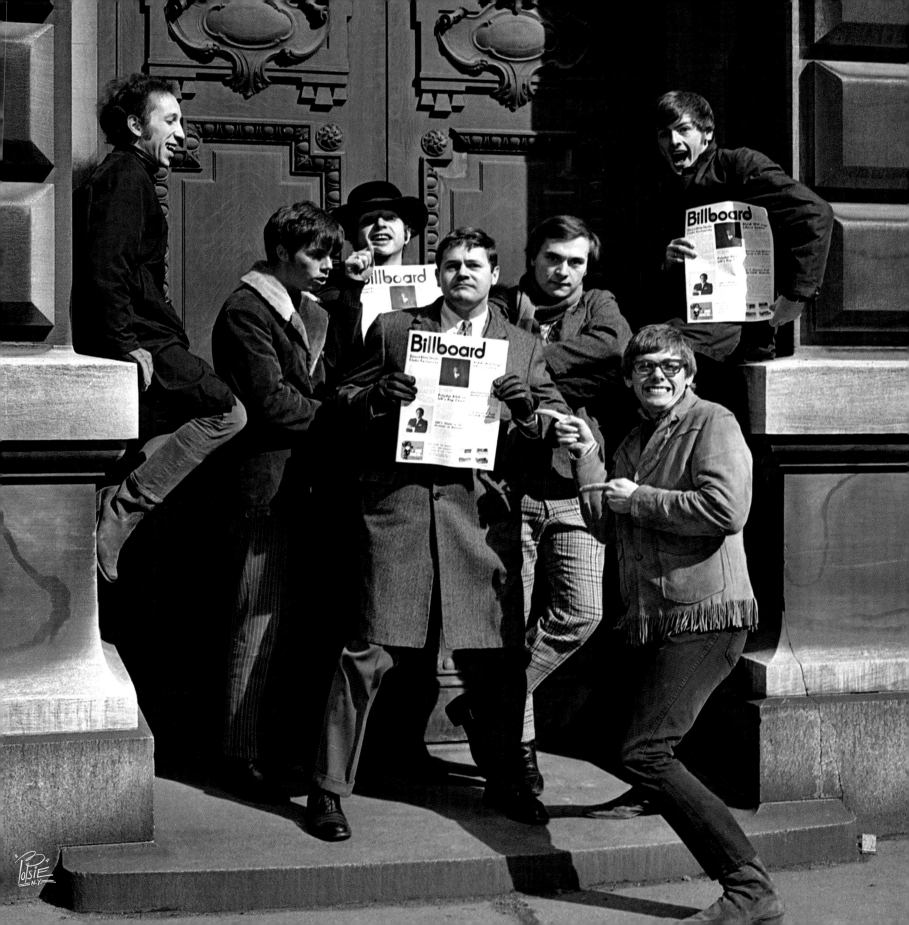

riding high on the charts

Van Morrison, who at the time was riding high on the charts with his release of "Brown-Eyed Girl," poses for PoPsie during a performance on August 2, 1967.

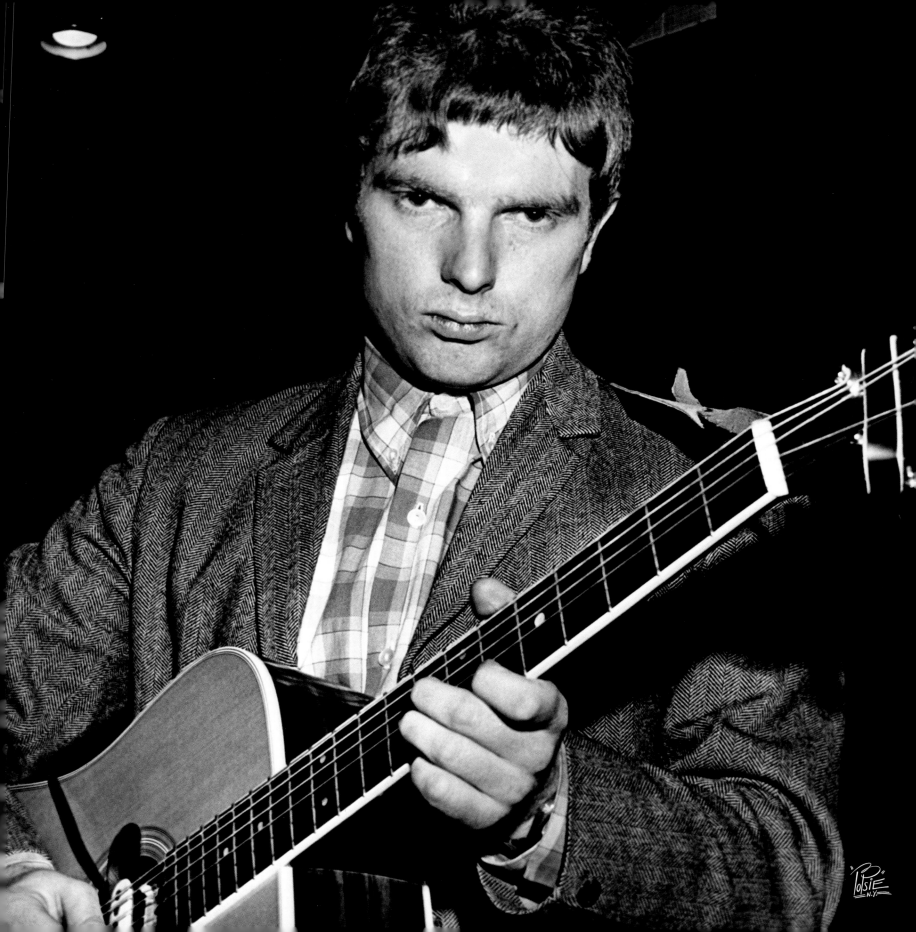

15 minutes of fame

Andy Warhol (left) and **Jackson Browne** converse at a party in 1967. If only PoPsie's camera could have recorded sound…

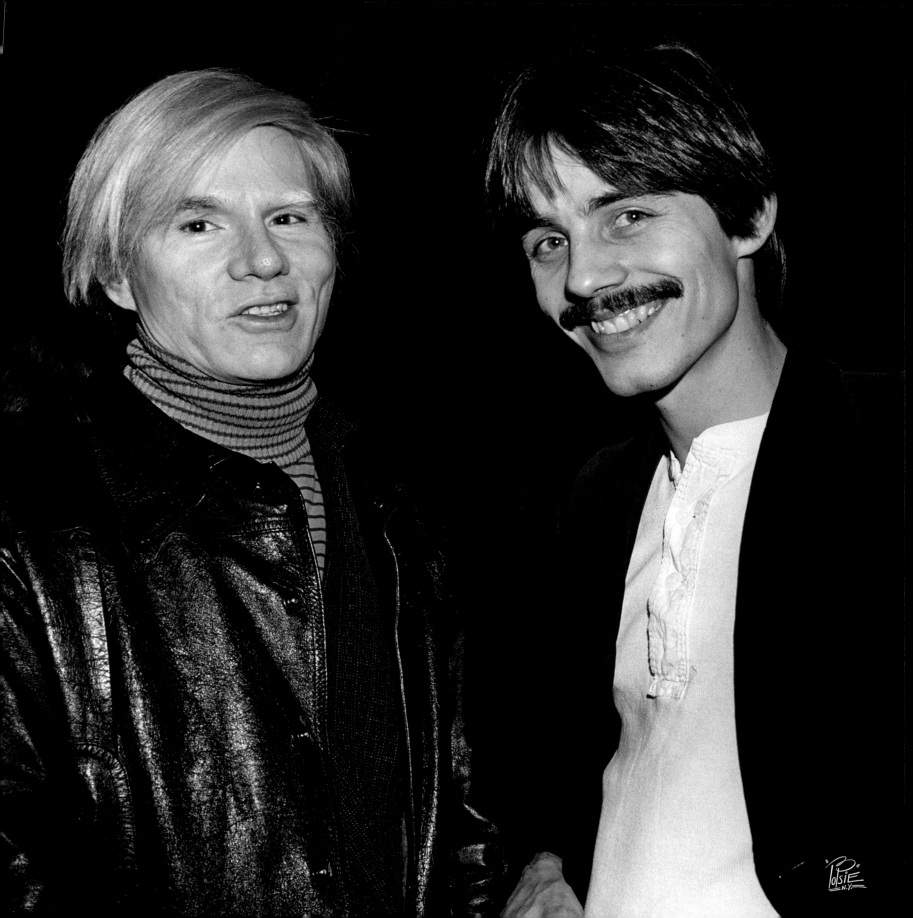

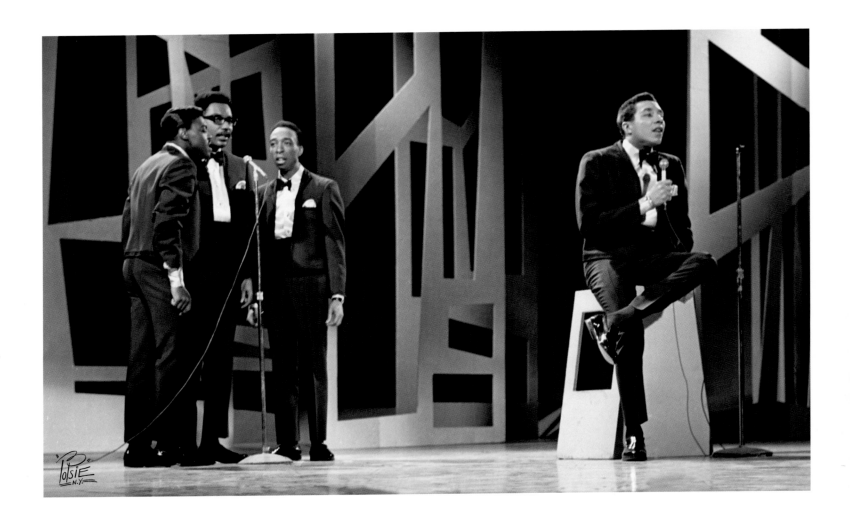

Smokey Robinson and the Miracles perform on *The Ed Sullivan Show* (above)
and pose backstage (opposite), March 31, 1968.

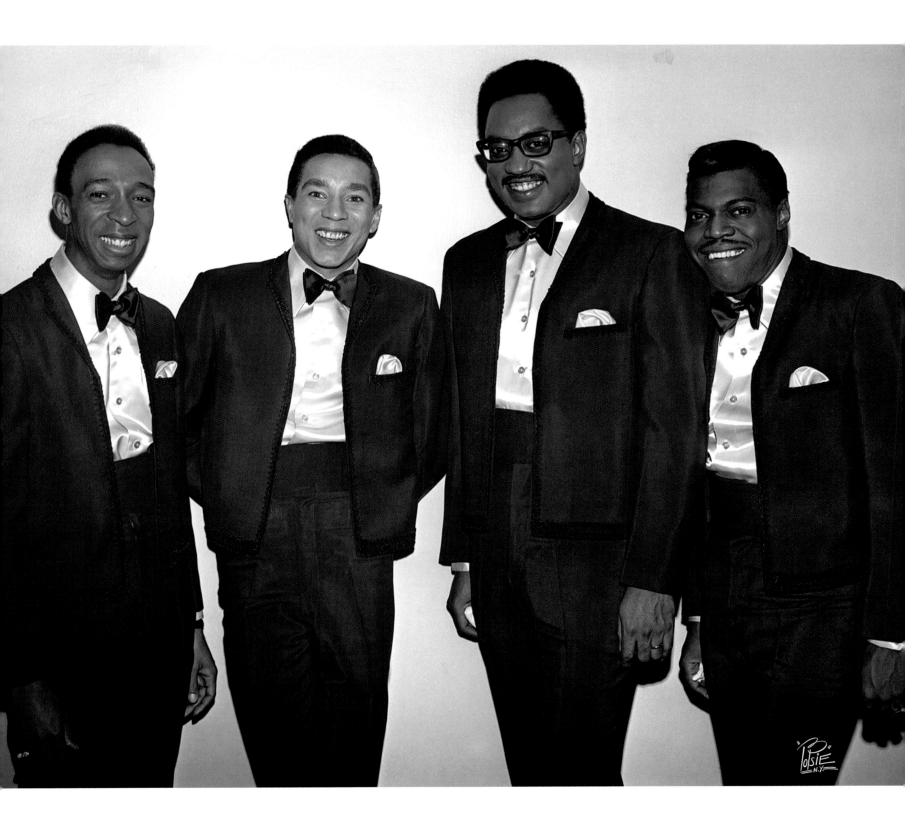

This is a pairing PoPsie could not take credit for. **Nancy Wilson** and **Cannonball Adderley** did an album together for Capitol Records and were in town to promote the new release, April 19, 1968.

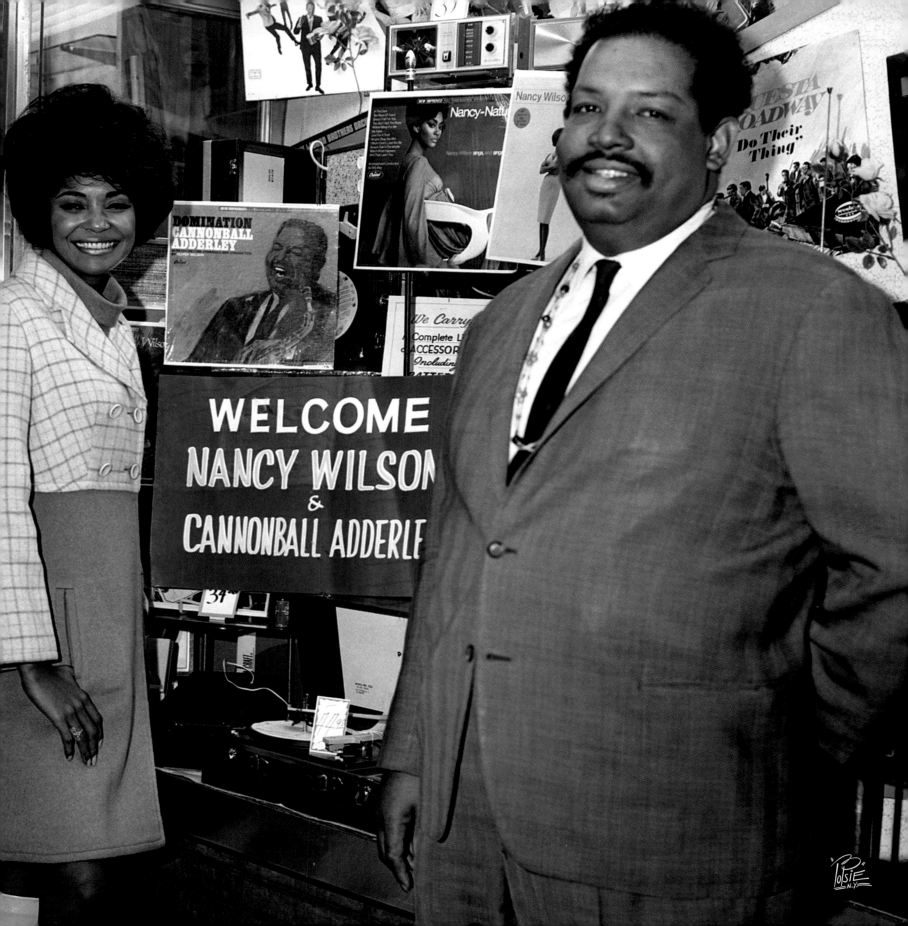

This portrait of **Freddie Hubbard** was taken in PoPsie's studio on August 6, 1968.

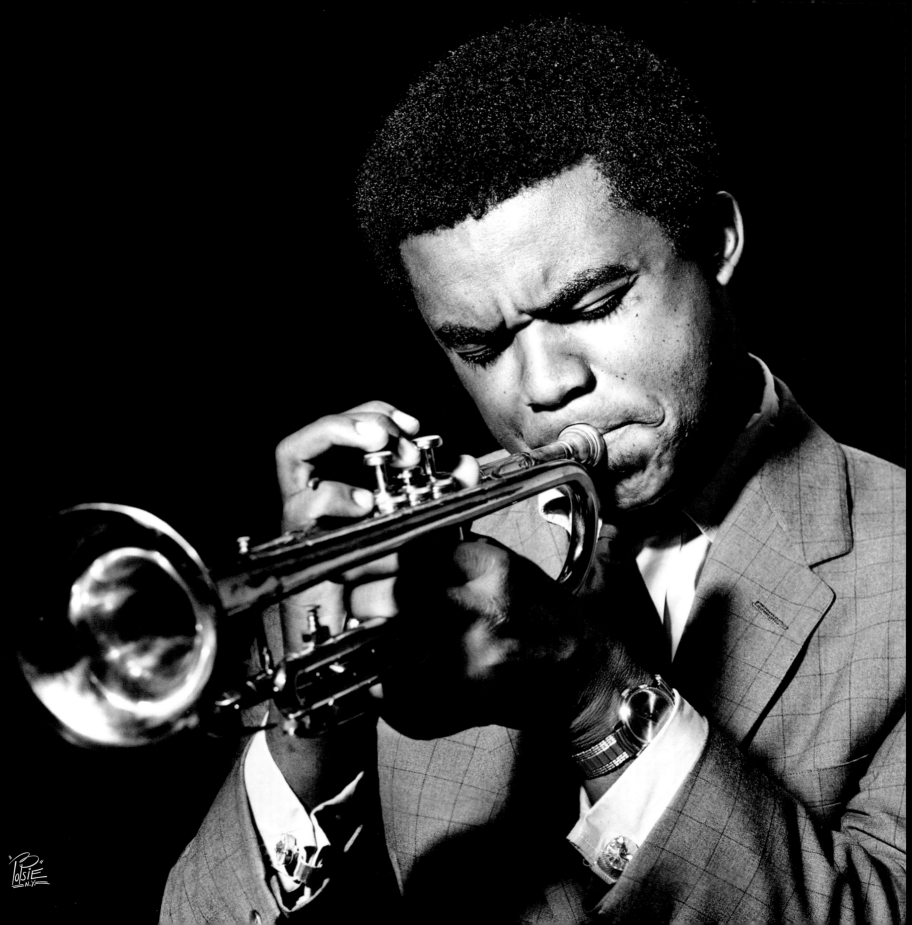

Oscar Peterson at A & R studios,
laying down tracks on April 1, 1969.

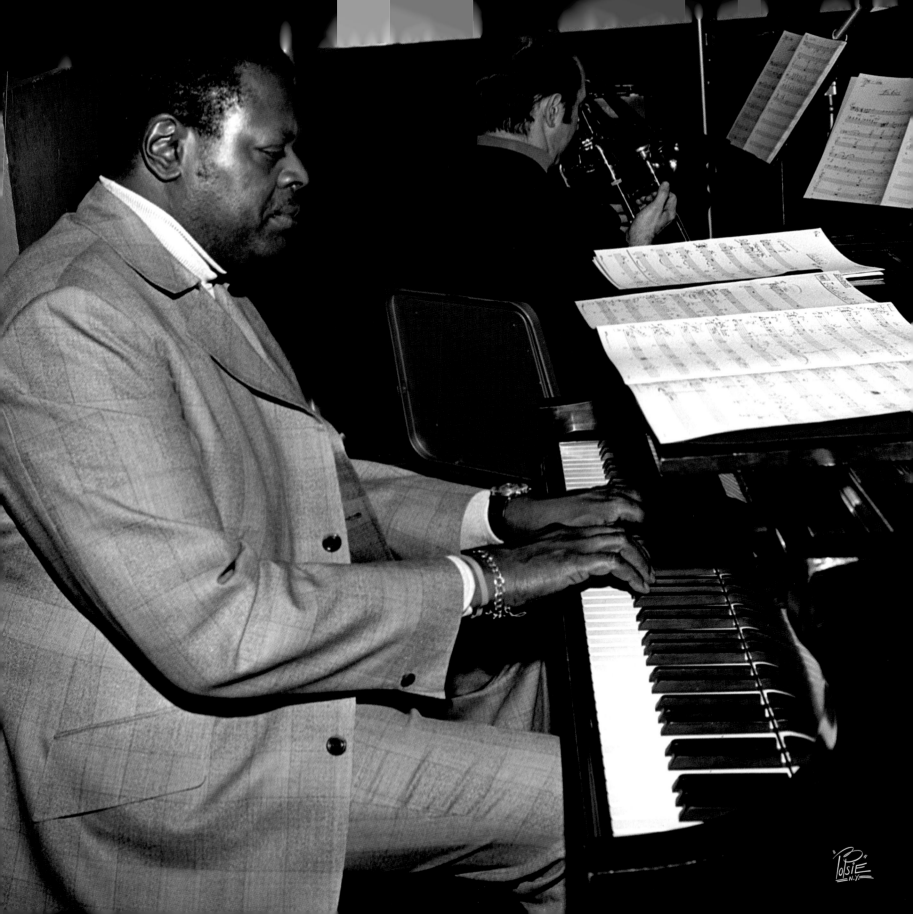

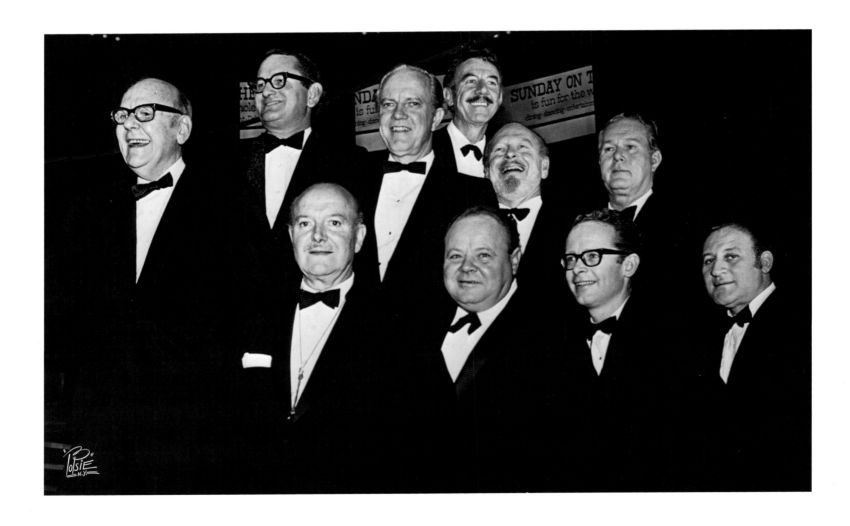

One of the few holdover big bands, **The Yank Lawson and Bob Haggard Band**
kept the sound of the era alive. Their appearance at the Riverboat was photographed
on November 17, 1968. Yank Lawson, Bobby Haggard, Bob Freeman, Bob Wilbur,
Ralph Sutton, Lou McGarrity, Carl Fontana, Billy Butterfield, Clancy Hayes, Maury Feld.

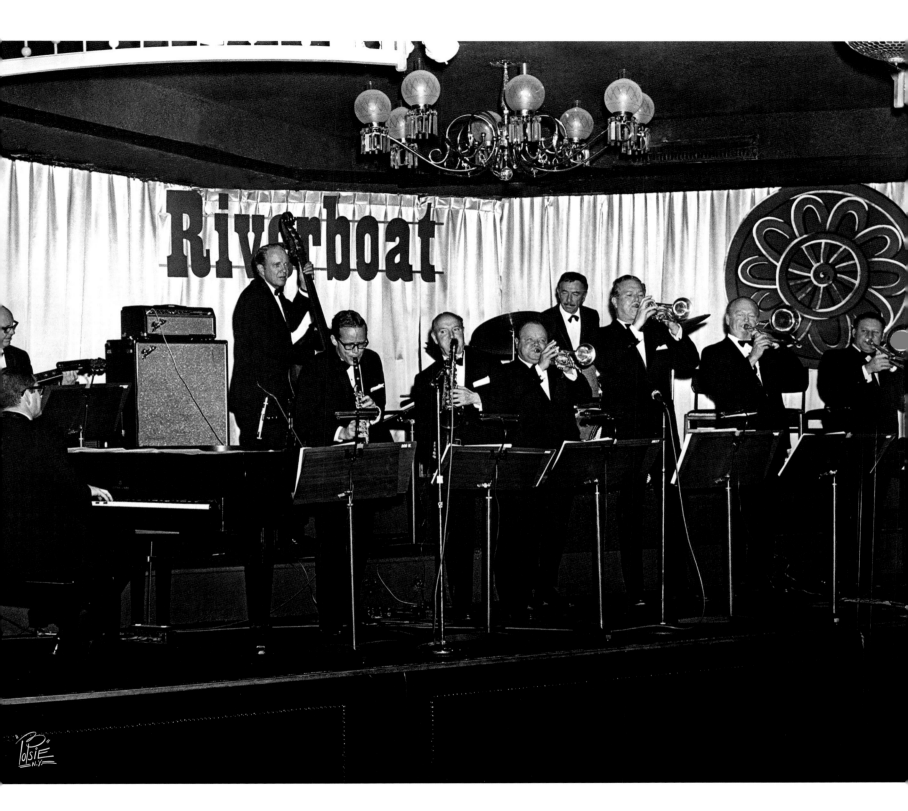

Ramblin' Gamblin' Man

Bob Seger showcases his propulsive new song, "Ramblin' Gamblin' Man," for Capitol Records executives at the Cheetah nightclub on January 8, 1969.

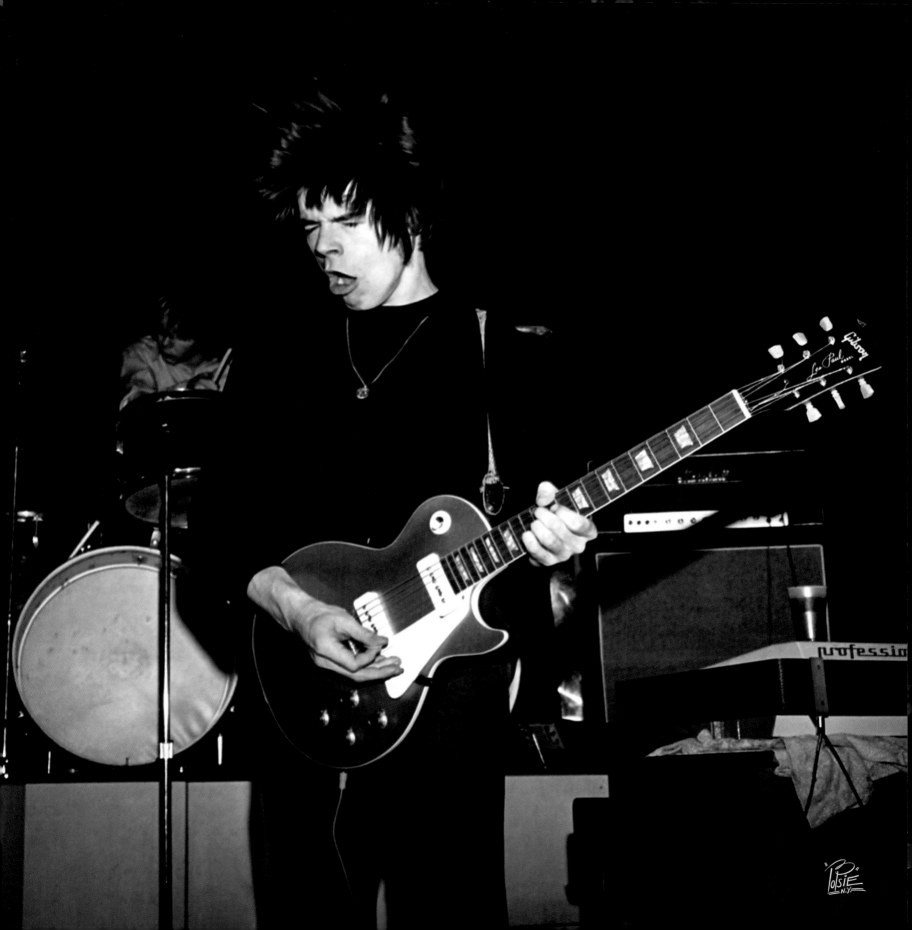

Lou Reed and the Velvet Underground recorded a
fourth MGM album that was never released. Two
songs from that project were recorded at The Plant
on May 6, 1969—"Coney Island Steeple Chase" and
"Foggy Notion." The songs were finally released on
two mid-Eighties collections of previously unreleased
tracks, *VU* and *Another View*.

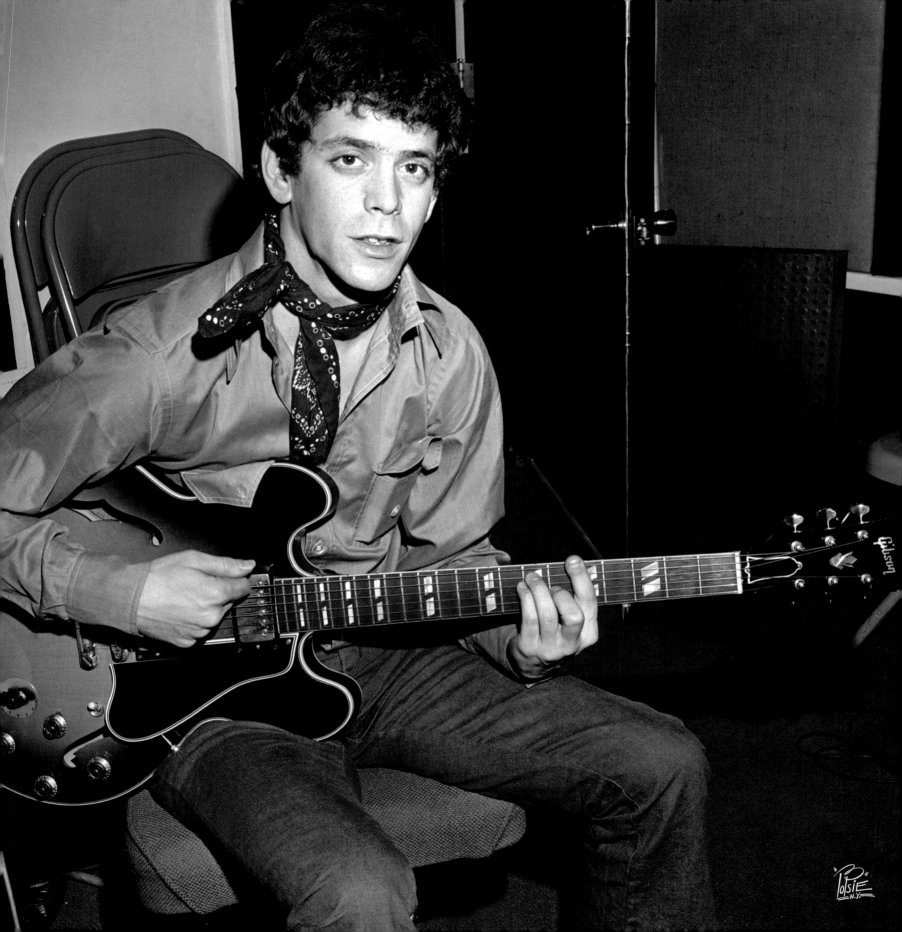

keeping up with the times

By the end of the Sixties, established
performers had to change their sound
and look to keep up with the times.
Johnny Rivers was no exception, as
this July 10, 1969 photo shows.

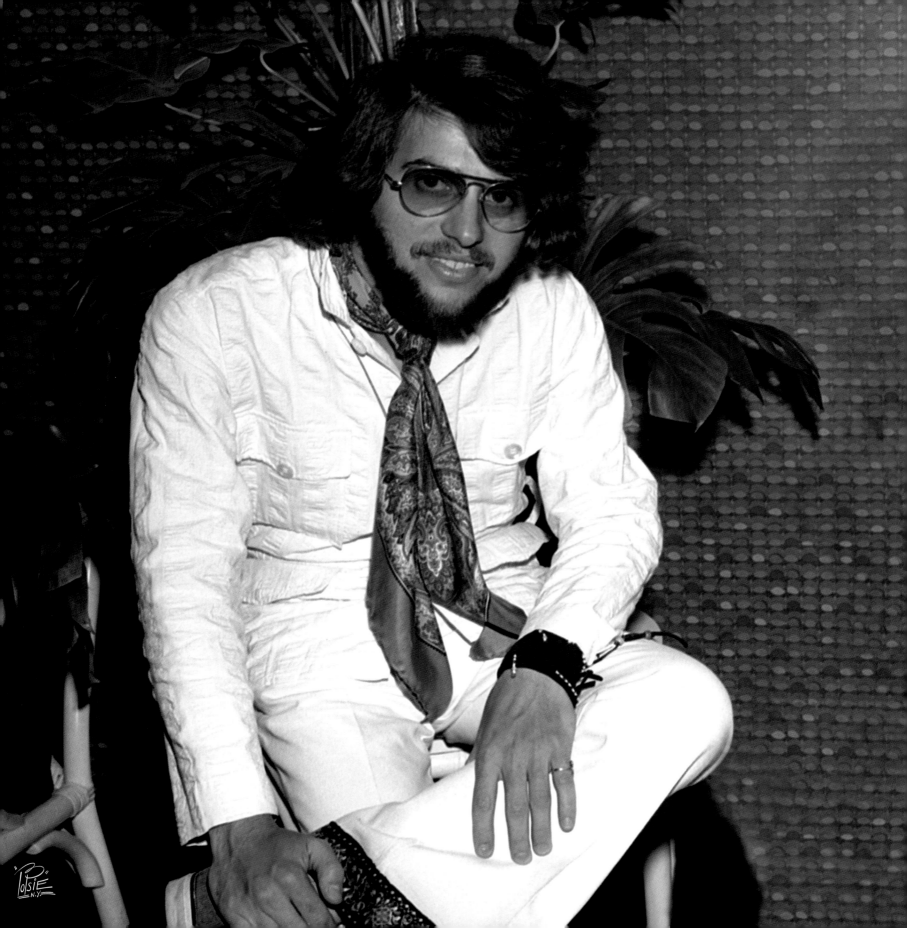

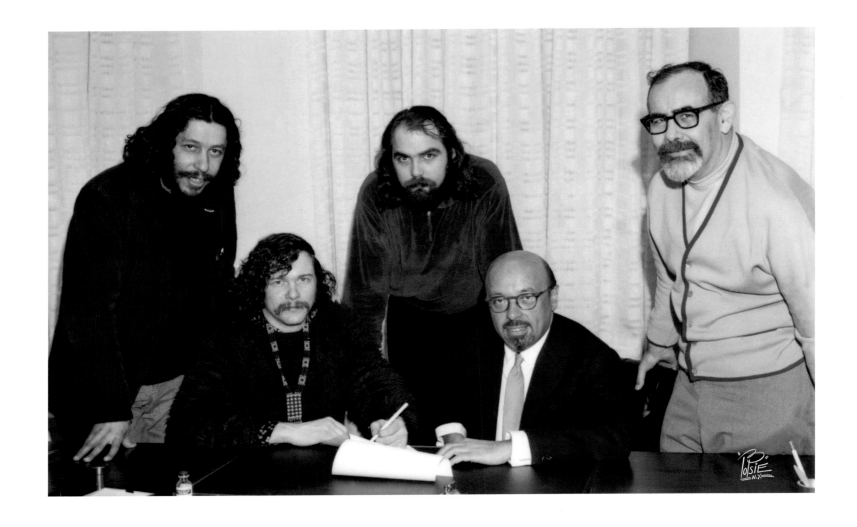

The **Fugs** signed with Atlantic Record executives **Ahmet Ertegun** (seated, right) and
Jerry Wexler (far right) on February 10, 1969. The band did not shy away from
controversy, and the contract failed to produce a recording on the label. According
to the Fugs, Atlantic indicated it would not censor any of their material. The sessions
were recorded and listened to, but Atlantic declined to release any of the songs.

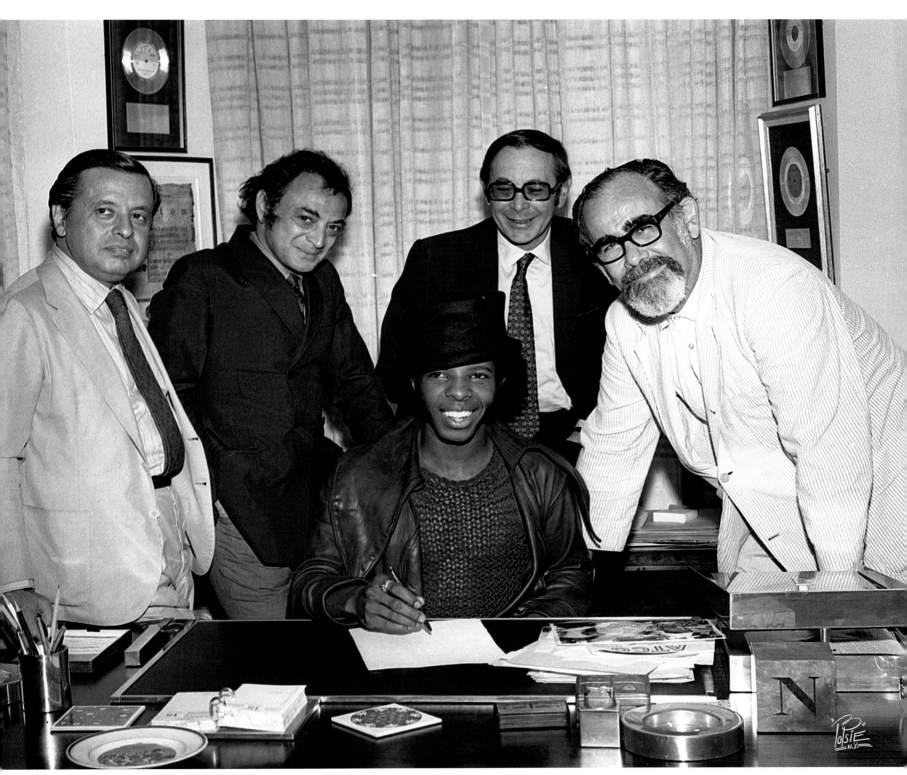

At the time of this photo, taken in the offices of Atlantic Records on August 15, 1969, **Sly Stone** was on the top of the charts. The brain trust at Atlantic decided to give him production responsibilities for a new record label named Stone Flower. Sly released only four singles on his label before pulling the plug in 1970.

Lou Rawls and his entourage get a pleasant surprise while reading *Billboard* magazine, November 19, 1969. Magazine executive **Don Ovens** looks on.

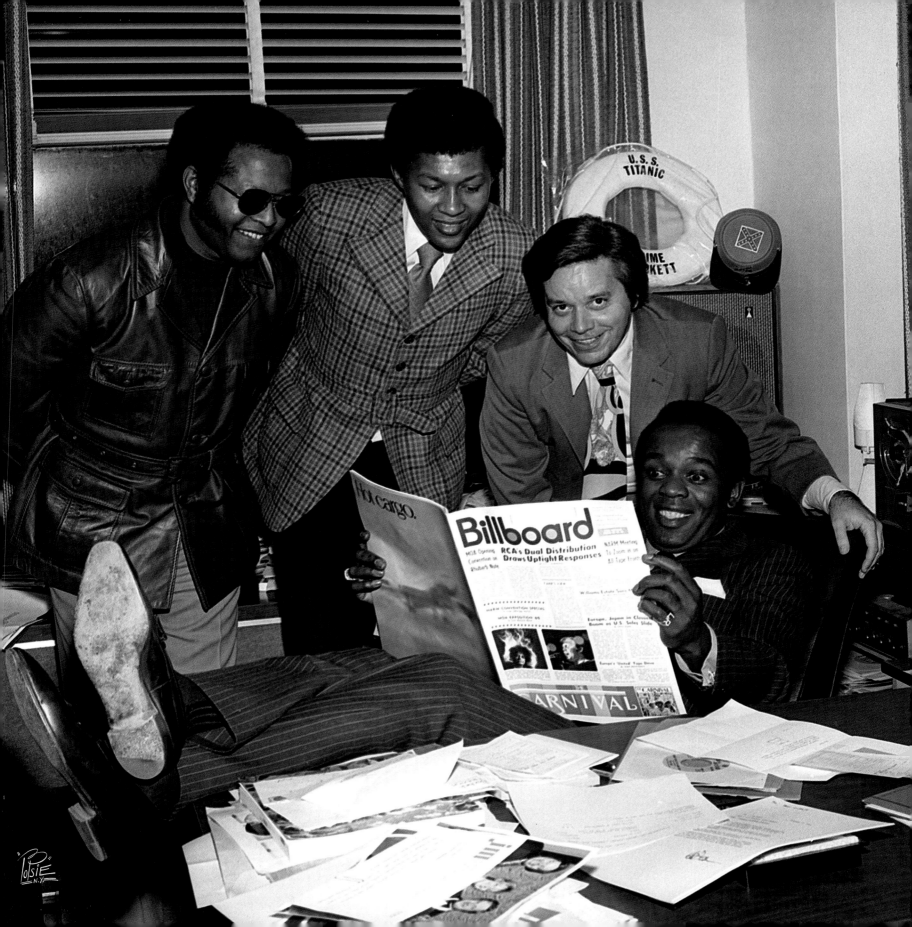

"Polsie" N.Y.

THE EARLY SEVENTIES

As the world became smaller and faster, PoPsie took time to slow down and "smell the roses." He began to take fewer assignments and do more favors. He started to think about life outside of New York. The desert foothills of Arizona began to beckon him. He was a wealthy Greek, and it was time to enjoy the fruits of his labors.

Frankie Valli puts the finishing touches on a
new recording on February 10, 1970.

Conway Twitty and **Loretta Lynn** receive a GRAMMY Award®
for "After the Fire Is Gone" March 15, 1972. This was ABC's
last live telecast of the ceremony; it moved to CBS the
following year.

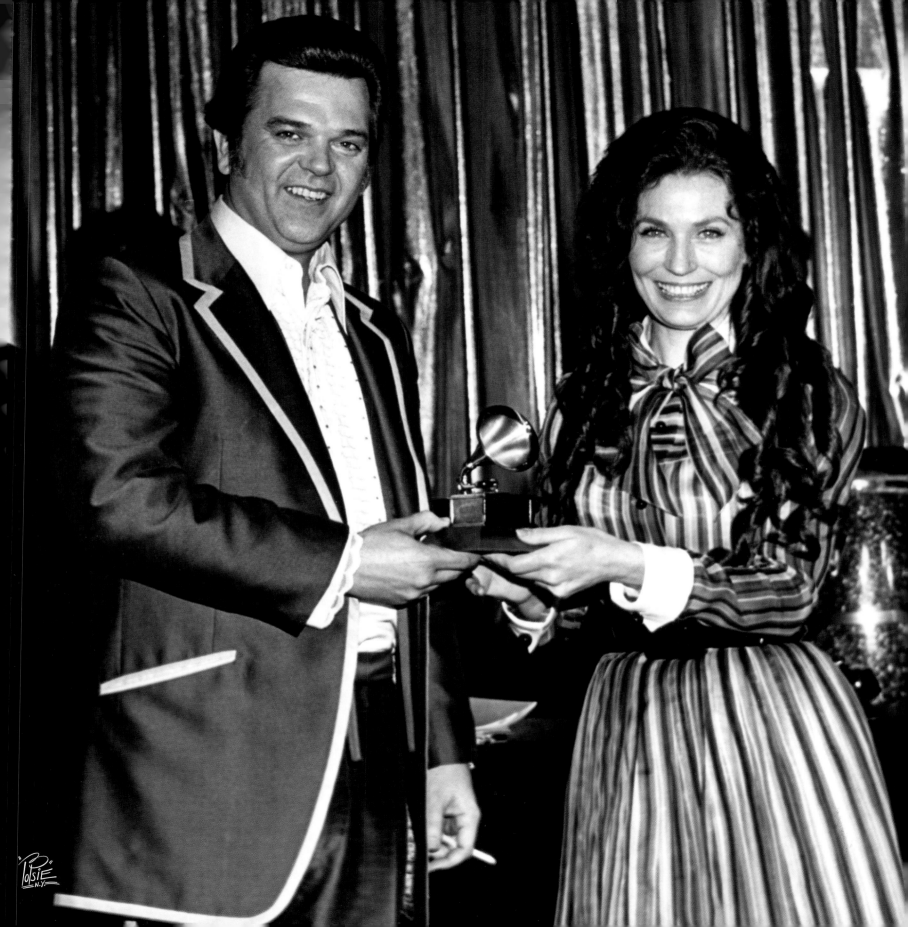

This is one of the last photo sessions with the group billed as **Patti LaBelle and the Blue Belles**, March 24, 1970. They moved to Europe later in the year and became simply Labelle. Left to right: **Sarah Dash, Nona Hendryx, Patti LaBelle**.

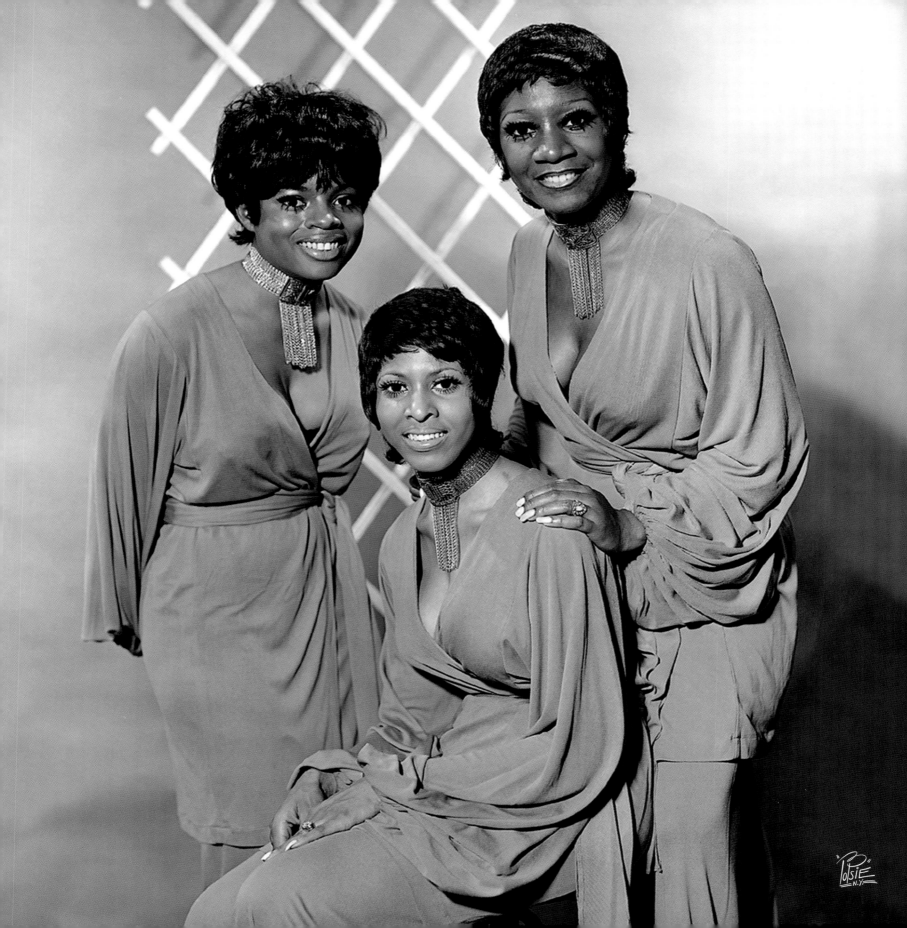

cutting it up

Legendary seven-string guitarist
Bucky Pizzarelli (right) cuts it
up with **George Barnes** at
The Guitar nightclub, New York,
October 9, 1970.

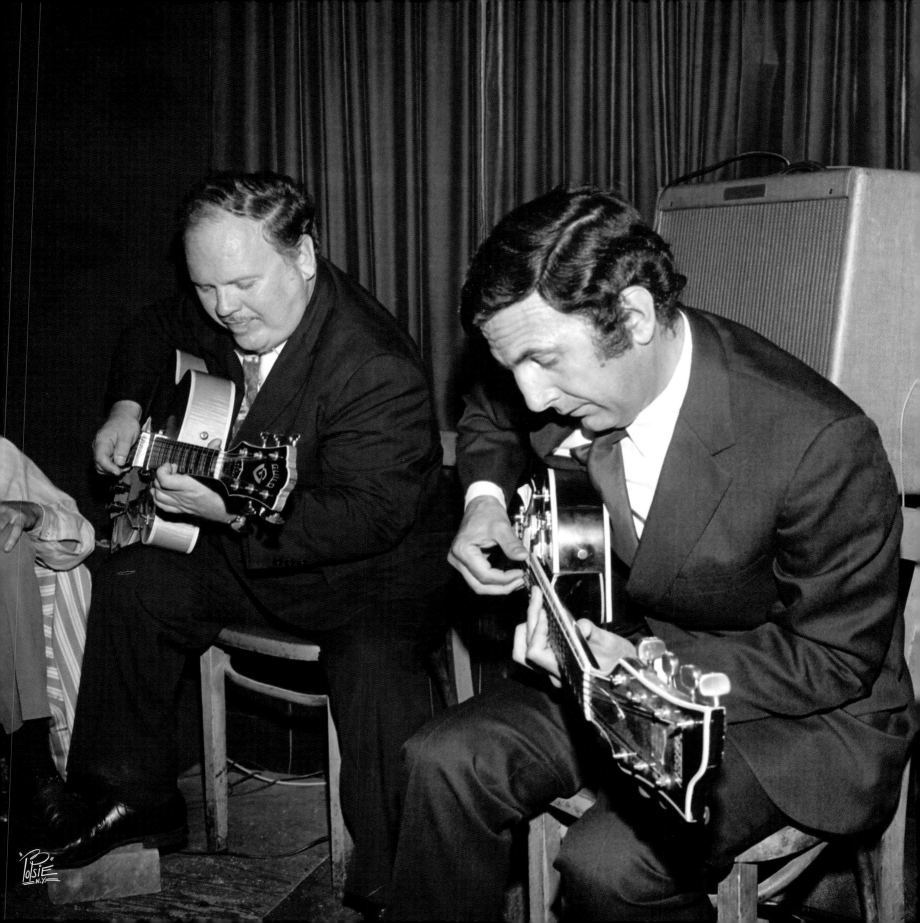

Neil Diamond and *Billboard* magazine's **Don Ovens**
celebrate Neil's latest success as a songwriter,
Billboard offices, November 6, 1970.

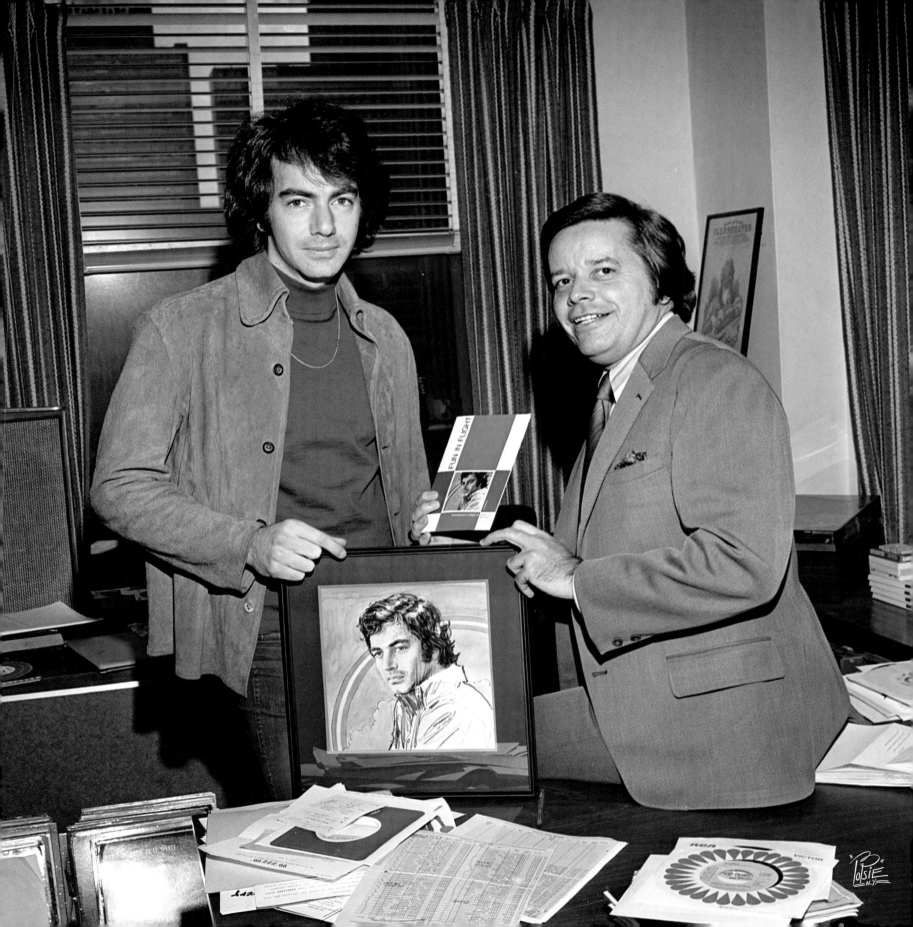

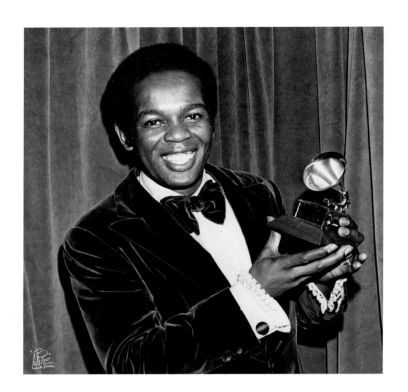 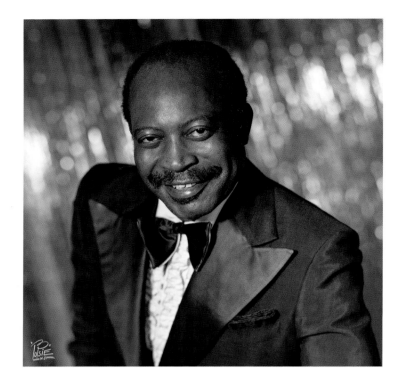

Above left: **Lou Rawls** smiles with his newest accessory, a GRAMMY Award® presented for his single, "Natural Man," March 1972.

Above right: Vocalist **Jimmy Ricks**, known mainly for his work with the Ravens, smiles for a portrait at PoPsie's studio, January 29, 1972.

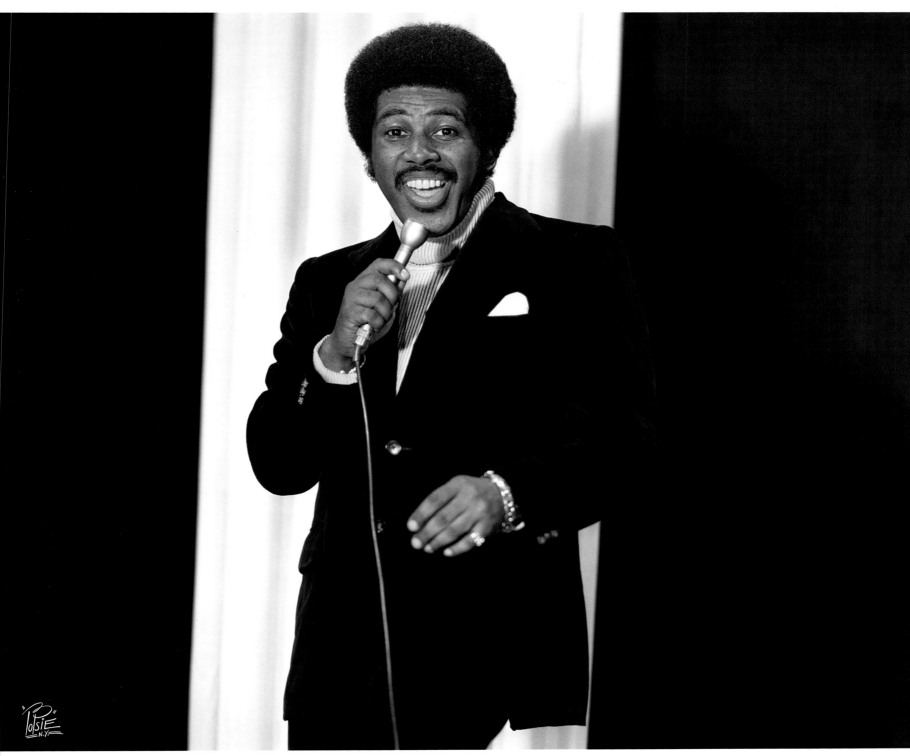

Ben E. King, who knew PoPsie from his days with the Drifters, stopped by for a promotional photo on February 25, 1972.

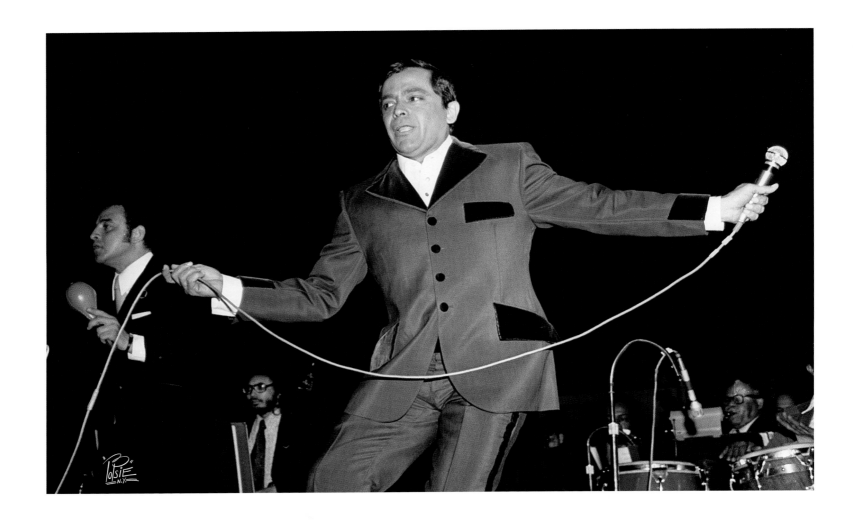

One of PoPsie's last trips to the venerable Madison Square Garden was to photograph
Tito Rodriguez performing at the Latin Festival on February 2, 1973. This was Tito's
final public appearance; he died of leukemia on February 28, 1973.

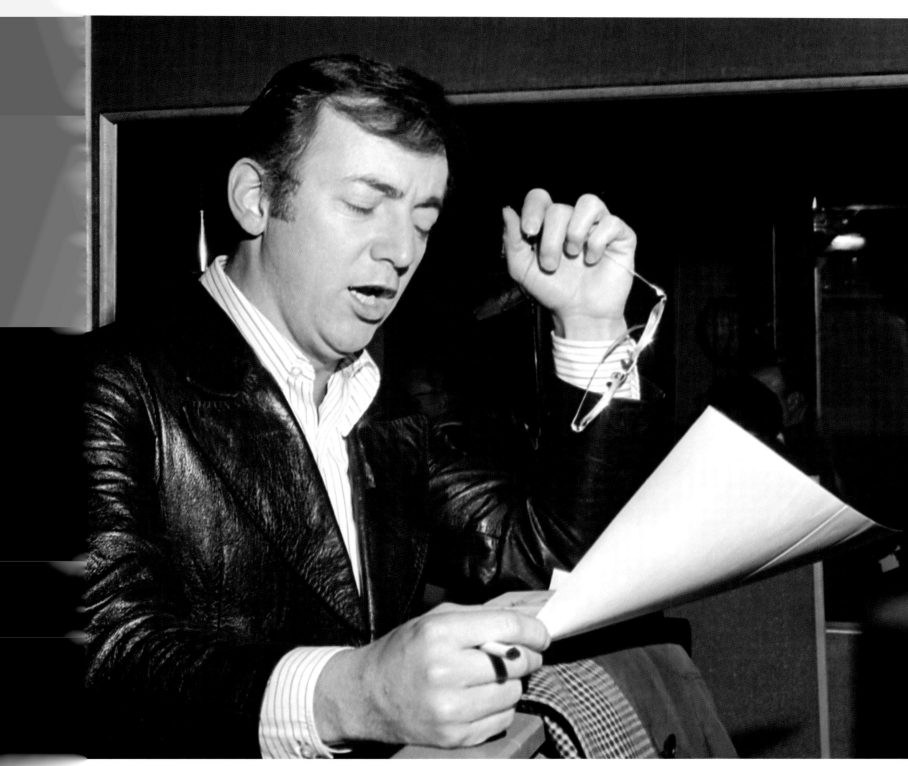

was present when the great **Bobby Darin** recorded his sessions with Motown Records, November 7, 1972. Darin is
d doing a run-through of a song before committing it to tape. Sadly, this would be his last recording session before his
y death in 1973.

Close friend and fellow trumpeter **Sy Oliver** remembered to call PoPsie during a recording session on March 13, 1973.

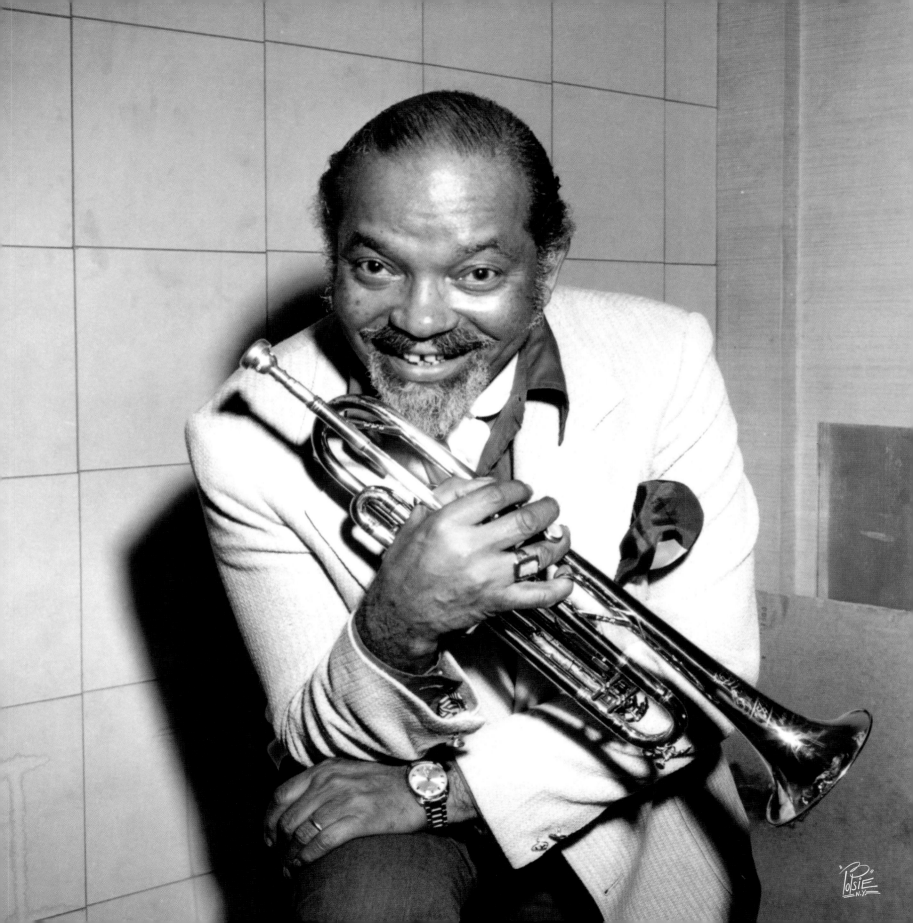

end of an era

Roy Eldridge was another fellow trumpeter whom
PoPsie knew from his days with the Goodman
Band. This photo was taken at Jimmy Ryan's Club
in New York on April 21, 1973. Little did Roy and
PoPsie realize that the end of an era was near.

two jazz greats

The 1973 GRAMMY Awards® dinner was PoPsie's last big assignment for NARAS®. After 28 years and thousands of photos, PoPsie decided this was it. For one of his last duo photos, he decided to bring together two of the greatest jazz pianists in history, **Count Basie** (left) and **Dr. Billy Taylor**.

PoPsie closed this chapter of his life with more than 100,000 photos taken over the span of almost 30 years. He watched the history of music evolve from behind his camera and was ready for a well-deserved break. He was free to go to Arizona and build his dream house. He bade farewell to New York City and the music industry.

PoPsie built his retirement home in Cavecreek, Arizona, drove his Thunderbird, listened to his jazz albums, and played his trumpet in the desert sun.

AFTERWORD

My production schedule takes me to many televised boxing broadcasts at Madison Square Garden. On location, hungry, and in need of a break from the production truck, I leave the TV compound for my favorite power-walk toward PoPsie's old studio, located at 1625 Broadway.

On the way, I make my usual visit to Colony Records, a few doors away from the studio. While I browse for new piano music, senior staff members at Colony constantly remind me of the times when PoPsie would walk in after his studio sessions and visit with the shop's owner, Nappy.

PoPsie and Nappy would browse through scores of record albums, listening to jazz and talking all night about their love for music and the musicians who influenced their lives. Their discussions were so intense, the customers and staff members would invariably join the conversation. Of course, PoPsie's photos were featured on the record albums and record magazines, which enhanced the stories and added to the excitement of the moment.

Those memories often encourage some of the senior employees at Colony to yell out loud as I'm leaving: *"Your father PoPsie was a legend!... The legend of Broadway!"*

I walk past the Brill Building and what used to be Jack Dempsey's restaurant. And there it is, the old studio! It's now a delicatessen. The dining area on the second floor is exactly where thousands of stars posed for PoPsie. Forty years later, my wife Judi and I still have lunch upstairs at this same location... and PoPsie's spirit joins us every time.

PoPsie was quite the character. When he couldn't get a decent smile, he'd assumed a pleasant tone of voice and asked his subjects to say "shit." It worked every time, and they'd laugh their rear ends off!

PoPsie's studio was usually quite a mess. On occasion, my mother traveled to the city to help him clean. Frank Sinatra's studio and the office for Reprise Records were also on the second floor. As PoPsie was leaving his studio one evening, he left his trash on Sinatra's doorstep. The next morning, Sinatra had some choice words for my father. But they were old friends and they got over it.

In the summer of 1948, my father purchased a Dumont console television set for our living room. From that moment, I was destined for a lifetime career in television. I loved every hour of New York programming that radiated from that 10-inch round picture tube. For years, I was on location with my father in every network TV studio in New York City. He photographed the guests on Dick Clark's *American Bandstand, The Andy Griffith Show, The Ed Sullivan Show, The Bell Telephone Hour,* and *The Arthur Godfrey Show.*

My favorite broadcast was *The Perry Como Show.* I was fascinated with the dress rehearsals on Saturday afternoons, and I watched the engineers change the tubes in the monster color television cameras. All the commercials were live in those days. In 1954, I was on location when the NBC peacock made its debut for *The Perry Como Show*—"in living color."

In addition to the television sessions, the majority of PoPsie's 24-hour day was absorbed with photo sessions for recording studios and music magazines. He existed on pure energy, cheap hot dogs from vendors on the streets of Manhattan, and that nasty cot in his office that he used for a three- or four-hour nap.

PoPsie was totally dedicated to his art—at times to a fault. He could not spend time at home with his family. When he did, he had a tendency to be on the grouchy side, and we kept our distance. PoPsie provided for us extremely well, and our mother gave us the home life that our father was not able to make available. Because of PoPsie's not-so-unusual lifestyle (at least not so unusual for people in the entertainment business), my mother, brother, sister and I became totally independent of one another. We were perfectly happy with such a state of affairs. It worked for us, and I have to thank Mom and PoPsie for that.

PoPsie has clearly influenced my life and my career in television. I was an engineer for the ABC affiliate WPLG in Miami, which segued to my present position as an associate producer. Listening to the dialogue and conversations between PoPsie's friends and clients, and experiencing their love for their work, has impacted the way I bond with my close friends. I travel worldwide, televising live boxing for Showtime, HBO International, and Belmonte Productions. My colleagues and I have the best times of our lives working in such an aggressive and high-tension environment. How do we do it? We take a few lessons from PoPsie.

Life in the fast lane caught up with PoPsie. He was wealthy and decided to take an early retirement in the mid-Seventies. He invested in many properties out West and settled in the desert foothills of Cave Creek, Arizona. I would fly out from St. Thomas or Miami and catch up with him in the middle of the night. He would be playing his trumpet with a few retired jazz cats in some cowboy watering hole in the middle of the desert.

PoPsie passed away from colon cancer on January 6, 1978. He was only 57 years old.

It's easy to stay in touch with my father. His spirit is with me when I am working with his archives and when I regularly visit his gravesite. As I'm looking out of my aircraft window during a red-eye flight to Europe or from the West Coast, I always say hello to PoPsie and thank him.

PoPsie replies—by sending me a shooting star!

–Michael Randolph

ACKNOWLEDGMENTS

Putting together a book from my father's photographic archives would not have been possible without the support of my wife Judi and the help of my colleagues in the music and broadcast industries. Considering my weekly television broadcasts around the world, the project was completed in only seven months. After all, PoPsie had already done most of the work!

Cliff Malloy, my publicist and music researcher, spent a considerable part of the past four years embracing and orchestrating PoPsie photo projects. I know the music trade magazines are knocking at his door. Thank you, Cliff, for your dedication and contributions.

Steve Farhood, my editor, highlighted his skills as the editor-in-chief of *The Ring* and *KO* magazines. He's the on-air analyst for Showtime's *ShoBox* series. Thank you, Steve, for your creative advice.

I was fortunate to have many friends enthusiastically contribute their time and memories to this project. (I apologize in advance to anyone I have inadvertently left out.) These friends include PoPsie's sister, Aunt Catherine Tsaketas, and her family, the Sezenias family, my attorney, Michael Lee Jackson, my lifelong friend, David Clarke of Video Projects International, the Maimone family, Joe, Cathy and Joe, Jr., Erica Bole Makar of Key Largo, Claude Hall, Bruce Spizer of 498 Productions, Chris Murray, Kurt Loder, Charles Seymour, David Finkle, Jerry Wexler, Vincent Aiosa, Marie Arena, and Irv Lichtman. Thank you, Richard Slater and Linda Nelson, for your support and for introducing me to your professional staff and colleagues at Hal Leonard Corporation.

I must thank my golden retriever, Gracie, for insisting I take her and my wife for walks on the beaches of Ocean City, New Jersey. I needed the many breaks from my work. And many thanks to my cats, Lucy and Donna, for rearranging PoPsie's photos and paperwork on my desk.

–Michael Randolph

Some people say the Rock and Roll Hall of Fame is the ultimate place to honor music history. I say I have had a greater honor in helping Mike Randolph compile this ultimate visual history of his father's work.

For the past four years, we have revisited many of PoPsie's faces and places and discovered a great deal of musical history in the process. The greatest discovery I've made is that there was a common thread to the history of modern music. That thread was William "PoPsie" Randolph, the Legend of Broadway!

Thank you, Mike, for helping me find it and giving me a ringside seat.

–Cliff Malloy

Anyone who ever knew PoPsie would surely testify... PoPsie delivered! I first met PoPsie Randolph in the late Forties when I started working in the record business as a secretary to Bob Thiele, president of Signature Records. PoPsie was our events photographer—always there, always delivering. We continued our business friendship in the Fifties, while I continued my career working with the Ray Anthony Orchestra and at Capitol Records, and, in the Sixties, at Mercury, Roulette, and RCA Victor record companies. This was a time when the record business was really booming, as was PoPsie's photography studio. We'd call him on very short notice. He'd be there and would deliver our 8x10 glossy prints by 9:00 a.m. the following morning. We all thought this to be an unbelievable feat, but only a few knew that PoPsie was actually up through the night developing the prints for that 9:00 a.m. delivery! Despite the lack of sleep, PoPsie was energetic and loved his work.

Our personal ties grew stronger in the early Sixties, when I married Joe Maimone, legendary promotions manager at Capitol Records in New York City. (PoPsie was our wedding photographer, of course!) Besides their business relationship, PoPsie and Joe were close friends and direct opposites—Joe was always impeccably dressed, PoPsie's tie was always askew (his signature look). After Joe and I had our two sons, Joe Jr. and Christopher, we moved from Manhattan to the New Jersey suburbs. There, PoPsie was a constant and welcomed guest, especially on those winter nights when the studio was too cold for overnight stays. On these occasions, PoPsie would drive over the George Washington Bridge for a bowl or two of his favorite soup. It was during these visits that PoPsie would speak of his dream home in Arizona. He finally delivered on this, too.

He built that Arizona home virtually by himself—with the exception of the frame, where he had help. He was indeed a happy man. After over 30 years of photographing some of the most famous names in the music world, PoPsie closed his studio and retired to Arizona in the early Seventies. PoPsie Randolph was unique. He was loved and he always delivered!

–Cathy Favaro Maimone

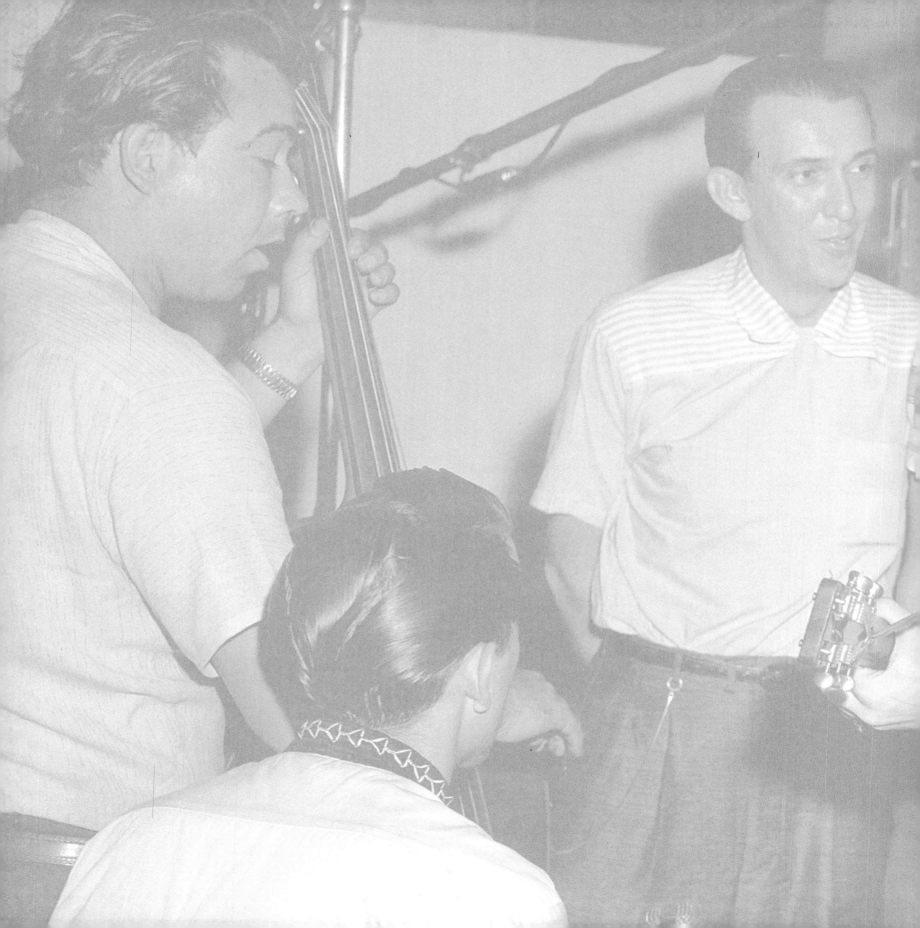